The XVIIth Century I

History of Art

Title page illustration:

Peter-Paul Rubens
1577-1640
Rubens and Isabella Brandt
Munich, Pinakothek

Cover illustration:

Pietro da Cortona
1590-1669
Bacchus (detail)
Ceiling of the Palazzo Barberini
Rome, Galleria d'arte antica.

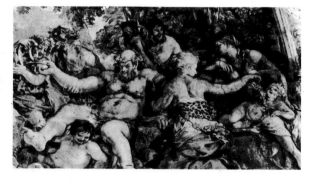

The XVIIth Century I

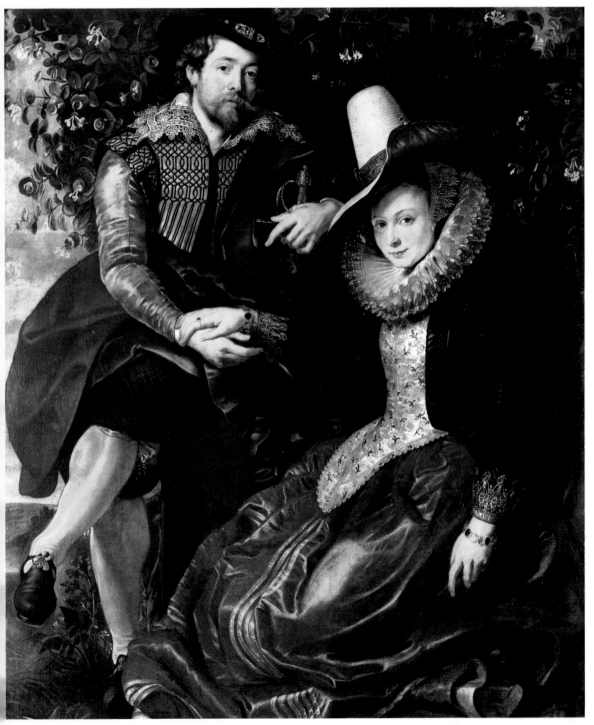

Philippe Daudy

Heron Books, London

Series edited by Claude Schaeffner
Artistic adviser: Jean-Clarence Lambert
Illustrations chosen by André Held
Assistant: Martine Caputo

Translated from the French by Joan White

The colour illustrations in the first part and the
cover were provided by André Held, Lausanne,
except:
Scala, Florence: pages 18, 25, 34, 40 and 47.

The black-and-white illustrations in the dictionary
were provided by:
Giraudon, Paris: pages 151, 157, 158, 162, 164, 166,
167, 168, 174, 175, 176, 180, 181, 183, 185 (right),
188, 191, 195, 196, 200 and 202 (left);
André Held, Lausanne: pages 153, 154, 156, 160,
173, 178, 189, 192, 198 and 202 (right);
Alinari-Giraudon, Paris: pages 147 and 185 (left);
Anderson-Giraudon, Paris: pages 146, 172 and 187;
Brogi-Giraudon, Paris: page 197.

Contents

Caravaggio
Narcissus
Rome, Galleria Nazionale d'arte antica,
Palazzo Corsini

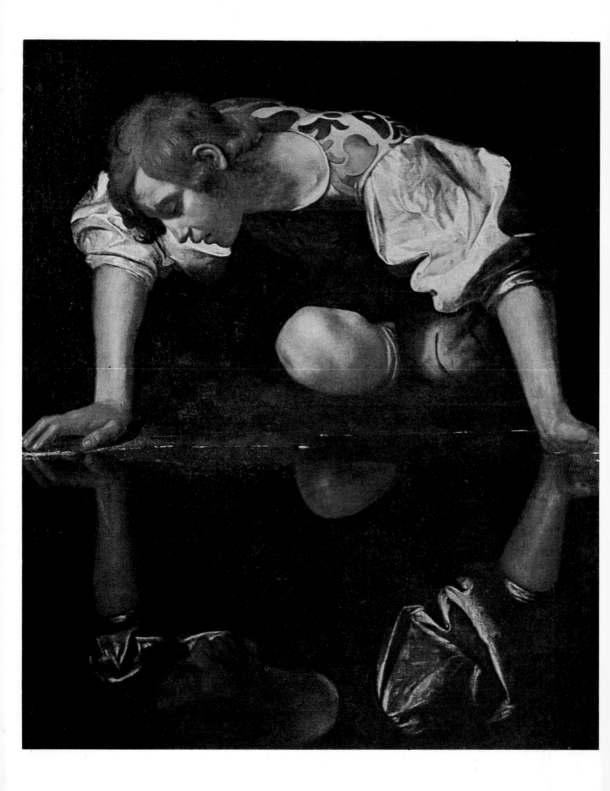

Introduction

The 19th century, obsessed by the discovery of Spanish painting, the rediscovery of Vermeer, the revelation of Rembrandt and his immensity, the marvel of Ruisdael and the Dutch landscape, for so long the source and inspiration of the Barbizon school and the Impressionists, abandoned the Italianate, Baroque vision of Rubens, Bernini and Lebrun in favour of a Madrid-Amsterdam axis which was better suited to its own aspirations. The Rome-Paris-Antwerp triple alliance was out of fashion. For Stendhal, 17th-century pictorial art was Guido Reni, Domenichino, Guercino and Pietro da Cortona. But by the time the Romantic movement entered its last phase, these painters were no longer understood. Indeed, are they any better understood today, even after sixty years' concentration on the Baroque, the disinterment of Caravaggio, the intensive study of Poussin? One is tempted to say no, if one is to judge by the poor reception given to a recent exhibition of Italian Seicento painting at the Louvre (1965). The reason is not hard to find: the plastic art of this particular period was one of the most subtle in the whole history of civilisation. It was the preoccupation of a circle of highly cultured connoisseurs, each one skilled in the appreciation of everything Europe had produced since 1450, for whom everything was an involved web of reference and allusion, for whom invention and transformation were only of secondary importance. This was a school of painting which had its own codes in the same way that the novels of Proust have a Balzac code, a Saint-Simon code, a Marquise de Sévigné code, a Chateaubriand code, all of which work together to produce not mutual destruction but mutual support: only culture itself can afford the comprehension of this particular feature, itself due to culture; and this is why it has proved essential to organise these two volumes on the 17th century in such a way that the first of them is devoted to Rome and to all that happened there then.

For indeed everything did happen in Rome. It was the focal point for the whole of Italy: for the first time in the history of Italian art (and for the last time, too, until something different happens) the Italian peninsula enjoyed the centralisation of all its artistic trends. At the same time, all Europe made its way to Rome: artists from Flanders, Germany, Holland, France and Spain either passed through (Velasquez and Georges de La Tour, for instance) or worked there for several years before going back home to start a new career in their own country (such as Vouet and Honthorst—known as Gherardo delle Notti in Italy) or else settled there permanently like the Caravaggesque Valentin, Poussin and Claude Lorraine. So there was a Rome which was purely Italian, occupied exclusively with the Classicism developed by the Carracci brothers and the Baroque of Pietro da Cortona and conspiring to crush or at least to relegate to a minor position the realism of Caravaggio. All around them flourished a European Rome which made it possible for Poussin and Lorraine to do work which no Italian would have done but which they themselves could have done nowhere else in the world.

This was the period of the great syntheses, when century-old problems at last found a solution: Rubens for example achieved the first complete organic and creative synthesis of the Flemish spirit and the Italian manner, something that had been sought unsuccessfully by the 16th-century Romanists. It was also the period of the fringe painters, the odd men out, the off-beat artists: there was Salvator Rosa and, at the end of the century,

7

Magnasco; there were the bamboccianti *with their low-life and peasant subjects and at the other end of the scale there was Dughet, a landscape artist "mad about nature" according to his contemporaries, the prototype of the modern art student striding around the countryside with his painting tackle on his back, like the young Corot 200 years later. It was the period of the easel picture, in the truly portable sense of the term, and at the same time of the vast decorative scheme such as the painted ceiling of the Salone of the Barberini palace.*

It was also the century when the still-life made its definitive claim for a separate genre of its own, as in the work of Caravaggio and Baugin, and started on the path which would, through Chardin, lead to Manet and Cézanne; and it was, finally, the century when there appeared in the Carracci studio a particularly entertaining little thing which was to have a great future, a kind of portrait heavy with meaning, a rittrato caricato, *later called a caricature. (Leonardo had, it is true, drawn deformities, but he had never produced portraits which deliberately accentuated the dominant features of a human face.) In France, there was the same variety as elsewhere: it was a period which ranged over a wide field, from the court-painting of Le Brun to the social comment of the three Le Nain brothers, from the astonishing Escalier des Ambassadeurs at Versailles to the timid flowers of Louise Moillon; it was an age when representational painting was perhaps more than at any other time totally overwhelming and all-enveloping, crowding and spiralling all over every ceiling and every wall, a constant and dominant reflection of the ruling dynasty's arrogance and of the strange solitudes of forest and ocean, presenting the beholder with a vastly complex cinerama vision of theology and mythology and with the plain statement of the humble peasant's crust and the wide translucent gaze of a tiny child.*

<div style="text-align:center">Jean-François Ravel.</div>

Anthony van Dyck
Drunken Silenus
Dresden Museum

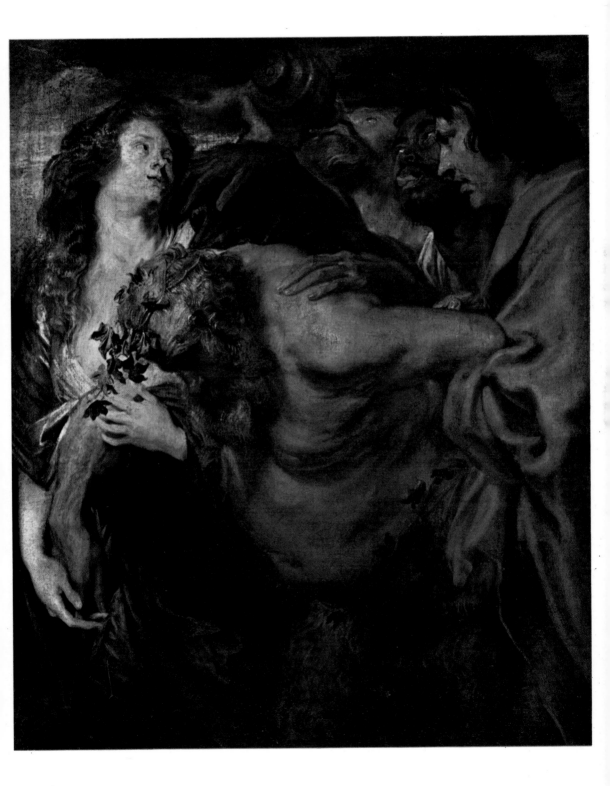

Peter-Paul Rubens
The Three Graces
Madrid, Prado

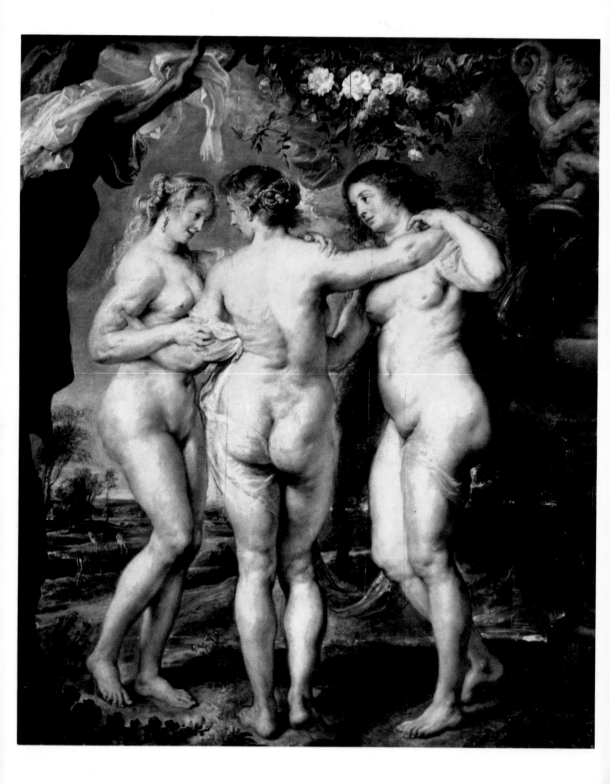

Festivals and Entertainments

In Rome on 31 December 1599, the Pope opened the Porta Santa of St Peter's to mark the inauguration of the Holy Year. This is a ceremony of great holiness and takes place only once every twenty-five years. It is always an occasion of high solemnity, but neither before nor since has it ever shone with the brilliance and splendour it had on that last day of 1599, the very eve of the 17th century of the Christian era. Clement VIII* appeared on a *sedia* of crimson velvet and gold, carried by eight men dressed in red, beneath a great embroidered canopy fringed with gold. Before and behind came a long procession of clerics and musicians dressed in red and white, seven men carrying silver crucifixes, countless people bearing candles, forty bishops in white satin mitres, fifty cardinals in white chasubles embroidered with gold and silver, their long scarlet trains held by priests in white lace surplices, and, last of all, sixteen laity dressed in black and carrying silver sceptres. The Pope himself was a shimmering figure in white satin, gold and precious stones. On his breast glittered a cross of diamonds, rubies and emeralds. In the midst of this splendour one moment of exquisite simplicity: the Pontiff's right hand held a candle and around his middle finger a handkerchief of plain white lawn was looped to symbolise the Fisherman's Ring.

The door was reached: a wall barred their entry in the traditional way. To the accompaniment of prayers and chants, the Pope knocked on it three times with a tiny gold hammer and as though by a miracle—though in reality thanks to the strenuous efforts of several sturdy workmen hidden in the basilica—the wall fell to dust at the Pontiff's ardent prayers.

The vast throng of people which counted in their numbers no less than 30,000 foreigners, "princes, counts, lords and nobles with hundreds of pilgrims" then rushed forward to pick up some piece of stone or splinter of wall plaster, a precious relic guaranteed to keep them safe from sin and danger during their lifetime.

The Castel Sant'Angelo* and the Vatican Palace were hung with flags, salute after salute was fired and the Wurtemburg burgomaster, Heinrich Shikhard, went back to his native Germany in such a tremendous state of excitement that he sat down and wrote page after page on what he had seen.

Renaissance Italy had seen similar occasions of pomp and circumstance: marriages, accessions, embassies, everything calculated to exalt the magnificence of princes and stave off the people's hunger. In January 1491, when Beatrice d'Este married Lodovico el Moro* and her brother Alfonso married Anna Sforza, Leonardo da Vinci was charged with the invention of a complex entertainment worthy of the occasion. It was Leonardo, too, who was given the task of planning the jousting costumes for those taking part in the mock tournament against the Sforza guests.

Everywhere in Europe, Burgundy, Imperial Germany, France, Spain, Austria, every court plunged into a whirl of elaborate, ruinous gaiety: they were on the verge of ruin—the party was over. But a festival is always the easy answer when bankruptcy looms near. It is a statement of strength, a confession of weakness, a summary of hopes

11

and fears: it seeks to deny their existence by an act of fusion. The very essence of this festival is political. But a change was now at hand. On the threshold of the 17th century, European politics lost its typical fluidity and began to settle and set like metal in a mould. The most cruel phase of the wars of religion was over. The Europe of scattered tiny feudal powers and small powerful city-states began to disappear in the face of the growing strength of national rulers and governments.

The Counter-Reformation, splendid, stupid and unyielding, met the fierce passion of the Reformation face to face. A great patchwork of alliances, betrayals, wars and treaties changed the face of Europe over and over again. The confrontation was alternately violent and peaceful and, through it, the noble Lutheran ethic, the austerity of Calvin and the moving steadfastness of the Roman Catholic faith each hurt and spoilt the other. The Inquisition went on burning bad books, good Jews and relapsed heretics; Louis XIV revoked the Edict of Nantes and Charles I was beheaded. But the Low Countries and their British protector Elizabeth, Protestant Germany, Hapsburg Austria, the Papacy, the most Christian king of France and the very Catholic king of Spain stayed exactly as they were: all hope of total destruction of their enemies was abandoned; at the most they sought to reduce them or at least to impress them. Prestige was a new idea: it took the place of decisive battles and ideological struggles, of tournaments and duels, prettied-up versions of war and the wrath of God.

But the living voice of the past preserved a sure pre-eminence over a still uncertain future. Rome remained the spiritual capital of the Western world, in spite of her corruption and inflexibility, and indeed maintained her position long enough for Calvinist Geneva and Lutheran Augsburg to grow slack and corrupt in their turn.

The most powerful nation on the European continent, France herself, only won back her uniformity and pride at the cost of Henry IV's conversion. In spite of her Gallicanism, her deep undercurrents of Jansenism, her expanding population, her wealth, her unity, her victories and defeats served the glory of the church as well as that of the nation.

Prestige and glory, too, found their expression in revels and festivals. The Comte de Brienne, Secretary of State to Louis XIV, left an account of the ceremonies which marked the occasion of the king's marriage to the Spanish Infanta, Maria Teresa. For a hereditary monarch, marriage represented a renewal of the act of coronation, a solemn preface to the birth of a successor, a promise of perpetuity.

A living monstrance, the new Queen of France made her entry into Paris on 26 August 1660:

"The Infanta wore a material which looked like damask, with huge silver flowers on a white background. In fact, this effect was achieved by the embroidery which covered the cloth. The princess wore a chain glittering with diamonds, held on to a great knot by means of another smaller chain which met and supported the larger one. She wore, in the Spanish manner, a sort of bodice with a basque falling over a rather short skirt which was held out by a farthingale, wide at the sides and narrowed before and behind, a kind of oval shape. Neither bodice nor skirt was embroidered

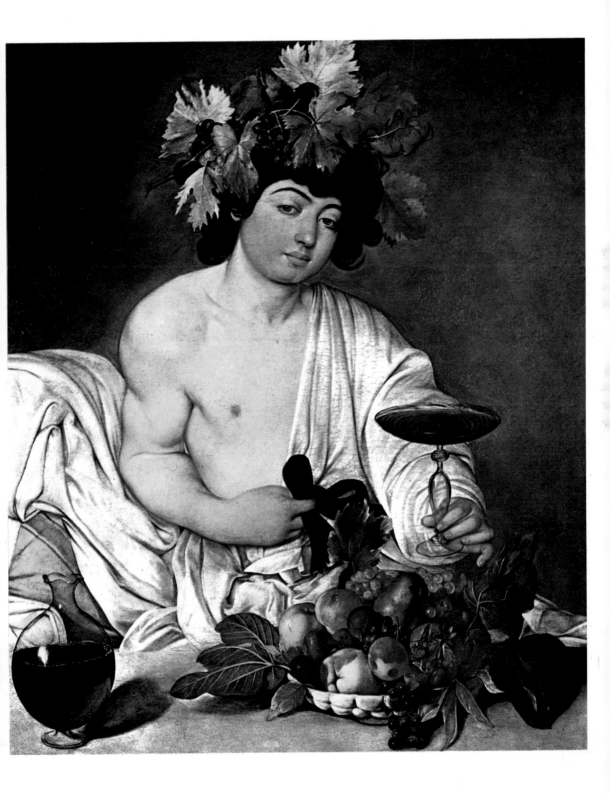

Caravaggio
St John the Baptist
Basle Museum

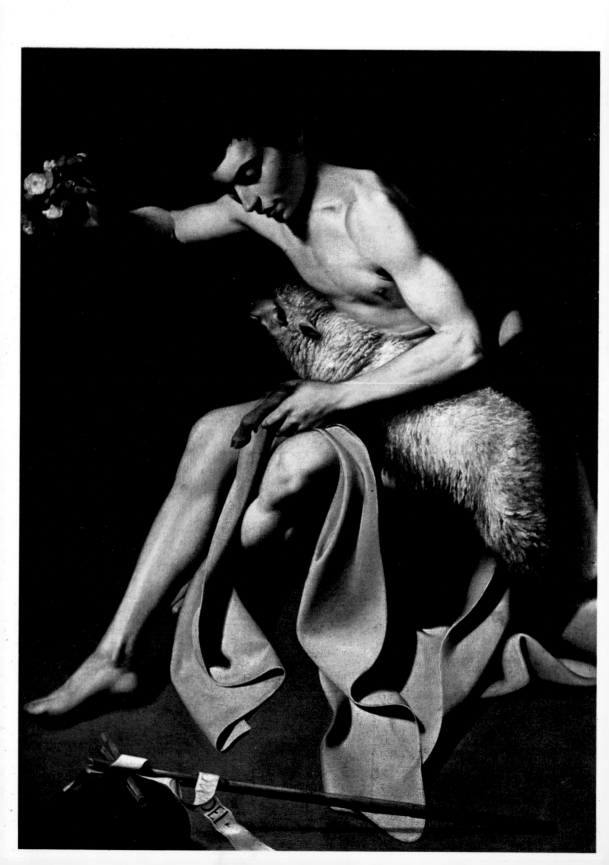

down the front, as is usual in France, but instead there was a long strip of gold and jewellery, thickly encrusted and intricately worked....

"There was no collar, but a chain of diamonds around the neck: the cuffs were met by precious bracelets all around the wrists.... Instead of having her hair over her ears, it was dressed in such a way that on either side of the head there were two large shapes like the wings of a great bird, and on to these were fixed row upon row of curls of real and false hair. Between and behind these heaps her own hair was arranged, piled up high on the top of the head; it hung down from there in waves and curls, with bunches of pink ribbons on either side, fixed in such a way that ribbons as well as curls and waves were absolutely firmly set and fell no further than the lower half of the face."

The Infanta's suite was dressed with equal splendour. Designer and director for the whole ceremony was Diego Velasquez.

He was Court Marshal and had already carried out the task of decorating the Cathedral at Fuenterrabía where the proxy marriage had taken place. He had also converted the rooms and conference hall where the Treaty of the Pyrenees was signed on the Franco-Spanish island in the middle of the river Bidassoa. It is a pity that Velasquez was not allowed to restrict himself to painting a picture of the occasion and nothing more,[1] as Rubens did for the double wedding of Anne of Austria to Louis XIII and Isabelle de Bourbon to Philip of Spain. But painting had to serve the demands of festivals like all the other arts. Even Rubens had to act as master of ceremonies when the Cardinal-Prince Ferdinand of Austria made his entry into Antwerp in 1635. Velasquez was not the only one to suffer.

But to return to the royal wedding: the finest artists of France had been brought in to play their part. At the end of the Pont Notre-Dame, still lined with houses, the Beaubrun brothers, court painters to His Majesty, had framed with grey marble columns a portrait which showed the queen mother, Anne of Austria, the aunt of the young bride, "in the person of Juno", ordering the goddesses to honour the royal couple. Beyond Notre-Dame rose another triumphal arch, decorated with allegorical figures, the work of Michel Dorigny and François Tortebat. On the Place Dauphine, Charles Le Brun * had created "on a massive base with arched openings a huge pyramid carrying a statue of Glory seated on a sphere. A painting showed the king and queen together in a chariot driven by Hymen and drawn by a cock and a lion. Through the arches could be seen the equestrian statue of Henri IV and in the distance the outline of the Louvre.... As the king and queen passed by, they pretended to show great admiration for this ambitious set-piece whilst four-and-twenty violins played a hymn in their praise."

The king and queen *pretended to show great admiration*.... One other inspiration for these festivities was the royal caprice, and sometimes strenuous efforts to please were rewarded with bland indifference or active displeasure. When the last of

[1] Velasquez died a month after these ceremonies. They were immortalised in a superb series of tapestries by Le Brun.

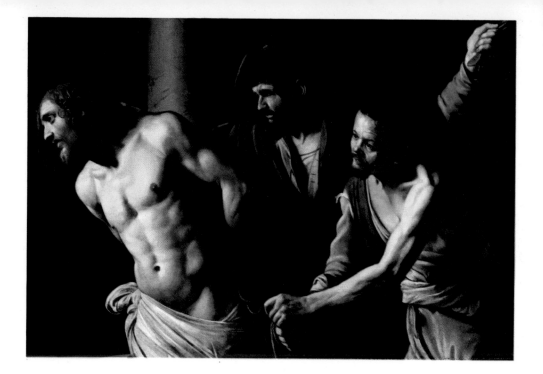

the Spanish Hapsburgs, Charles II, saw the fountain of Diana he had had built in his garden at La Granja, he exclaimed: "It cost me three millions and kept me amused for only three minutes!"

This particular festive occasion was not destined to please the king. He had only to glance at his bride, dumpy, pallid and huddled in a corner to realise that he was only there for show.

The trumpets and the Swiss soldiers who led the procession, the seventy-two mules harnessed with silk and silver and nodding plumes, the twelve horses with gilded bits and stirrups who led the royal train were there to make the crowd gasp and stare. So was the royal seal in its silver-gilt coffer draped with brocade, carried on the back of a white palfrey caparisoned in blue velvet, led by two attendants and preceded by officials in violet satin cassocks laced with gold, their chains of office around their necks.

Pierre Séguier, the Chancellor, in a large wide-brimmed hat stiff with embroidery, was surrounded by officials and protected by a carefully held violet parasol, heavily trimmed with gold and silver.

The town of Paris, reluctant to appear backward in this matter, had a canopy made for the king, all gold brocade and bearing his arms, and at the Porte Saint-Antoine they had a special portico built for him with three openings and in front of it statues of Hercules and Minerva—on top of it, pyramids crowned with fleurs-de-lis. Beneath the front pediment the bust of Louis XIV reigned in splendour in the midst of ornamental paintings from the brush of the Dutch painter Van Ostade.

So much hard work, care and inspiration for only one day! But at the time, it seemed right and proper. When the Duke of Burgundy made his formal entry into Grenoble, Menestrier found it quite normal to engrave nineteen folio plates to illustrate just one of the triumphal arches erected in the town to greet Louis XIV's grandson. For a celebration like this, time had no meaning—or else it counted in quite the wrong way. It took less than thirty days to build the "Monatsschlössel" (the one-month castle) at Salzburg. Every morning, architects, painters, interior decorators, musicians and poets met to invent a new entertainment for the marriage of Leopold I

Caravaggio
The Flagellation
Rouen Museum

to Margarita-Maria of Spain, a magnificent affair which went on being celebrated in Vienna for the whole of 1666.

A denial of the established order, the expression of a transcendant rhythm, only the leader of the revels had the right to direct the festival. Anything which happened to upset its successful outcome, the slowness of the work, shortage of finance gave so clear an indication of how limited were the powers of human beings that the Pope, God's Vicar on earth, kings and their lieutenants, their lords and privileged children could ill hide their resentment and displeasure.

Quicker, better and then better still—bigger and even more sumptuous: this constant striving to outdo one's self as well as others was the basic law of the grand festival like a fierce desire to break every record. The artists of the 17th century, justified as they were by faith and by the certainty that they were offering man a vision of Heaven rather than God a new Babel, found it all too easy to comply with the wildest fantasies and most extravagant demands of their masters and their clients.

Birth of the Baroque

The Baroque * sprang from entertainments and celebrations like these: through their agency, it developed into rococo and rocaille, began to fade away round about 1750 in the face of 18th-century Neo-Classicism and died eventually under the onslaught of the French Revolution.

Before turning to the development of the Baroque and in particular to the place of 17th-century painting in the Baroque concert, it would be appropriate to consider the word itself and the extent of its implications.

Semantic explanations of the real sense of this word are of very little help— every meaning is arbitrary and necessarily subjective, so that one is best served by a study of its most generally accepted uses. From this we can take a definition which may not be the best means of offering a critical judgement, but which will at least offer a conventional linguistic starting-point for discussion.

17

Annibale Carracci
Fishing (detail)
Paris, Louvre

Genuine etymological considerations are really only of anecdotal interest.[1] One might indeed copy Montaigne and say of those who seek the utmost ends of subtlety when they go looking for its origins: "It is Barroco and Baralipton which make their reasoning so befuddled."

For the purposes of this study, we need not go into the Portuguese and scholastic origins of the word. It is more appropriate to start with the best known meaning, the one the word took during the 18th century—"strange and extravagant". In 1701 Saint-Simon wrote: "It was very Baroque to have the Abbé Bignon succeed M. de Tonnerre, the count-bishop of Noyon." The President of the Dijon Parlement, de Brosses*, was the first to use it in an aesthetic sense: "The Italians complain that as far as fashion is concerned, we in France are sliding back into a rather Gothic style . . . that our decorative motifs are the last word in Baroque. . . . I have no wish to say anything good about this ridiculous Baroque. . . ." It is interesting that in this extract the word Gothic has the same ambivalence as Baroque—a pejorative application of a medieval term has been extended in such a way that finally it is used to describe a much more general style typified by excess and bad taste.

However, leaving aside this descriptive limbo, we soon find "Baroque" has become a word packed with positive meanings. In his *Histoire de l'Ameublement* (about 1750), Havard writes of "a Baroque balcony in bronze, gilded with ormolu, decorated with branches and flowers". Further on we find "of a charming Baroque design" and "twin beds . . . worked with ribbons and Baroque cut-outs".

This meaning was, however, restricted to Havard, and Trevoux's dictionary says in its 1771 edition: "In painting, a picture, a figure in the Baroque style: where neither rules nor proportions are observed, where everything is drawn according to the whim of the painter."

In the great *Encyclopédie* of Diderot and d'Alembert (the 1776 supplement), Jean-Jacques Rousseau gave a purely musical definition of "Baroque". "Baroque music has confused harmony, filled with modulations and dissonances, the vocal parts hard and unnatural and the action constrained." In a "letter on French music", he wrote as early as 1753: "The Italians claim that our music has a flatness of melody . . . we on the other hand say that theirs is peculiar and Baroque."

With the definition given by Quatremère de Quincy in the encyclopaedia published under the editorship of Panckoucke in 1788, we come at last to the meaning which has the commonest currency in modern France: "In architecture, Baroque is a tendency towards the bizarre. Better still, perhaps, it is over-refinement of the bizarre, or even the abuse of the bizarre, if it were possible to say this. What severity is to moderation of style, Baroque is to the bizarre; it is in fact the superlative of the bizarre. The idea of the Baroque automatically implies the absurd taken to excess."

"Borromini*, for instance, offers splendid examples of extravagance, but Guarini* goes further and is perfect Baroque. The chapel of the Holy Shroud in Turin

[1] The etymology is discussed in the Dictionary section.

for which this architect was responsible is the most perfect example of this style that we have."

The Italian dictionary of art and artists brought out by F. Milizia in 1797 quotes the French definition almost word for word. It seems, therefore, that the idea of architectural "Baroque" must have started in France before being taken over by the Italians.

It is thanks to German art historians that the word finally lost its pejorative— or laudatory—significance and was taken to characterise a particular style typical of a given period.

From 1887 to the outbreak of the first world war, Cornelius Gurlitt, Heinrich Wölfflin*, Schmarzov and Aloïs Riegl worked on their own definitions of the Baroque.

As early as 1860, Jacob Burkhardt* had recognised the important position of this style in his book *Cicerone*: "When we come to the 1580s, we no longer take each artist as an individual, but instead we take an overall view of the Baroque style in so far as it is possible for us to see it as it was." He added, not without ill-humour: "It is not our fault if the Baroque style is so predominant, if Rome, Naples, Turin and other towns are filled with its artistic expressions."

It was Wölfflin who threw light on the Baroque world to which Burckhardt had denied illumination. His "Five pairs of categories" is still the most fruitful analysis of the aesthetic evolution which took place between the end of the 16th and the beginning of the 17th centuries.

These polarities or categories were: linear and painterly *(malerisch)*, plane and depth, closed form and open form, multiplicity and unity, clarity and obscurity; this sums up the Baroque exactly. Of course, by inventing this vocabulary for describing the style Wölfflin opened the door to the descriptive exaggerations of the following generation, but if we restrict ourselves to using it within the precise historical limits he assigned to it, it is impossible not to be impressed by his insight.

After the first world war, not only was the Baroque considered one of the major art styles, it was the object of a passionate cult. The same unhappy fortune which had brought it the scorn of the sober art lovers once again worked to its disadvantage and it found no favour in the eyes of such critics as Benedetto Croce* and Bernhard Berenson, more responsive to ideas and to formal perfection than to the movement and disorder of Baroque. However, critics such as Longhi, Munoz, Delogu, Brinkmann, Voss, Fry, Bodmer, Posse, Pevsner and Weisbach in Italy, Germany, and England praised the achievements of Roman and European Baroque. Even in France, "the home of Classicism", A. Adam dared to draw attention to French Baroque.

But it was the Spanish writer Eugenio d'Ors* who raised the Baroque to the level of an eternal symbol and swamped in confusion and enthusiasm the reasoned and praiseworthy efforts which had sought to restore the Baroque to its proper position.

"1. The Baroque", wrote E. d'Ors, "is an historical constant which is found in periods as far away from each other as the classically decadent Greek Alexandria

Jean de Boullongne
Concert
Paris, Louvre

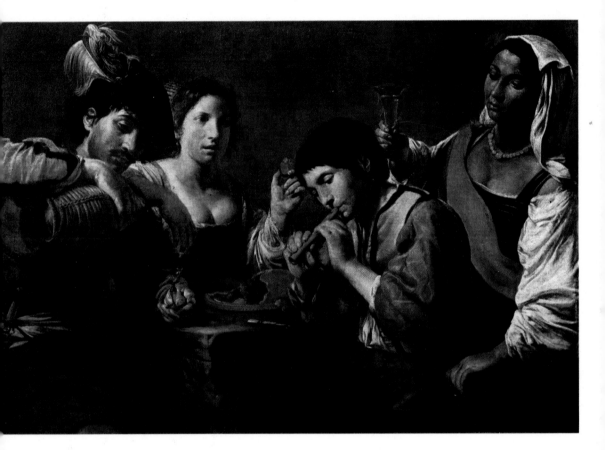

is from the Counter-Reformation and either of these from the "*fin-de-siècle*" art of the late 19th century. It is found in widely different areas, in the East as well as the West.

"2. This phenomenon concerns all civilisation and not art alone, and even, by extension, the form and shape of natural objects. . . .

"3. It is entirely natural and if one can speak of sickness in connection with it, then it must be with the meaning that Michelet used when he said 'Woman is always sick'.

"4. Far from being an offshoot of the Classical style, Baroque is in deep contrast to it, even more so than Romanticism, which itself is only a single episode in the development of Baroque."

Eugenio d'Ors, who managed to list no fewer than twenty-two Baroque styles, from "Barochus pristinus" to "Barochus officinalis" by way of "Barochus buddhicus" and "Barochus finisecularis", goes on to say: "Wherever we find several contradictory ideas expressed in one single gesture, the stylistic outcome belongs in the Baroque category. The Baroque spirit *has no idea what it wants*. It wants to be simultaneously *for* something and *against* it."

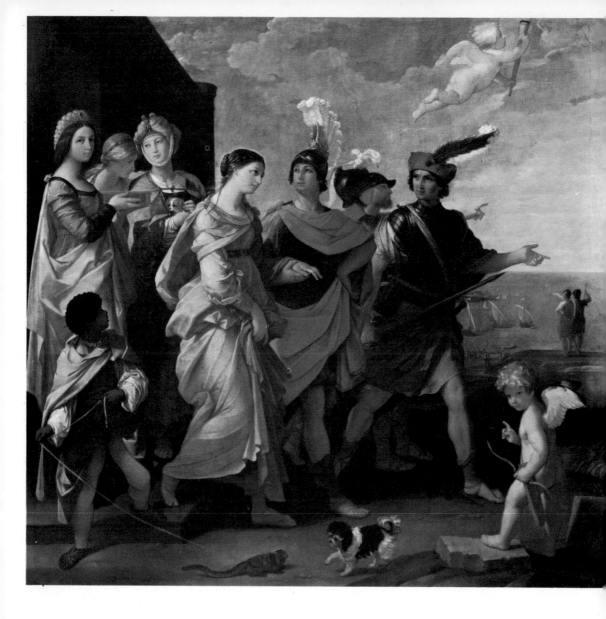

Without starting a full discussion of these peremptory definitions, one can at least say that they achieve an over-inflation of the idea of the Baroque, not only in time but also in its formal intent. All that the Spanish critic did was in fact to take the definition found in the 18th-century dictionaries and substitute praise for condemnation where appropriate.

Modern critics and art historians generally tend to reserve the term "Baroque" for a strictly defined historical period. As to the precise nature of the style, it is still a subject for research and discussion.

We must now turn to a close study of the Baroque artists themselves, of their works, lives, writings, so as to replace the metaphorical view of a period and a style with a proper view—possibly more complex than we realise even at the present time— of one of the richest and most brilliant periods of Western art.

Without prejudicing the conclusions later to be drawn from this study, one can at least say with certainty that Baroque art and civilisation spring directly from the aesthetic and spiritual synthesis of the Renaissance. The canons of beauty which the Renaissance developed, its religious heritage, the contradictions of its demanding

22

Guido Reni
The Rape of Helen
Paris, Louvre

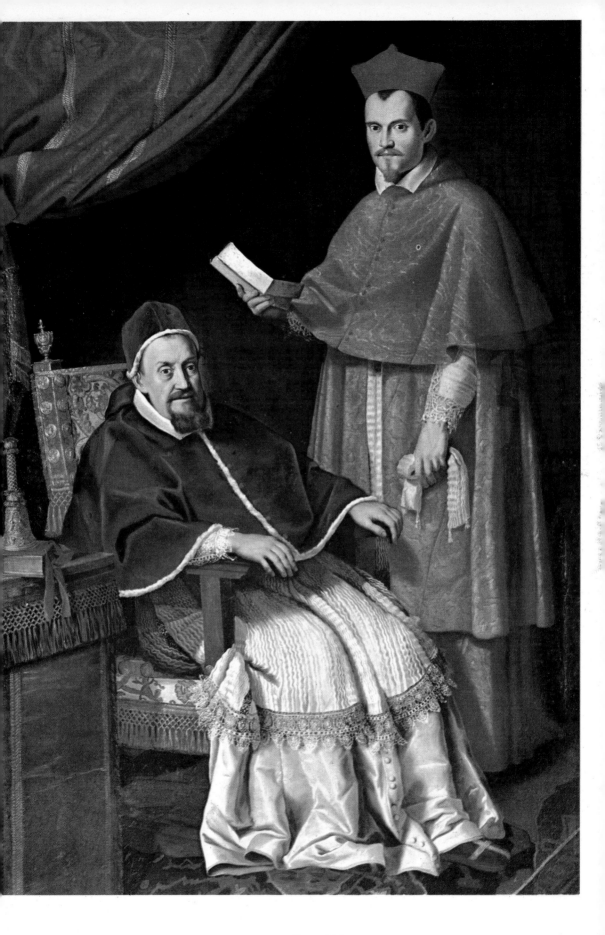

Domenichino
*Portrait of Pope Gregory XV
and Ludovico Ludovisi*
Béziers Museum

rationalism and ardent mystical aspirations provided the main source for two artistic trends which ceased to be important only with the appearance of Neo-Classicism in the last years of the 18th century. Mannerism—chronologically the first—rejected spatial perspective in favour of fantastic deformation. Turning its back on Classical antiquity as well as on the observation of nature, it achieved in its second phase a true virtuosity and created a new convention of form which owed little to imitation but which represented a sort of pictorial liturgy whose symbolic meaning was completely forgotten. Even though they came later in time than the Mannerists (though the latter were still painting contemporaneously), the Baroque masters by no means ignored " manner " as Constable was to define it in the 18th century, that is to say " the careful examination of what others have done " and the imitation of their works, " choosing and combining their different beauties ". But they rejected a system of values which turned its back on reality. Classicism, when defined as " an idealisation of objective reality ", that is, the exact opposite of Mannerism, came along at the same time as the Baroque and complemented it. It followed, therefore, that the Baroque artists and the Classical artists spoke the same language—but with different intonations.

"What I teach will breed ignorant masters", wrote Michelangelo, the father of Mannerism. He was only partly correct: there were a few inspired and intelligent painters who were able to open the way to that pictorial spirit of inquiry which was to lead beyond academicism to contemporary abstract art.

The Baroque, a vast river which swept all over Europe, carried along with it a sumptuous chaos of gold and gilding and wreaths and spirals. This exuberance of décor, this abundance of astonishing shapes which was really only one particular feature of the style was responsible for the misunderstanding of its function—a misunderstanding only recently recognised as such. The ornamentation aspect—" Baroquism ", if you like—is, as it were, the blossom. Baroque, however, is the fruit—the fruit of a dynamic concept of the world. The Renaissance had thought that the perfection of this world was unchanging: the Baroque was its moving, breathing representation.

Baroque Presentation

In the period between 1609 and 1615, St Ignatius of Loyola *, St Charles Borromeo, St John of the Cross, St Teresa of Avila and St Philip Neri were beatified or canonised. This empyrean of mystics brought spiritual light to the Catholic world and swept it into pure ecstasy, for the Council of Trent had confirmed it in its faith and in its expectations.

St Philip's Congregation of the Oratory and St Ignatius Loyola's Society of Jesus were the propagators of this transcendant vision which they offered to the world through the medium of ascetic discipline and education.

Is there not something distinctly Baroque about St Ignatius himself with his red hair, his passion for music, his admiration for the most Gothic saints and his dream

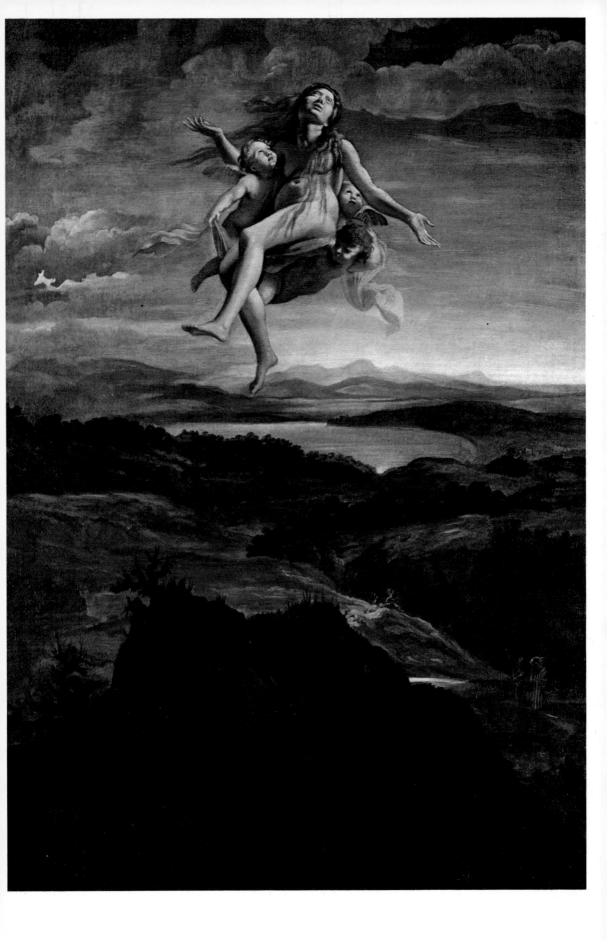

Giovanni Lanfranco
The Magdalene borne to Heaven
Naples, Capodimonte Museum

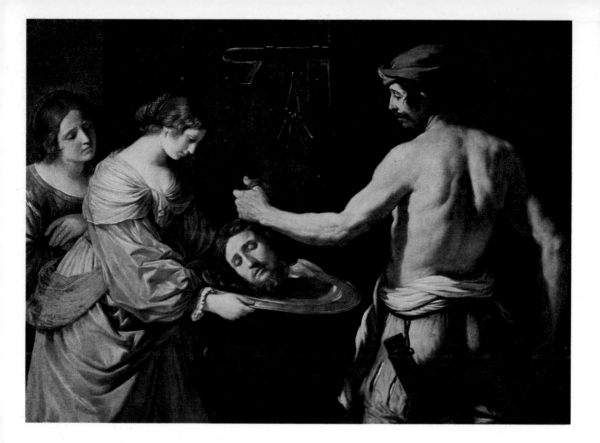

of the Knights of God? It is, however, in his *Spiritual Exercises* that we find the key, not of what was for a time called the Jesuit style—which never in fact existed—but of a completely new type of religious inspiration. These exercises, approved by the Pope in 1548 but constantly revised by their author, are very simply arranged. They are divided into four weeks. The first is devoted to reflections on sin and the chaos of the world. The last three, which follow the different steps of the Passion, the Resurrection and the Ascension of Christ, prepare the soul for the discovery of the will of God so that it may submit to it through service and love.

The originality of Jesuit prayer is that it is based firmly on the senses and is channelled into action rather than into contemplation pure and simple. Sin must be considered in all its foulness and hideous attraction. Its fatal consequences must be visualised and felt as actual physical sensations—the searing of fire, the smell of sulphur: the sinner's body sizzles, his bones melt. Christ's Passion is a long, endless agony. He is always alone, mocked and abandoned. His body hangs heavy on his outstretched arms, the gaping wound in his side makes him moan with pain: blood drips from his forehead and feet. His family and friends weep bitter tears of anguish.

At this moment, the Resurrection achieves its fullest meaning, the flesh comes back to life, the heart begins to beat anew, the dead eyelids lift, the storm-light lifts from the earth and the flowers spring into bloom. The glorious body stirs and stands.

The Ascension is a vertical flight. The ceiling is rent asunder, the roof opens, the clouds scatter, a sapphire sky proclaims the absolute freedom of the God-man, man's own witness, Son of the Eternal.

This mystical ecstasy which makes use of every resource of both body and nature stands firm in the face of the intimate and purely spiritual prayer of the Protestant. Man does not converse with God in solitude, but adores him in the fullness of his woes and the exaltation of the divine creation.

26

Giovanni Francesco Barbieri,
known as Guercino
Salome
Rennes Museum

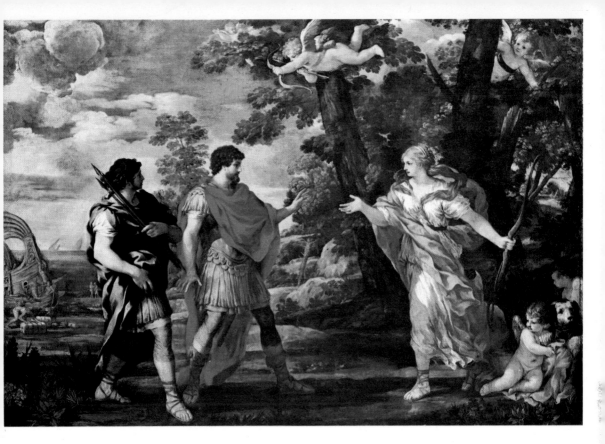

There is no more a Jesuit style than there is a Counter-Reformation style or an Absolutist style. The Jesuits launched a preaching crusade through a Europe in which the sovereign powers—in the Reformed camp as well as the Catholic camp—were strengthening their positions. As for the conflict between spirituality and sensuality, mysticism and rationalism, this is an old long-standing battle. This is not what gave birth to the Baroque. On the contrary, what started its development was the fusion or even the confusion of these opposing features.

Protestant sermons were iconoclastic, but the busy societies who listened to them extolled their unpretentiousness with the same feeling for pictorial presentation and glory as their Catholic counterparts. Rembrandt is Baroque with his love of panoply, turbans, shimmering colours, play of light and shade on black; and so is Rubens with his warm blondness and mother-of-pearl.

It is true that the Baroque took its triumphant self-assurance from the splendid Roman restoration, but in the main it found its source of strength in a double assumption: on earth, everything is perishable; in Heaven, everything is delight. Therefore, the supreme art is the one which transmutes the concrete into greater verisimilitude, into images which are more believable than those of deceptive reality, and the highest sensual pleasure achieves its climax only by means of the divine ecstasy.

But the Baroque artists, trained on the great works of the Renaissance and brought back to the observation of nature, did not fall into excessive purity. They "portrayed": the world was only a stage. And the Baroque manner is only truly intelligible on the stage.

The Baroque entertainment was always conceived as a dramatic progression: it opens on a stage and is itself a stage set in an infinity of mirrors. Pastorals, antique tragedies, scatological buffooneries, opera, ballet, Latin plays by Jesuits (even in this field...)—the stage is as vast as the universe itself. Masks from the Commedia dell'Arte,

Pietro Berretini da Cortona
The Meeting of Dido and Aeneas
Paris, Louvre

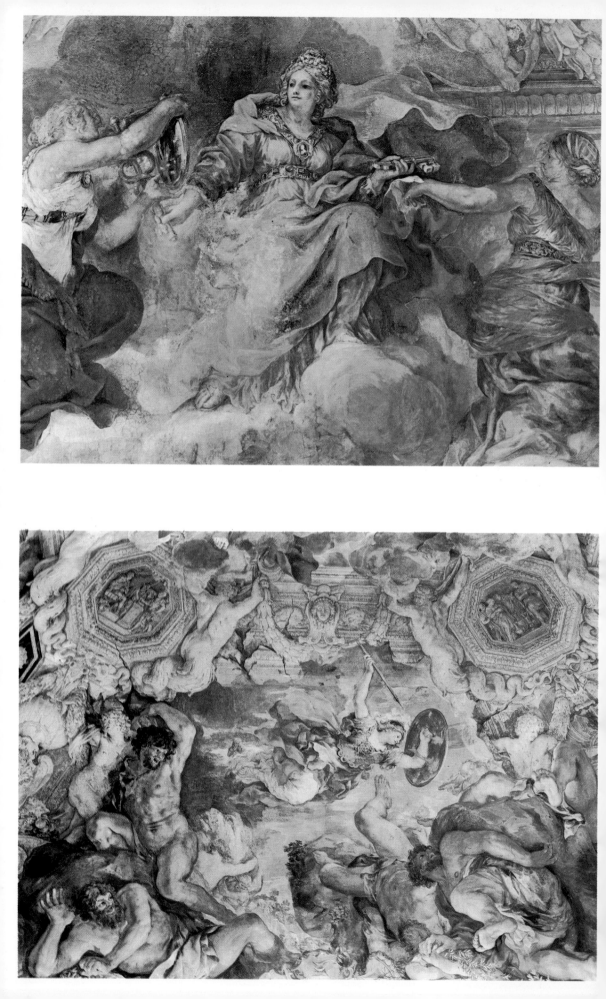

Pietro da Cortona
Two details from the ceiling of the great hall
in the Palazzo Barberini

painters, musicians, stage designers and, above all, scene-shifters—for stage machinery reigned supreme at this period—all united to bring into effect what we would call the greatest spectacular.

Apart from the brief parenthesis of French Classicism—which even at the time did not succeed in entirely monopolising the scene—Baroque theatre set up its stages in all the royal parks and laid its boards firmly over the pools at Versailles. It abandoned the modest static décor of the Renaissance in favour of elaborate schemes mainly concocted high up in the flies where a complex arrangement of pulleys and winches kept suspended all the gods of Olympus, their temples, the angels and even God himself. The Baroque theatre brought Heaven and the divine presence back on to the stage. The new iconography—which no one has classified more competently than Emile Mâle—was basically a visualisation and concretisation of ecstasy.

Bernini's famous *Ecstasy of St Teresa of Avila* in Santa Maria della Vittoria, with its smiling angel poised to pierce the saint's breast as she swoons in a languishing disorder, called forth the President de Brosses's remark: "If *that* is divine love, then I know what it is...." Yet even so, Bernini's group is well within the realm of truth, exactly as the Council of Trent ordained. St Teresa herself left a personal account of her ecstasy. The sculptor had no hesitation in using the splendour of ormolu to show the angel inflicting the mystical wound on his swooning victim. No beholder could take offence at the subject. Baciccia's *St Ignatius Loyola on the Threshold of Eternity* in the church of the Gesù, like the saint's vision painted over the high altar of this, the Jesuits' mother church in Rome, are not allegories either. The beyond acts as an authentic setting. Cavallino's* *St Cecilia*, Ribera's* *Magdalen in Ecstasy*, Simon Vouet's *Magdalen*, the *St Paul* painted in all his pride by Domenichino* and in a spirit of quiet contemplation by Poussin*, Guido Reni's* modest *St Sebastian*, all these saints offer proof that the lightness of the air, the palpitations of the heart, the delicious uncertainty of love are all in the service of God. Baroque imagery is triumphant, not conciliatory. It refused to make a hypocritical submission to religious taboos (the rationalist school of criticism wrongly believed that it did) and instead breathed the warm living breath of man into the host of fanatical saints and angels.

Back in the realm of court entertainments and royal revels, the use of *trompe-l'œil* opened new horizons not only to painting but also to architecture. These two arts learned how to take one, two or three painted canvases and use them to open up immense perspectives of palaces and gardens or to make streets stretch out far into the distance. The secret of *trompe-l'œil* is not deception but truth. An actor cannot make himself smaller; the furniture and trees in the foreground are life-size. The main object of *trompe-l'œil* is to abolish the distance between truth and its pictorial representation for the benefit of a truth amplified by its own resonance. Negro art, tom-tom art, echo art—the Baroque joined the firmest faith in the world to a technical skill which grew without ceasing and widened its field wherever it could.

In the middle of the Palazzo Barberini, the vault of heaven opens out, scattering the clouds, moving aside the stucco and the sturdy limbs of gods and heroes. Pietro

da Cortona* knew perfectly well that no one would ever believe in this heaven. Unless... unless there was a way of concealing where the fresco started and the stucco finished. The *inganno*[1] was not so simple and straightforward as it seemed. The victory of appearances was won when the frontier between high-relief and the actual painting was obliterated. Once a painted rosette mingled convincingly with painstaking plaster flowers, the battle was won. Altar-pieces planned according to this technique ended the architecture of the nave in a series of false perspectives. Thanks to *chiaroscuro*, the sacred mysteries rediscovered in the pools of light flooding in through plain glass the fascination which the blues and greens, reds and golds of Primitives had won through the sparse light of candles and stained glass.

Emile Mâle, who could not bring himself actually to use the dreaded term Baroque, even so recognised the truth: all the skill of the great entertainment, that is to say, of royal prestige, is a political skill and the Baroque used the equipment of the stage and its machinery to offer the public all the drama of a transcendent realism. But the transcendency was there to see. Its audacity, its coquetry, its flights of extravagance are no more than the splendid blossoming of its innocence.

The Precursors of Italian Baroque

Rome was never more eternal than under Sixtus V: to the grandiose enterprises of his predecessors, he added the unity and the movement which were to be the heart and soul of Baroque town-planning. A series of roads radiated from Santa Maria Maggiore leading to the basilicas of Saint John Lateran, Santa Croce, and San Lorenzo. In 1586 the Via Sistina was extended to Santa Trinità dei Monti, the church which commands the Piazza di Spagna from the top of the famous Spanish Steps. Domenico Fontana* had just completed the Lateran Palace. Obelisks, symbols of the vertical equilibrium of the Catholic capital, stood proudly before the main churches. During his reign the great Roman palaces were restored and embellished.

After Clement VIII, Paul V* (1605-21) carried on with this inspired undertaking; the Quirinal, the Borghese Palace were finished, the gardens of the Villa Borghese were planned. Carlo Maderna* built Santa Suzanna (1605). Borromini showed his genius and skill with San Andrea delle Fratte and San Carlo alle Quattro Fontane. Flaminio Ponzio*, in his Pauline chapel in Santa Maria Maggiore, employed a polychromy as vivid as the waters of his Janiculum fountain, the Acqua Paola (1612). More and more fountains were built, each a complementary union of water and sculpture.

Bramante, Raphael and Michelangelo were still the sources of reference for the new generation of architects, sculptors and painters to whom fell the task of embellishing the Vatican. Their interpretations of the works of the masters varied considerably.

[1] *Inganno:* deception.

Before Caravaggio, the Carracci * brothers and their disciples, a few artists had managed to avoid the new theories and the worst excesses of Mannerism and had struck new ground.

The most undeservedly ignored of all must be Federico Barocci *. A picture like his *Circumcision* offers the most extraordinarily Baroque expression in every feature. The picture is dominated by a swirling angel and the composition revolves around a charmingly sweet Infant Jesus. Its warmth and happy choice of realistic detail anticipate the work of Caravaggio, if not in its style, then at least in realistic spirituality. St Philip Neri, one of the founders of this new spiritual perception, admired to excess a *Visitation* painted by Barocci in the Chiesa Nuova in Rome. But this artist stayed for only a short time at the Papal court, and it was from his native town of Urbino that he exercised his influence, mainly through his altar-pieces which were commissioned from all over Italy.

The Cavaliere d'Arpino, as despised now as much as he was admired during his lifetime, should not be omitted from this genealogical tree of the Baroque. When his first works are seen in relation to the ethereal refinements of the Mannerists they disclose a certain health and strength. When Caravaggio became his pupil in 1592, he admired wholeheartedly his master's fresco on the ceiling of the Olgiati chapel of Santa Prassede; we have no reason to suspect him of being obsequious when he says to his future biographer, Baglione, on 13 September 1603: "I think that Jusepino (another nickname for Giuseppe Cesari, the Cavaliere), Pomarancio * and Annibale Carracci are men who have talent and the others are men who have not."

Caravaggio

Alternatively dismissed with scorn and greeted with praise, forgotten then rediscovered both by contemporaries and by posterity, Caravaggio was an artist who was perpetually in trouble. He was an eternal seeker after adventure, short-tempered and quarrelsome, passionately devoted to youth, the vivid life of the streets, a lover of ambiguity, deeply religious, devoted to the saints, a pious scoundrel eaten up with pride: pride in painting.

"There is nothing more incongruous than this overshadowing of the knight by the horse, of the saint by the animal", was Berenson's indignant criticism of the superb *Conversion of St Paul*. Leo Steinberg has brought this judgement of unseemliness into proper perspective by pointing out that the picture was specially painted for a narrow chapel and, like its companion-piece *The Crucifixion of St Peter*, was meant to be seen sideways. In fact, the work carries the spectator right to the heart of the dramatic moment when Paul was cast at his horse's feet, stunned and dazzled by grace. As to the means used by Caravaggio to achieve his effects, these are far less revolutionary and brutal than his admirers—and his detractors—claim.

The first teacher of Michelangelo Merisi, called Caravaggio * after his birth-place in Lombardy, was Simone Peterzano *, himself an assiduous but uninspired pupil

of Titian. The feeling for violent plays of light and shade which contemporaries attributed to the invention of Caravaggio himself (on his own authority) in fact came directly from the Venetian and Bergamo schools. Savoldo left a number of examples of this painting of strong contrasts in Milan.

Caravaggio totally ignored fresco painting, then considered the highest form of art, and with it rejected an entire tradition based on the imitation of antiquity. One of the first painters of still-lifes, and in his early days quite unable to paint from memory, Caravaggio built up a whole system from these limitations in his technique. But when his protector, Cardinal del Monte, turned him towards religious painting, he spontaneously returned to his early training. Caravaggio found his temperament more of a hindrance than a liberating factor. Instead of following new directions, he spent his time exploiting—and in many cases going far beyond—Mannerist teachings.

The Uffizi *Bacchus*—probably a self-portrait—and the *Concert* show clearly that the scandal Caravaggio caused sprang more from the carnal extravagance of the paintings than from any boldness of style. The body of the young Bacchus has all the soft clearly-stated musculature so dear to the Mannerists. If one ignores the attraction of their warm, sultry eyes, the sensuous young street urchins of the *Concert* form a poetic harmony reminiscent of Giorgione.

The legend which says Caravaggio found all his inspiration in the streets and the activities of everyday life does not stand up to examination any more than the other claims about his personal attitude to art. Whichever painting we consider, *The Gamblers* or *The Fortune Teller*, we must agree with the judgement of R. Wittkower that " they are more like *tableaux vivants* than snapshots taken from life ". Caravaggio's pseudo-realism is really an expressive interpretation of reality.

The Marchese Justiniani was quick to buy the altar-piece of St Matthew which Caravaggio had painted for the Contarelli chapel in San Luigi dei Francesi and which they had refused to accept. Similarly, on the advice of Rubens, the Duke of Mantua bought *The Death of the Virgin* which the monks of Santa Maria della Scala thought vulgar. Caravaggio was greatly irritated, though not seriously upset, by these incidents. In any case, as Baglione points out in his biography, "a head by Caravaggio brought in more money than a whole picture by his rivals". He was a costly and sophisticated painter with an admiring and appreciative public of connoisseurs. The ignorance of a few timorous monastics has lent credence to an image of a misunderstood artist close to the people. Far from it: in spite of his irritation, Caravaggio at once started a new altar-piece for San Luigi dei Franchese and produced for the side-walls *The Calling and Martyrdom of St Matthew*; all were eventually placed on the altar for which they were intended. The new *St Matthew* was not more dignified than in the previous painting, only more ecstatic. It was with the full agreement of his clients—often members of the Oratorians—and also with his own willing concurrence that Caravaggio, as it were, purified his inspiration until he finally achieved a different and strangely carnal mysticism, as in his *Seven Works of Mercy*; it is strange that this violent, sensitive and

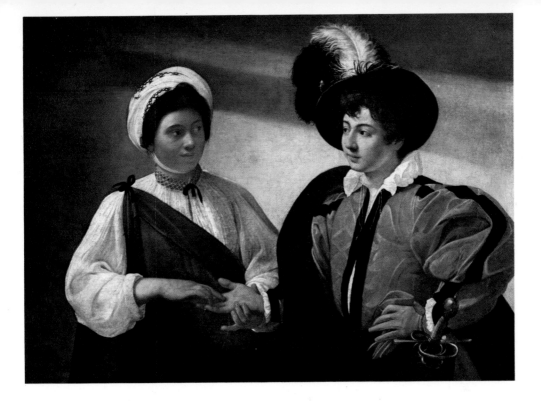

tender painter should have been able to interpret the spirit so much better than his contemporaries.

It was, however, neither the naturalism nor the spiritual vehemence of his works which gave him the reputation and influence he had during his lifetime—it was his "tenebroso". Giovanni Pietro Bellori*, whose secondhand information should be treated with a certain reserve, nevertheless wrote illuminatingly on the attraction Caravaggio's contemporaries felt for his striking use of the contrasts of light and shade: "Caravaggio increased his reputation by his extreme boldness in colouring. For the soft tints and unusual hues of his first paintings, he substituted stronger colours in *The Lute Player* and *St Catherine*. From these, he went on to a much harder colouring with strong shadows and a plentiful use of black to show relief. Carried away with this new system, he gave up painting his pictures in full light. His models were placed in a dark room with a strong light placed high up near the ceiling, its rays falling on the main parts of the body and leaving the rest in shadow: this new system he had perfected produced the effects of light and shade he particularly sought.

"This way of painting aroused tremendous enthusiasm amongst the young painters", Bellori goes on, "for they considered Caravaggio the only real artist who could imitate nature... and therefore they started finding their models in the streets and spent ever more time in painting ever stronger relief. The older painters, however, complained that Caravaggio was an artist only capable of painting in a cellar." Bellori, who was a great admirer of antiquity, probably exaggerates in this matter of Caravaggio and his disciplines, but, for all that, he brings out the very special character of his use of blacks, their artificiality and their opacity. Realism in his models, theatrical use of lighting brought to bear on religious symbolism, Caravaggio, like all great painters, took what he wanted where he found it. Neither a Mannerist nor a truly Baroque painter, and for that matter not truly Caravaggesque either, he had no real followers— at the most he had imitators; but of all the 17th-century painters who knew his work there were few who escaped his influence entirely.

Caravaggio
The Fortune Teller
Paris, Louvre

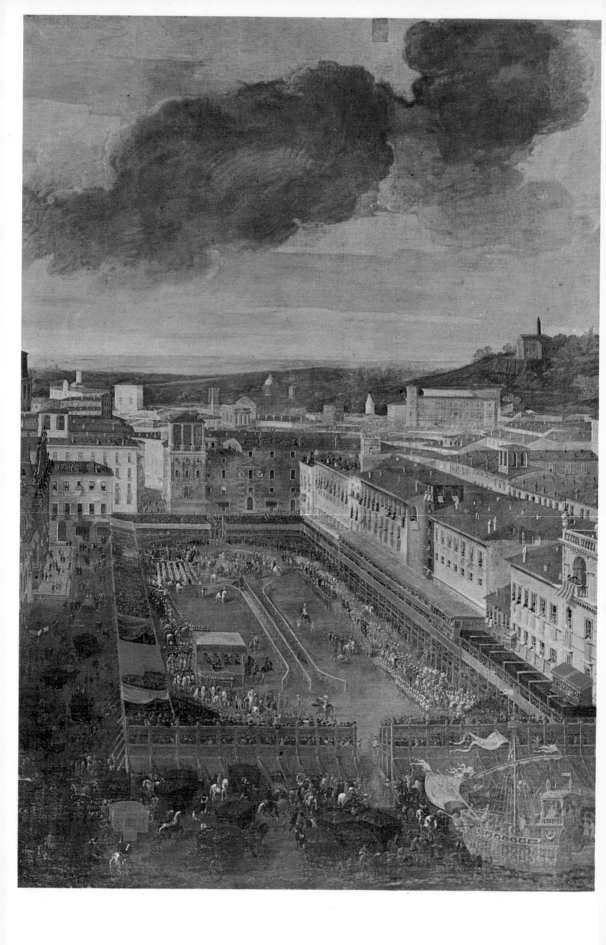

The Carracci

To Lodovico Carracci falls the credit of having maintained a merciless struggle against the later type of Mannerism which emasculated painting at the end of the 16th century.

The son of a butcher, he was born in 1555 and was originally a pupil of Prospero Fontana *, a very esteemed Mannerist whose daughter Lavinia * followed in his footsteps and was elected to the Academy in Rome after painting the portrait of every woman of distinction in Roman and Bolognese high society.

Lodovico's biographers say that he was rather slow and his fellow-pupils nicknamed him " The Ox ". Ox he might have been, but he soon saw that Bologna had nothing else to offer him and set off for Venice, where he hoped to meet Tintoretto. He went on from there to Florence, where he was taught by Passignano for a time, and then to Parma, where he studied the paintings of Correggio and Parmigianino; finally he went to a Mantua still dominated by the art of Giulio Romano.

Back in Bologna, Lodovico felt sufficiently sure of himself to offer opposition to the powerful Mannerist circle, but rather than tackle the job alone, he persuaded his cousin Agostino and the latter's younger brother Annibale to start painting, too, and to travel around Italy as he had done. It seemed at first that Agostino was the more gifted of the two. It was only later, in Rome, that Annibale revealed his talent.

Bound by the solid ties of affection—which by no means excluded quarrels between the two brothers—the Carracci gradually became more and more important in Bologna. After 1582, they together founded the teaching Academy of the Incamminati, whose most famous pupils were Guido Reni, Francesco Albani * and Domenichino.

Eclectic and Classical—these adjectives are frequently applied to the Carracci as an indication that they refused to submit to the same traditions as Caravaggio or to show his deliberate scorn for the rules. But their eclecticism was really only that " manner " which Constable rightly says no artist can avoid. Eclecticism or culture? Eclecticism or profound knowledge of the great masters? Apart from a few zealots after naïvety or spontaneity at any price, there is no artist who is not ready to use the short cuts which help him make his own discoveries all the more quickly.

One of the main criticisms made by the Bologna Mannerists was that the Carracci, and more especially Annibale, were too keen on the imitation of nature, reproducing it with no personal inspiration at all. Their pupils spent hours drawing live models, seeking the most elusive gesture, the most revealing feature of a particular face. It was from their studio and their dogged, steady research that the technique of caricature came, not from the crude virtuosity of Caravaggio. In about 1740, an English publisher of engravings, Arthur Pond, brought out a collection of twenty-five caricatures from Annibale Carracci's original drawings. *The Butcher's Shop*—attributed either to Annibale or to Agostino, one is not certain who—is an excellent example of this wonderful spirit of parody where reality follows the pattern of social comedy.

The frescoes of the Palazzo Fava*, commissioned from the three Carracci in

35

1584, reveal the similarity and even quality of their drawing technique, but their altar-pictures, especially their countless Assumptions, destined—on account of the Feast of the Assumption on 15 August—for the summer palaces of the nobility, allow us to distinguish their respective styles: Lodovico conveys a feeling of mystery and dignity —the least gifted of the three, but the most religious, he influenced Murillo and prepared the way for Zurbarán; Annibale has a calm serenity—his *Last Communion of St Jerome* was to inspire altar-pieces by Rubens and Domenichino; Agostino was the most cultured and absorbed the Venetian traditions into his technique, but it was, however, as an engraver that he became most famous. His engravings from Titian and Tintoretto reveal his gifts and the influences which moulded him.

Working as a team, Lodovico, Agostino and Annibale painted the Palazzo Magnani*. Annibale's huge luminous landscapes are settings for Roman scenes and offer a foretaste of Domenichino and Poussin. In 1595, Annibale left his *Charity of St Roch* unfinished to go to Rome at the invitation of Cardinal Odoardo Farnese. The usually accepted ideas about the Counter-Reformation's ban on certain iconographical themes find instant contradiction in the Cardinal's commission to Carracci. As in the heyday of the Renaissance, the motif of the decoration was mythological and a thorough knowledge of the great classical authors provided illustrations for the general theme of the power of love. A close study of Raphael and of the Sistine Chapel helped form Annibale's style, already much influenced by the Venetian school, and led him to a classical perfection.

The ceiling of the Galeria Farnese was to be the model for innumerable Baroque ceilings which borrowed its *trompe-l'œil* effects and its clever compositions where the warm pink bodies of cherubs and realistic *putti* combine with the grey and white of statues and figured stucco. Every corner has the false sky-blue window-light soon to become a regular feature of Baroque cupolas. All the pictures which go to make up this ensemble are separated by false frames and on this account have the appearance of properly individualised compositions. *The Triumph of Bacchus and Ariadne* covers the centre of the ceiling. An incomparable spirit of movement and life seems to stir the procession of gods and revellers surprised at the height of their gaiety. Agostino, summoned to Rome by Annibale to help him complete the work, painted the two scenes occupying the middle of the ceiling side panels: *Cephalus and Aurora* and *The Triumph of Galatea.*

It was in his easel-paintings that Annibale showed most brilliantly the sensitivity which had been sharpened by his stay in Rome. The *Domine, Quo Vadis?* in the National Gallery in London and the *Pietà* in Naples have the descriptive and emotional breadth of a classical tragedy. The background landscape is not merely decorative in function— it plays a proper part in the action. Poussin and Claude Lorraine will go even further with this symphonic concept of harmony between subject and landscape, but will never excel Carracci in the expression of a restrained pathos which unobtrusively reveals the conflict between a realist temperament and an ideal vision. Agostino had by now left Rome for Parma, where he undertook some commissions for Ranuccio Farnese.

Cristoforo Allori
Judith holding the Head of Holofernes
Florence, Pitti Palace

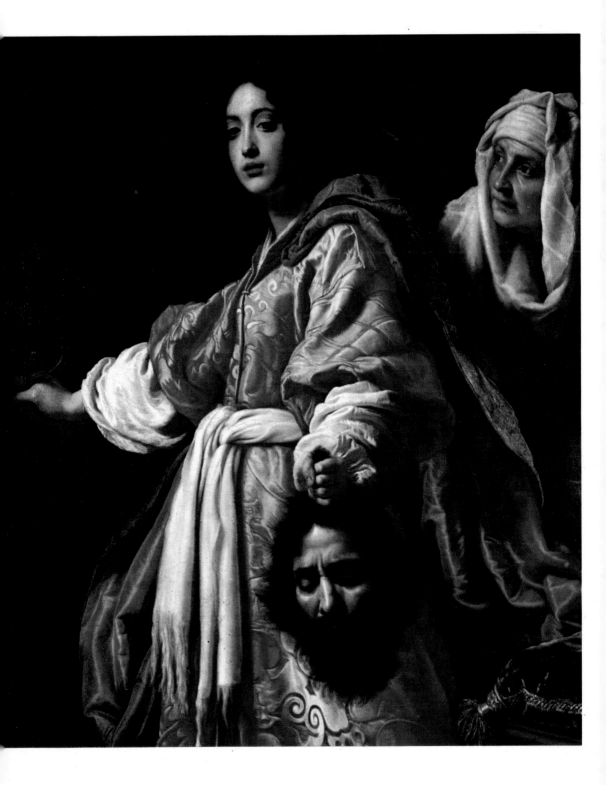

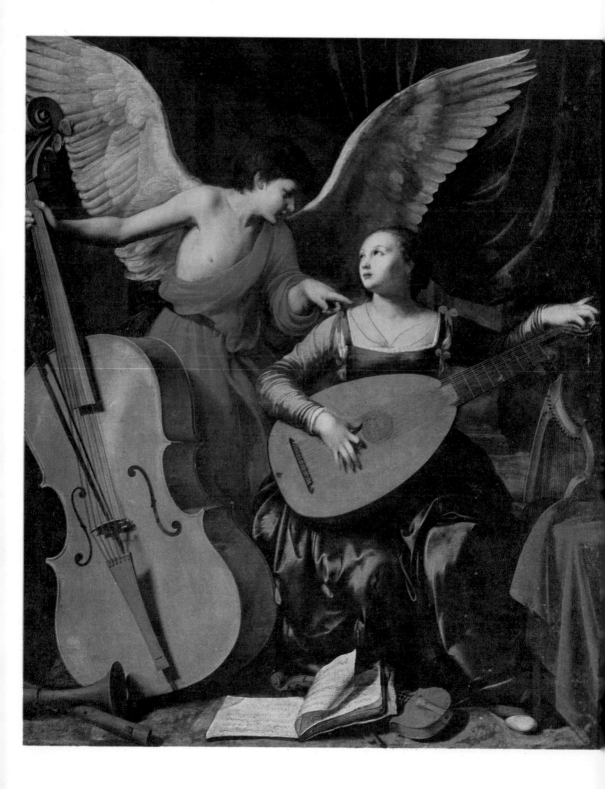

Annibale, whose health grew worse and whose hard work had brought only a meagre sum of money in payment from Cardinal Farnese, painted very little from now until his death in 1609. Only Lodovico remained to carry on their mammoth undertakings. When Annibale died, however, their Academy lost its driving spirit. Even when Guido Reni took over its direction on the death of Lodovico, there was no revival of the faith and enthusiasm so typical of the first years of its existence.

Followers of Caravaggio

Caravaggesque: almost an abusive term. Many were the features so called—and originally always with a distinct feeling of disapproval. For more than a hundred years, any picture shot across with flashes of black, every face looming out of an opaque shadow was called Caravaggesque, irrespective of authorship.

But no style was ever *less* imitable than his. As an artist he was the very antithesis of a teacher. He was completely sufficient unto himself. He needed no pupils: his works spoke for themselves. They aroused the most fanatical admiration amongst other painters. But by 1620, the Roman fashion, the Caravaggio style, was forgotten and after a gap of several years it was only outside Italy that his *tenebroso* aroused enthusiasm once again; without actually claiming a direct influence, one can at least say that both Velasquez and Guercino* made use of his dramatic lighting effects, though with completely different purposes.

Only two artists, Orazio Gentileschi* and Carlo Saraceni*, were able to profit at first hand from the precepts, if not the actual supervision of Caravaggio. They knew him personally. Gentileschi's first job had been painting the people into the landscapes executed by his friend and associate Agostino Tassi*. Once he had left Pisa, his birthplace, for Rome, he won many commissions for altar-pieces. His *Circumcision* (in the Ancona Gesù), the *Annunciation* (in San Siro in Genoa), his two versions of *The Flight into Egypt* (in the Belvedere in Vienna and the Louvre in Paris) retain a limpidity that is typically Tuscan, in spite of their use of contrast. His range of colours remained luminous and somewhat cool, especially during the last years of his life when he became court painter to Charles I of England at Hampton Court and devoted himself to a succession of similar themes.

His daughter Artemesia*, who was even more successful than her father, can also be considered a second-generation Caravaggesque, even though she was a pupil of Guido Reni. Her picture of *Judith and Holofernes* (Wadsworth Athenaeum, Hartford, Connecticut) is a hymn to triumphant energy. Having turned down her father's old friend Agostino Tassi, she married Pier Antonio Schiattesi and settled in Naples, where she painted her three most notable works for Pozzuoli Cathedral.

Carlo Saraceni, a Venetian who came to Rome in 1598, was mainly influenced

Guido Reni
The Rape of Europa
Tours, Museum of Fine Arts

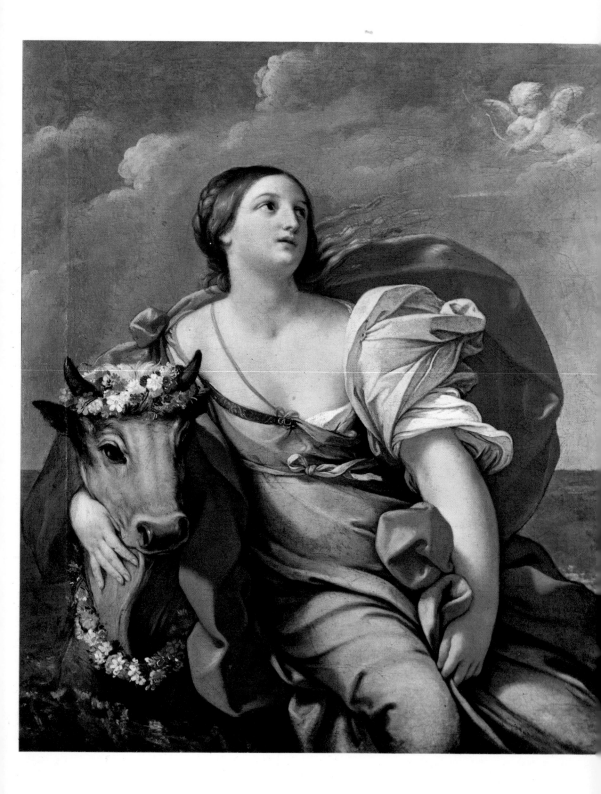

Guido Reni
The Rape of Europa
Tours, Museum of Fine Arts

by the German painter Adam Elsheimer, who arrived in the Eternal City some two years later, dying there in 1610. Elsheimer's landscapes are small-scale forerunners of Claude Lorraine's compositions. The same atmosphere can also be found in the background of Saraceni's paintings. But Saraceni's main ambition was to become above all a painter of people rather than things. His limitations were soon seen in his larger compositions, but his soft colours straight from Venetian tradition—even if they do not arouse the same violent feelings as Caravaggio's contrasts—warm and enliven such pictures as his *St Gregory the Great* and his charmingly serious *St Cecilia with Angel Musician*.

The *St Charles Borromeo* of Orazio Borginiani (San Carlino, Rome) displays lavishly that tender, pathetic religious feeling which Baroque art particularly expressed throughout this century with varying degrees of sincerity. Borginiani was not a pupil of Caravaggio, who did in fact manage to quarrel with him before his precipitate departure from Rome in 1606—but, like so many others, he could not avoid the influence of painting's black sheep.

Giovanni Serodine and Bartolomeo Mandredi, the French artist Jean Valentin *—whose style is so close to Manfredi's that their works are often confused—were particularly influenced by Caravaggio's naturalism. Valentin never left Rome once he was settled there, but even so made Caravaggism popular in France. His *Concert*, probably painted after 1620, maintains the psychological depth and evocative power of Caravaggio. But this type of painting was to be vulgarised and reduced to the level of anecdote, as in the *Bambocciate* of painters like Pieter van Laer.

Many foreign painters, either staying in Rome for long periods or simply passing through, conscientiously learnt what they could of Caravaggism. Rubens, of course, took what he wanted where he pleased, learning as much from the Mannerist Otto Venius, with whom he had studied in Antwerp, as from the canvases of Caravaggio, whom he greatly admired and whose works he saw wherever he looked during his eight-year stay in Italy. There was nothing Caravaggesque about the paintings he did for the mother church of the Oratorians where Caravaggio's own *Entombment* (now in the Vatican) was hanging at the time.

On the other hand, Simon Vouet, the French painter, spent fourteen years in Rome (1613-27) and became thoroughly impregnated with Caravaggio's style: his interpretation of it was simultaneously more noble and more dramatic and in this was like that of another French artist, Claude Vignon *.

What is truly remarkable, though, is the fact that as soon as these painters returned to their own countries, they forgot Caravaggio's style and methods, however deeply they had marked them previously.

The Dutch painters Hendrik Terbrugghen and Gerard Seghers *, the Flemish artists Theodor Rombouts *, Jan Janssens * and Theodor Baburen were all very much influenced by Caravaggism but they, too, transposed his style to meet their own requirements until finally their pictures have only the most tenuous link with those of Caravaggio.

The Roman Pupils of the Carracci

Rarely in the history of painting have artists been as fortunate as the pupils of the Carracci. It is true that the great Renaissance painters had huge studios and that Italy of all places had marvellous sources of information for any beginner who wanted to widen his field of experience. But the *Incamminati* Academy offered something more than this to its pupils. Not only did the teachers treat their pupils as assistants, allowing them to take part in the everyday work of the painters' studio so that they could learn the elements of painting, then their own "manner" and finally sufficient skill to stand on their own feet; they also received a full training in both theory and practice in the Academy. Agostino, the intellectual member of the family, had written a course of lectures on perspective and architecture. A professor of anatomy taught the pupils the main points of this science and Agostino gave talks on mythology. An exhibition of each student's work, followed by collective criticism, encouraged the young artists' spirit of competition and the irreplaceable Agostino praised the most gifted pupil in odes composed by himself to his own accompaniment on the lyre. Lodovico was the great theorist in matters of style, believing wholeheartedly in the imitation of nature. Annibale acted as a sort of coach. He drew or painted in the midst of the students. The usual distraction between sessions of life-drawing was practising caricatures.

The whole concept of academicism can be found in bud in this system of teaching, but in the confined atmosphere of Mannerism it opened the door to realistic observation and the organised study of the past.

It is therefore hardly astonishing that painters as different as Guido Reni, Francesco Albani, Lanfranco*, Domenichino and later Guercino developed side by side and later on went to Rome to compete for the best commissions in the capital.

Jealousy and rivalry in course of time set pupil against master and divided the students amongst themselves—but this in fact was a further proof of the success of the Academy.

When Annibale Carracci reached the end of his work on the frescoes of the Farnese Gallery, he was assisted by Domenichino as well as by his brother Agostino. It was Francesco Albani who finished almost unaided the decoration of a chapel in Saint Giacomo which Annibale had started and which he had been unable to complete. But Albani never surpassed either his masters or his predecessors, in spite of the charm and ease of his works. He was employed by Guido Reni for the decoration of the Quirinal chapel. His style was closer to Domenichino's than to anyone else's, but he never achieved the same severity.

Guido Reni

Guido Reni arrived in Rome in 1600 as a fully-fledged artist, not as a student; he was at once a rival to Annibale Carracci. His *Crucifixion of St Peter* showed with style and brilliance what his possibilities were. He no more forgot the lessons he had had from

Denys Calvert, the Bolognese Mannerist who had trained him, than he ignored the lighting effects typical of Caravaggio, but the strict harmony of his compositions gave a clear indication of the Classicism to come, as for instance in his picture *David, conqueror of Goliath*.

After a brief return to Bologna to paint the frescoes of San Michele in Bosco, Guido Reni went back to Rome in 1607 at the request of Pope Paul V. In the Vatican, he painted the fresco of the *Nozze Aldobrandini* and the *Donne*, then at the commission of Cardinal Scipio Borghese, tired of Annibale Carracci's constant delays, he painted frescoes in the San Andrea chapel of San Gregorio Magno, as well as in the Santa Silvia chapel. The frescoes illustrating the life of the Virgin in the papal chapel of Montecavallo and in the Quirinal palace are probably the most perfect pieces of work from this very productive period.

Trouble with the papal treasurer made him return to Bologna in some irritation, but the Pope recalled him with the assurance that henceforward he would be treated with the respect owed to one whose genius was universally recognised. It was after his return that he painted (between 1613 and 1614) the ceilings of the casino in the Borghese Gardens—later the Palazzo Rospigliosi-Pallavicini—with the fresco *Phoebus and the Hours preceded by Aurora*.

Guido Reni was admired most extravagantly during his lifetime and even more so during the 18th century, especially by the French; but he was much disparaged by the Romantics and completely dismissed by Ruskin and his rivals. These accusations of servile imitation—a trait more aptly associated with the empty pomposities of his followers—have now been abandoned in favour of a more reasoned appreciation and Guido Reni is seen, as he should be, as a disciple of Raphael. But his Classicism was not drawn from as close a study of the art of antiquity as was that of Poussin. The famous group *Laocoon and his Sons* was as much a source of truth for him as for all artists from the Renaissance to the end of the 18th century. But where the Greek sculpture expresses the anguish of extreme physical effort, Reni's paintings took the same forms and turned the same movements into idealised expressions dissociated from emotional content and related only to rhythmic movement in an ethereal context. For him, the Classical heritage was represented by a feeling for beauty. His Atalanta does not run—running is a physical effort; does not fly—flight is a struggle against the force of gravity; but she is the incarnation of the victory of movement over immobility.

The *Labours of Hercules*, four pictures painted for Federigo Gonzaga, Duke of Mantua, and now in the Louvre, present the same image of timeless serenity contained in restrained exertion.

Lanfranco

It was possibly in 1600 that Giovanni Lanfranco and Sisto Badalocchio became pupils of Agostino Carracci, newly arrived in Parma at the invitation of the Duke Ranuccio Farnese. On the death of Agostino in 1602, the Duke sent the two young artists to Rome

José de Ribera ►
The Club Foot
Paris, Louvre

Salvator Rosa ►►
Mounted Soldiers
Naples, Capodimonte

to complete their training with Annibale. Both worked with him until his death in 1609.

His earliest works clearly reveal that Lanfranco was exceptionally talented. In his painting of the *Magdalen carried to Heaven*, dated as early as 1605, a vast bluish landscape leads into the horizon which Claude Lorraine in his religious and mythological paintings will later extend ever further.

Another feature introduced by Lanfranco into Baroque painting was the pictorial expression of ecstatic saints entranced by divine love. His *St Margaret of Cortona* swooning in the arms of an angel is a forerunner of Bernini's *St Teresa*. He also adopted a technique used by Correggio and placed his *Ascending Christ* beneath a brilliant source of orange light which represented the warm sunshine of paradise: its brilliance seems to melt away the ceiling of the Sacchetti chapel in San Giovanni dei Fiorentini. This is not the *trompe l'œil* which the architecture of the time made impracticable, but certainly the Classical mould was now broken.

The Assumption of the Virgin, painted on the dome of San Andrea della Valle, ensured the success of this High Baroque of which Lanfranco was the first true exponent. Stupefied admiration—the highest aim of Baroque art—was the emotion aroused by this circular projection of clouds, saints and angels, dominated by the figure of Christ in glory. The form of a gigantic diorama produces an astonishing three-dimensional illusion.

In 1634 Lanfranco left Rome for Naples, where he painted a variety of frescoes and set the southern capital free from the magic of Caravaggio.

Domenichino

The rivalry between Lanfranco and Domenichino anticipated the celebrated quarrel between the supporters of Rubens and Poussin in France. The outcome was never very clear, however, except in Naples at the end of Domenichino's life. It was indeed a battle royal between the two: a struggle for favour, a fight for commissions, each artist a man of superb skill and equally firm of purpose. An odd quirk of fate now joins these two sworn rivals in the admiration of posterity.

Domenichino was not a Classicist in the same sense that Guido Reni was: he was not given to abstracting emotions. Even before the advent of Poussin (who, in fact, considered him the greatest living painter) he was in ardent pursuit of the antique order of things. Before Poussin and Claude Lorraine, he brought to his landscapes that almost tangible mystery—the mystery of heroes and gods and nature-spirits which Guido Reni was never able to express. His universe was imaginary, not idealised. Where Guido Reni found objectivity, Domenichino found proportion.

The *Scenes from the Life of St Cecilia* painted from 1615 for San Luigi dei Francesi, *The Last Communion of St Jerome*—inspired by a painting by Agostino Carracci on the same subject—the superb tapestries on the theme of *Diana* in the Galleria Borghese confirmed Domenichino's reputation. When a citizen of Bologna

became Pope in 1621 under the name of Gregory XV, it was a Bolognese he chose as architect—Domenichino himself—and in the years between 1624 and 1628 he painted a series of frescoes in San Andrea della Valle. And from this circumstance came the first clash: the cupola decoration for which Domenichino had prepared working drawings was entrusted to Lanfranco.

He did not abandon his own personal style, but could not completely resist the attraction of the Baroque drama. His last works in Rome, his four frescoes for the pendentives in San Carlo ai Catinari and the *St Sebastian* originally intended for Saint Peter's but now in Santa Maria degli Angeli, are drawn more freely and are composed less formally.

But in Naples his efforts to shake off his natural restraint, easily visible in the cathedral frescoes on the life of St Januarius, met with insults from Ribera and did not bring him any success in his rivalry with Lanfranco.

But in spite of this, Domenichino was admired unreservedly throughout the 17th and 18th centuries. It was the 19th-century art critics who disliked him so much, but now he is treated with the respect he deserves.

Guercino

Guercino was probably the first victim of Academicism. It may be that the influence of Lodovico Carracci's paintings and the complete supremacy of Guido Reni over all painting in Bologna were factors which suppressed to some extent his finer qualities. His style was not typically Bolognese—he used the opposition of light and shade in the best Venetian tradition, which bore no relation to Caravaggio's *tenebroso*; he showed

45

realism, brilliant colours, a somewhat unbalanced composition and a tendency to wide brush-sweeps which did not relate to the eclecticism and elegance so popular in Bologna.

His famous *Aurora* on the ceiling of the *gran salone* in the Palazzo Ludovisi seems to mark the breaking point between his personal style with all its faults and predilections and the ambitions inspired in him by Mgr Agucchi, Gregory XV's private secretary and ardent admirer of Annibale Carracci. The *trompe-l'œil* effect produced by Agostino Tassi's surrounding architectural framework is very striking. The *St Petronilla* he painted for the Vatican Gallery reveals the efforts he made to master a style of painting already on the wane and shows the dangers of the teachings offered by the Bolognese school.

The last years of Guercino were divided almost equally between works of strength and works where his style is strained. But when the too-perfect Guido Reni died in 1642, Guercino went to live and paint in Bologna, free at last from his "evil genius", able to paint with freedom of conscience till he died in 1666.

The Triumph of High Baroque: Pietro da Cortona

Three names dominate the fifty-odd years between 1625 and 1680 which saw the development of the Italian High Baroque. It is wise to define terms here, for depending on individuals and places, the chronological division can be made longer or shorter, though in general terms it corresponds roughly to the birth and development of a very recognisable style. Three names allow us to select its main distinctive features and its variations: Gian Lorenzo Bernini, Francesco Borromini and Pietro da Cortona.

Bernini's works and personality can be treated only briefly within the compass of this book, but his talent was such that five Popes acknowledged its brilliance. His main claim to fame comes through his work as architect and sculptor, but his work as a painter should not be overlooked. In fact he produced something like 150 pictures but he signed none of them. He never accepted any major painting commission and always appeared to consider painting more a form of entertainment than a means of artistic expression.

But his aesthetic vision, the decisive importance of his official functions, the breadth of his projects and his great fame make him the true leader of Baroque in Italy, as well as the inspiration of a whole line of artists throughout Europe.

The work of Borromini, even in his lifetime a subject of lively debate, was the epitome of intelligence and Baroque freedom. It is the true ancestor of the finest Rococo, especially in Central and Eastern Europe.

Pietro da Cortona would have won permanent fame by his architectural work alone. Rome is indebted to him for SS. Martina e Luca and the marvellous façade of Santa Maria della Pace. Like Bernini, his plans for the extension of the Louvre were not accepted, but his reputation in no way suffered. He was the only 17th-century artist to follow simultaneously the careers of painter and architect.

His first patrons were the Sacchetti family, Cardinal Francesco Barberini and the Cavalieri Cassiano del Pozzo, the latter's secretary, also a great friend of Poussin.

Pietro da Cortona had been painting extremely fine pictures ever since 1620, when he was twenty-four, and worked on the decoration of Saint Peter's in Rome together with Lanfranco and Bernini. It was in 1629, the year which saw the confirmation of his maturity with *The Rape of the Sabines* (Rome, Capitoline Gallery), that he was commissioned to do the frescoes for the *gran salone* of the Palazzo Barberini.

After choosing all the finest talent possible to decorate Santa Maria della Concezione, from the great painters such as Guido Reni, Domenichino and Lanfranco to the most promising of the up-and-coming artists—Andrea Camassi, Andrea Sacchi*, Pietro da Cortona—Cardinal Antonio Barberini, the Pope's brother, chose the last two painters, Sacchi the Classicist and the spirited Pietro, to paint the frescoes of his new *palazzo*.

The splendour of the ceiling, painted in great bright sweeps with a tremendous range of colours, defies description and challenges the eye. Out of it, one could take a whole series of works, pictures, still-lifes, abstract canvases, portraits, all drawn from that magical gathering of beauties, that glowing masterpiece of achievement which took Pietro da Cortona six years of hard work. One year in Venice halted the work for a while but doubtless contributed to his ultimate mastery of a fantastic task.

The famous Bolognese *quadratura*, the art of extending real architecture through painting, was given a new complexity by his combination of false stucco and allegories, of background heavens of blue and fake statues. A succession of elaborate but significant allegories was composed from material taken from a little book by the poet Francesco Bracciolini, the text of which has unfortunately been lost. It is rare for any work of art

to be so carefully and so deliberately prepared, all its intellectual, its moral and even its metaphysical correspondences skilfully explored and orchestrated.

The elegance of the ceiling of the Pitti Palace in Florence, where the stucco (real this time) harmonises even more perfectly with the fresco, the richness of the decoration in Santa Maria in Vallicella and in the main gallery of the Palazzo Pamphili—all this was not enough to exhaust his creative genius. Pietro's large easel-paintings, in particular his *Battle of Issos*, have the same controlled passion and ordered disorder as his frescoes.

Without ever reaching the same heights, Ciro Ferri and Giovanni Francesco Romanelli showed with some brilliance how Pietro da Cortona's type of art could fill the ceilings of palaces and churches if only the artist had the magic touch.

Sacchi or Baroque Classicism

Pietro's great rival was Sacchi, just as Domenichino's was Lanfranco, and it was Sacchi who learnt the most from Domenichino as well as from Raphael's view of antiquity. His preference for strict economy of line may perhaps be termed Classical. He is Classical in the sense that Racine's *Athalie* is Classical. He is Baroque in his drawing sense and in the expressive intensity of his characters—which are, however, few in number—and his greatest achievement is his *Vision of St Romuald*. But with his fresco *Divine Wisdom* in the Palazzo Barberini, Sacchi's Classicism, this Classicism which was supposed to develop into a majestically planned order, collapses in abject confusion. Admirable figures carefully placed and planned float in a dizzy void filled with clouds.

How much more Classical and rigorous are the vast compositions of that great Baroque artist Pietro da Cortona.

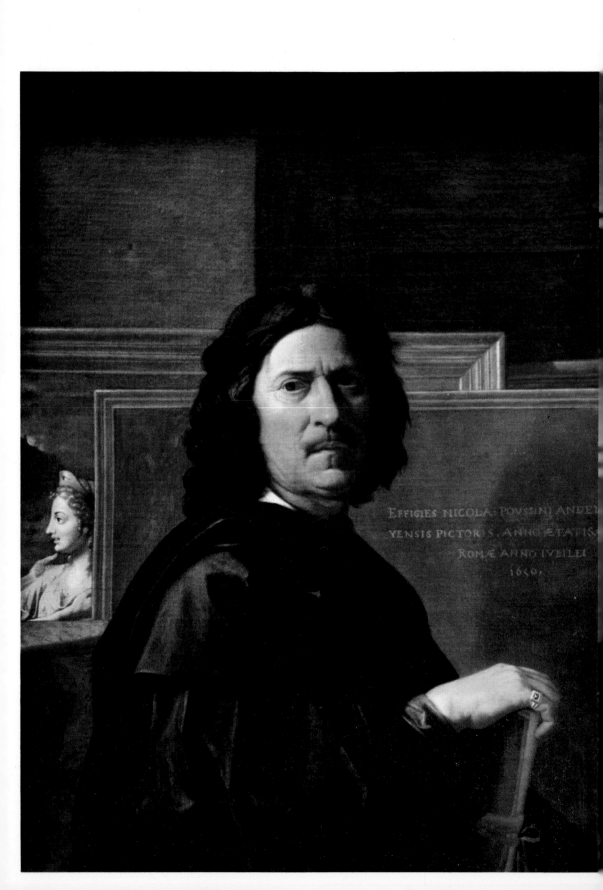

Nicolas Poussin
Self-portrait
Paris, Louvre

EFFIGIES NICOLAÏ POVSSINI ANDEL
YENSIS PICTORIS, ANNO ÆTATIS
ROMÆ ANNO IVBILEI
1650.

Nicolas Poussin
Echo and Narcissus or *The Death of Narcissus*
Paris, Louvre

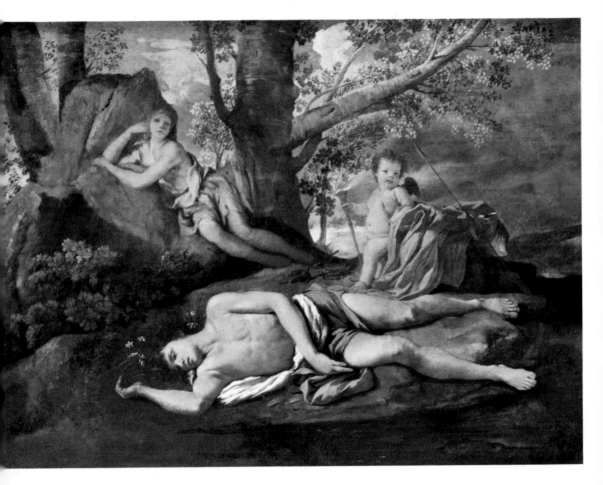

Later Baroque and Academicism

Giovanni Battista Gaulli (known as Baciccia), Filippo Gherardi and finally Andrea Pozzo, a lay brother from the Company of Jesus, followed Bolognese "quadratura", the discoveries of Lanfranco and the achievements of Pietro da Cortona in the second half of the century, all with renewed mastery of style and exuberance. But this was the ultimate achievement of Baroque.

Under the influence of his friend Bernini, Baciccia, like all great Bolognese artists, went to study the work of Correggio in Parma. Between 1672 and 1685, he transformed the severe Gesù in Rome into the very archetype of Baroque decoration, which of course contributed, even though retrospectively, to the legend of a "Jesuit art form". The combination of real and fake stucco and painted relief created an illusion which only the heavy gilded frames were able to dismiss.

Filippo Gherardi's great fresco *The Triumph of Mary's Name* on the ceiling of San Pantaleone even dispensed with this last prop of reality. The illusion is created by

51

Claude Lorraine
View from the Campo Vaccino, Rome
Paris, Louvre

▼

Claude Lorraine
Cleopatra's disembarkation at Tarsus
Paris, Louvre ►

the ingenious disposition of figures lying laterally, their arms and legs, as it were, caught on the side wall whilst their heads or the upper part of their bodies are directed towards the radiance of the sun against a blue sky stippled with clouds and filled with a host of angels held entranced by the gaze of the Lord.

Padre Pozzo lacked the delicacy and human warmth of Baciccia—but his zest was tremendous. When he painted *The Triumph of St Ignatius Loyola* on the nave of Saint Ignatius in Rome, he seemed on the point of surging off to Heaven like his patron. But this fantastic Baroque was no longer a surprise to the Romans—and the very essence of Baroque is surprise. So it was the tiny courts of central Europe and the petty princes of the German states who abandoned themselves to the joys of *trompe-l'œil*. In 1703, Padre Pozzo went off to Vienna where he stayed for the rest of his life. This exclamatory style was followed by the fine discursive illustrations of the Academicians and Neo-Classicists.

Rhetoric is to art what marriage is to love. They say the one kills the other but no survival is possible without it. Carlo Maratta espoused Classical painting. His characters in folds and draperies are heavy with thought and feeling; in the sumptuous framework of the Palazzo Altieri they stand and ponder and not a single cherub dares to step out of his stucco cage. The dizzy glamour of the Baroque was cast aside and he painted exactly as the old masters had painted before him, as artists should always paint, and Bellori, biographer of all the great artists of his time and sole arbiter of Beauty stated that Maratta was the greatest living painter. His judgement has roused some laughter—wrongly. Rhetoric is not the same as pomposity and a speech is not necessarily packed with bombast. Maratta's style was as strong, as lively and as vivid as that of his Baroque rivals. Indeed, he counts as Baroque himself in that his Classicism was a completely new intellectual conception.

Perhaps no painter has ever been more badly served by his own success. Who looks at his works nowadays? Most people have probably seen one of the countless copies made from his Madonnas.

They are sentimental and sugar-sweet, a total contradiction of his real art, which was all diligent application and majestic restraint. *The Death of St Francis Xavier*, which he painted for the Gesù at the same time as Baciccia was painting the same subject for San Andrea al Quirinale, is far better than the latter's by virtue of its calm reserve and figure composition.

Rome, Capital of Painting

It is impossible to list all the painters who spent their lives working in Rome in the shadow of the great masters. Rome in the 17th century was like Paris in the late 19th century. Artists from Holland, Flanders, Germany, France and even Slavonia, Scandinavia and Russia came to form what could be called " the Roman school", rich in sources of inspiration and varieties of expression. Following in the steps of Bamboccio —Pieter van Laer—the Flemish painter Jan Miel produced quantities of genre scenes,

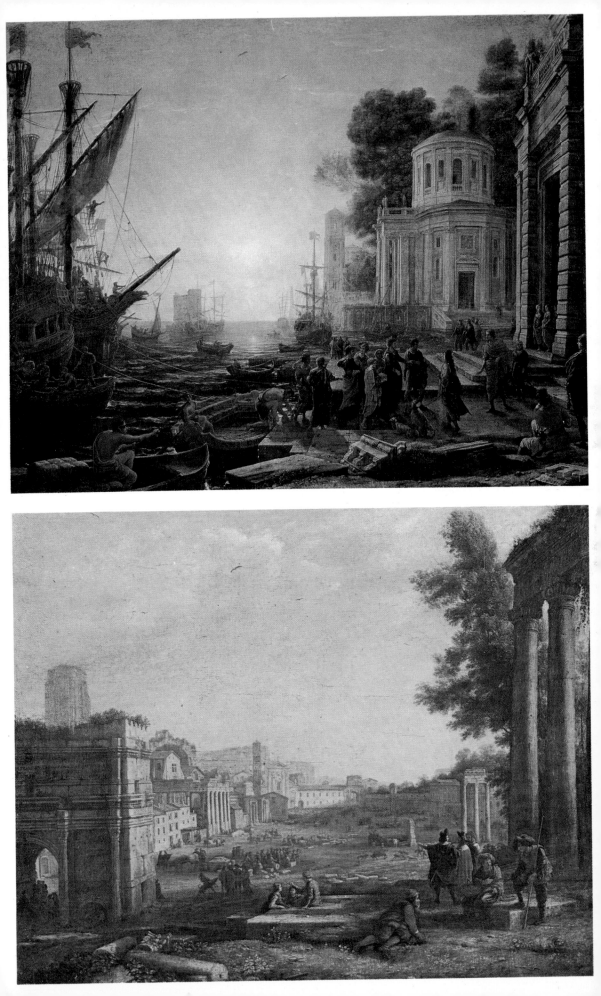

whilst Gaspard Dughet—brother-in-law of Nicolas Poussin and better known as Gaspard Poussin—painted landscapes which in style lie somewhere between Elsheimer and Claude Lorraine.

Many Italian artists who never achieved the fame of the great leaders of the Baroque and Classical movements made important contributions to the decoration of Roman churches and palaces. The old-fashioned Giovanni Battista Salvi, nicknamed Sassoferrato; the engraver Pietro Testa who worked with Gaspard Poussin and the outstanding Pietro Francesco Mola, whose *Barbary Pirate*, now in the Louvre, is painted with genuine warmth and Romantic feeling; Francesco Cozza, pupil of Domenichino, his younger colleagues Giacomo and Gugliemo Cortese—the latter known as "il Borgogne"—all produced with much charm and occasionally a rather absurd poetry various genre paintings and Baroque works soon to be submerged by the art of Maratta and his disciples.

Bologna

After the death of Lodovico Carracci and the reign of Guido Reni, the teachings of the Academy were taken up and interpreted with outstanding dramatic intensity by Alessandro Tiarini, Giacomo Cavedoni and Leonello Spada.

Simone Cantarini, whose work is packed with Correggian undertones, produced a fine picture in his *Adoration of the Magi*, possibly the best of the Emilian school. Guido Cagnacci gave a foretaste of the worst excesses of 19th-century Academic quietism with his astonishingly fresh and novel style of painting. But his two versions of *The Death of Cleopatra* show a strikingly bold modernism.

Carlo Cignani and his pupil Marcantonio Franceschini, pallid imitators of the Carracci, fathered that conventional art style which the Clementine Academy, founded in 1705, was to display in all its surpassing dullness. Only G. M. Crespi managed to escape the rigid conformism of its teachings and succeeded in winning a place amongst the greatest Italian painters of the following century.

The Tuscans

The reaction against Mannerist excesses began in the early years of the 17th century with the work of Florentine and Bolognese painters. Santi di Tito had shown them the way. His pupil Agostino Ciampelli, Domenico Cresti, known as Il Passignano, Jacopo da Empoli and, above all, Lodovico Cardi, known as Cigoli, sought and found the clear Venetian light of Correggio, painting very much like the Carracci, but with less passion. Cigoli, the most talented of them all, was much influenced by Barocci. His *Martyrdom of St Stephen* shows all the finest features of Baroque art.

Cristofano Allori, Giovanni Biliverti and Matteo Rosselli were his pupils and it was Allori who showed the greatest mastery in his superb *Judith* and his *St Julian welcoming Poor Travellers*.

Claude Lorraine
The Dawn
Turin, Pinacoteca

Rosselli had the distinction of training such students as Giovanni Manozzi, known as da San Giovanni, and Furini *.

Carlo Dolci was the Florentine equivalent of Sacchi, but painted with rather more affectation. Baldassare Franceschini, known as Il Volterrano, has the same kind of rustic verve as Manozzi.

Siena, still Florence's great artistic rival, managed to preserve a certain individuality till the middle of the 17th century. Ventura Salimbeni, Francesco Vanni and a pupil of Vanni's, Rutilio Manetti, went on to follow the path which led from the classical realism of the Carracci to the light and shade of Caravaggio.

Genoa

It seems almost as though the three generations of 17th-century Genoese painters worked with the sole aim of preparing the way for the most inspired of them all: Alessandro Magnasco (known as Il Lissandrino), who put the finishing touch to Genoese Baroque, and for that matter to Italian Baroque as well.

The movement was started by Sinibaldo Scozza with a style much influenced by the Flemish masters who had come to Italy to decorate the palaces of rich Genoese ship-owners.

Van Dyck *, on the other hand, whose portrait style was much improved by his studies in Venice, created no school.

Henri Testelin
Louis XIV, Protector of the Arts
Private collection

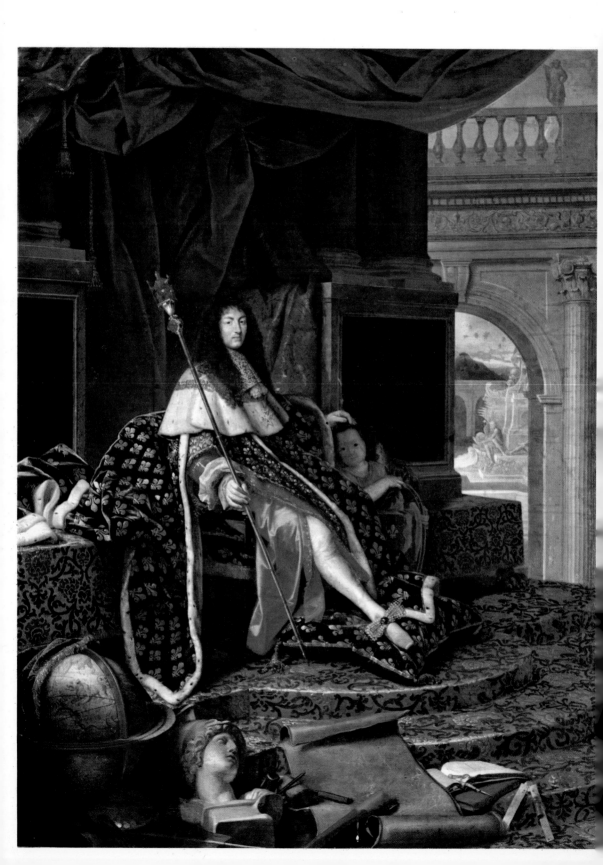

Genoese Baroque was virtually created by Bernardo Strozzi before he went off to work in Venice in 1630. Brought up in the Mannerist tradition and fully acquainted with the Flemish still-life, he extended his talents to take in religious themes in popular settings.

Two painters, Gioacchino Assereto and Giovanni Andrea de Ferrari, went even further than Bernardo Strozzi in this direction, but it was two of Ferrari's pupils, Valerio Costello, painter of lyrical frescoes—whose allegory *Fame* in the royal palace in Genoa is typical of his work—and Gian Benedetto Castiglione who offer a real foretaste of Magnasco.

After Domenico Piola, Gregorio de Ferrari, with a *Cupid and Psyche* on a ceiling in the Palazzo Saluzzo-Granello, a work stripped of all superfluous decorative material, opens the Rococo period with a flourish. And After him, Magnasco, his strange compositions and his peculiar genius.

Venice

Tintoretto died in 1635 and with him Venetian painting—for at least another century. Pietro Muttoni della Vecchia was a poor imitator and nothing more, Girolamo Forabosco an undistinguished follower of Titian. It is in fact hardly worth while mentioning Venice in a history of Baroque painting in Italy. Saraceni, though Venetian by birth, was basically a painter of the Roman school and one knows very little of Domenico Fetti*. During his short painting career, he produced in both Mantua and Venice mythological and biblical scenes set against bright landscapes in the best Veronese tradition.

The Vision of St Jerome (San Niccolo dei Tolentini, Venice) by the German artist Johann Liss shows all the freedom of the finest Rococo art.

Bernardo Strozzi, too, was much influenced by Veronese before he left his native Genoa for Venice. Overburdened with commissions, much of his work was done on a sort of production-line system, for he and his band of assistants turned out vast numbers of originals and copies. Strozzi was a Baroque artist in the best—and sometimes the worst—meaning of the word; he had a dramatic temperament and a keen appreciation for setting.

He had a great influence on Francesco Maffei and Sebastiano Mazzoni.

Tiberio Tinelli and Sebastiano Bombelli left portraits more original and firm in presentation than those by the general run of Titian's imitators.

The Duchy of Milan

Giovanni Battista Crespi, known as Il Cerano, opens this so-called "Borromeo" period —a period notable for the brilliance of the Lombard art of the Counter-Reformation.

The best of its iconography was borrowed from St Charles Borromeo, archbishop of Milan from 1564 to 1584; its inspiration was drawn from his severe yet tender

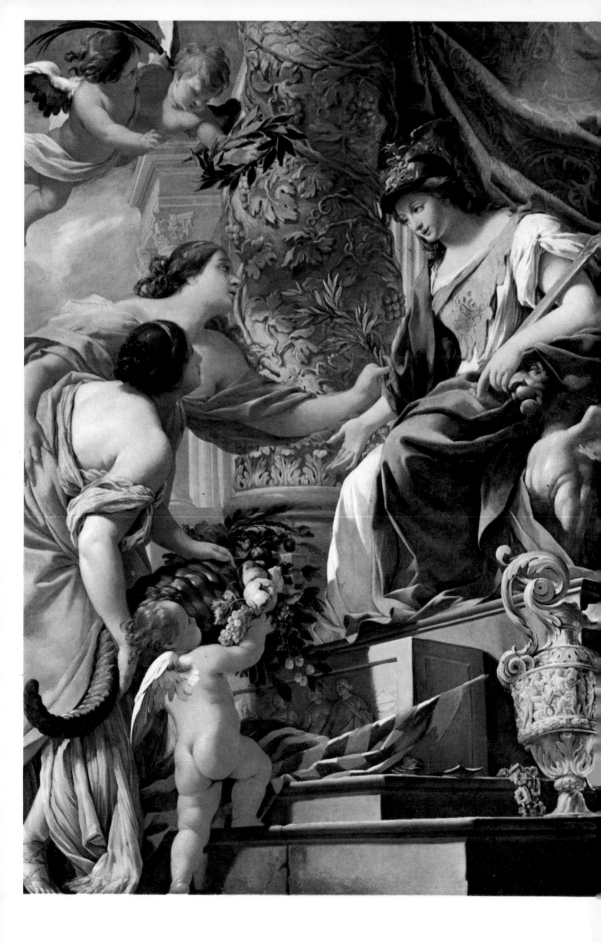

mysticism and it developed according to the rules laid down by his cousin, Cardinal Federigo Borromeo, archbishop of Milan from 1594 to 1631.

Federigo Borromeo, a man of deep religious sensibility and much learning, founded the famous Biblioteca Ambrosiana as well as an Academy of Art in Milan and also wrote a treatise entitled *De pictura sacra*.

Crespi was an energetic Mannerist of deep sincerity; there is no contrived artifice in his work. His masterpiece, *St Ambrose baptising St Augustine* (San Marco, Milan), is deeply impressive with its rhythmic composition.

Giulio Cesare Procaccini* and Pier Francesco Mazzucchelli, known as Il Morazzone*, stayed faithful to a special kind of Mannerism which had its roots firmly set in a Lombard background. Morazzone painted some fine frescoes at Varallo, Novara and in Piacenza Cathedral; the latter remained unfinished at his death.

Daniele Crespi*, twenty-six years younger than Morazzone, died only four years later than he did, at the age of thirty. His works recall Ribera's and his *St Charles Borromeo Fasting* anticipates Zurbarán.

The painter Tanzio* di Varallo came from the Valais and seems never to have lost sight of his mountain homeland; Francesco del Cairo*, last representative of the "Borromeo" school, offers us an anguished and somewhat melodramatic vision of saints and biblical heroes destined for tragedy.

The Bergamo painter Evaristo Baschenis*, neglected on account of his deliberate rejection of the contemporary grand style, produced superb still-lifes with musical instruments, all endowed with exquisite delicacy and subtlety.

The same discreet charm is seen in the portraits of Carlo Ceresa*. His *Woman with a White Handkerchief* is a marvellous study in black and white which approaches abstraction yet loses nothing of its psychological truth and physical accuracy.

Parma and Schedoni

Apart from Lanfranco and Badalocchio, Parma also produced Bartolomeo Schedoni, a painter of whom we know very little. The works he left show a Baroque art already tinged with Romanticism. Most of them are now in Paris, though some got as far as Naples, where they formed part of the superb Farnese collection in which they had a well-deserved place of honour.

Naples

Jesuits, Theatines and Oratorians shared Naples between them and gave a good illustration of the thesis that an abundance of wealthy religious establishments will produce striking artistic developments.

The same vigour was brought to the development of lay architecture by the centralising process of the Spanish viceroys and the establishment in Naples of the great landed proprietors.

Father Valeriani *, Father Grimaldi *, Giovanni Antonio Dosio *, Giovanni Battista Cavagni *, Domenichino and Giulio Cesare Fontana *, architects from the north of Italy, were the first masters of Neapolitan Baroque. Fra Giuseppe Nuvolo *, Giovanni di Giacomo Conforto *, Pietro d'Apuzzo, Francesco Antonio Picchiatti *, all Neapolitan architects of great talent destined to design churches and palaces at every street corner, acknowledged one great master, Cosimo Fanzago * from Bergamo—architect, sculptor, town-planner, decorator and deviser of entertainments.

At first, painting seemed less favoured. Here, in the early 17th century, the Mannerist school flourished in its most flaccid sentimentality. Neapolitan churches are still packed with the dull works of Fabrizio Santafede *, Girolamo Imparato *, Francesco Curia *, Ippolito Borghese *, Luigi Rodriguez (known as Il Siciliano *), Belisario Corenzio * and Giovanni Bernardo Azzolini *.

Caravaggio's brief descent upon Naples between 1606 and 1607 swept away this dull, old-fashioned style. The *Flagellation* he painted for the altar of San Domenico Maggiore can be considered the outstanding example of all Neapolitan Baroque. It is not only the deep darkness surrounding a Christ whose face turns in agony towards his left shoulder which holds one's eye; it is also the searing truth of his characters and the sublime simplicity of his composition.

Ribera

Jusepe Ribera, known as Il Spagnoletto, was well and truly Spanish, but in spite of this was a Neapolitan painter—even perhaps the greatest Neapolitan painter of the 17th century. Nothing is known about his life in Spain apart from the name of his birthplace —Jativa, near Valencia. According to A. Palomino, he started as a pupil of the Spanish painter Francisco Ribalta. As a young man, he worked in Parma and Rome. In 1616 he was married in Naples, and it was in that city that he did all his greatest work.

His first known picture is a *Crucifixion*, probably painted for the Duke of Osuna, viceroy of Naples from 1616 to 1620. We have engravings by him dated 1621—*St Peter* and *St Jerome*, another *St Jerome* dated 1626 (Hermitage Museum, Leningrad). The *Drunken Silenus* (1626) from the Naples Pinacoteca suggests that Ribera must have known and liked the works of Rubens and Van Dyck.

As well as these traditional religious and classical subjects, Ribera began to paint, from 1631 onwards, a series of paintings showing what one might call a rather deformed type of reality: *The Bearded Woman* from the Lerma Collection in Toledo is a typical example. In 1642 he painted the most vivid and attractive of this genre—*The Child with the Club Foot* (Louvre, Paris).

In the period 1637-43 he worked at the Charterhouse of San Martino, painting a *Pietà* and a series of larger-than-life prophets which show the full maturity of Ribera's naturalism. As the years passed, he acquired a serenity never found in the paintings of Caravaggio, whose influence on his style has always been much exaggerated.

On the other hand, it is not unlikely that Velasquez' two visits to Naples (1630-31 and 1649-50) had some effect on Ribera's work: certainly his colour range became more brilliant and his works grew lighter in atmosphere. His very typical objectivity relates him closely to the Seville school rather than to Caravaggio, in any case.

His *Holy Family with St Catherine* reflects the new peace and brightness which begin to illuminate his realism.

His last painting for the Charterhouse of San Martino, *The Communion of The Apostles*, opens the way to a warm and vital Baroque Classicism.

The Neapolitan " Tenebristi "

Before Ribera's particular talent gained a dominant position, two painters, Giovanni Battista Caracciolo *, known as Il Battistello, and Massimo Stanzioni *, were affected by Caravaggio's work, without, however, growing too enveloped in his "tenebroso". Stanzioni did not altogether escape the influence of Bolognese Classicism, but his eclecticism effectively prevented him from ever becoming a truly great painter. As a teacher, though, he served Cavallino well.

The rising generation of Neapolitan painters developed around Ribera from 1630 onwards. Francesco Fracanzano *, brother-in-law of Salvator Rosa *, achieved a certain dramatic intensity. Artemesia Gentileschi and the Flemish painter Matthias Stomer * continued the "tenebrist" tradition. The most substantial commissions for the religious bodies and the churches remained the private province of Ribera or else of great masters from Rome such as Lanfranco or Domenichino.

Bernardo Cavallino

Strictly an easel-painter, Cavallino showed the freedom of colour and style which was to be typical of the best Rococo artists. The Capodimonte Museum in Naples has a limited but striking selection of his religious paintings, with an outstanding *St Cecilia*; a pastoral scene, *Erminia amongst the Shepherds*, reveals his natural spontaneity and elegance.

His pupil, Johann Heinrich Schonfeldt *, never equalled his teacher's marvellously light and delicate touch.

Salvator Rosa

Salvator Rosa was one of those rare painters whose art is intimately linked with their particular way of life.

Actor, poet, musician, playwright, all Salvator's talents were in the last resort subservient to his painting. In 1647 he took part in Masaniello's rebellion against the Spaniards and was obliged to flee to Rome at the approach of the loyalist troops.

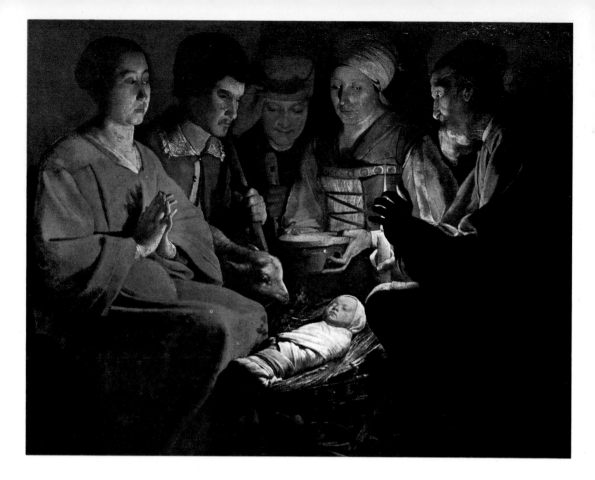

His first teacher was his uncle Paolo Greco, but his real grounding in art was given by his sister's husband, Francesco Fracanzano, a pupil of Ribera's, and by Ribera himself. Aniello Falcone, a great painter of battles, passed on this rather special talent to Salvator Rosa, but a much stronger influence was undoubtedly that of Lanfranco. It was Lanfranco, in fact, who urged Salvator Rosa to go to Rome for the first time in 1635. He returned to Naples two years later, but left again for political reasons, never to return.

A series of engravings published in 1656 brought him a European reputation. They were scenes of bandits and pirates in wild landscapes and for the whole of the 18th century were accepted as entirely typical of his particular talent. Unfortunately, none of his early paintings remain, so we have no real indication of what his youthful Romanticism was like—a spirit he tried hard and unsuccessfully to forget when he sought to develop a Baroque Classicism rich in the knowledge of art and literature which the passage of time had brought him.

A guest of Cardinal Brancaccio in Rome, he nevertheless dared to write a satire against the Eternal City under the title of *Babylon* and, on the invitation of Cardinal Giancarlo de Medici, went to Florence where he stayed for nine years, in the company of the poet-painter Lorenzo Lippi * and the members of the Accademia degli " Percossi ". He was closely acquainted with Ugo and Giulio Maffei in Volterra, where he wrote four more satires: *Music, Poetry, Painting* and *War*. When he was back in Rome, he answered his critics with one last attack from his inexhaustible pen: *Envy*.

This intensive activity and overwhelming passion produced his finest works in the last years of his life: the magnificent *Battle* in the Louvre, *Saul and the Witch of Endor* and *Pythagoras and the Fishermen*.

Georges de La Tour
Nativity
Paris, Louvre

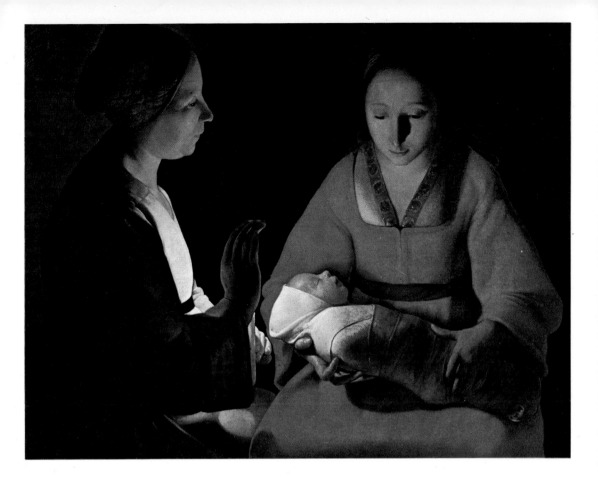

Mattia Preti

Two huge frescoes commemorating the plague which killed two-thirds of the population of Naples in 1656 were commissioned from Mattia Preti* to appear on the wall above the main entrance gate to the city. They were completed in 1659. Art lent its powers of transfiguration to a town still weak and exhausted from its losses. It was a process which showed better than any other how the artists and the general public of the 17th century gave proof of their good faith and deep sincerity before a work of art.

Any doubts which one might have entertained on their true religious feelings must disappear in the face of Preti's frescoes—though unfortunately the original work has disappeared and only the cartoon in oils remains for us to see. The work must have been his masterpiece and it is certainly one of the most significant Baroque paintings.

A Virgin with the heavy features of the Neapolitan "Mamma" stands above the dying, surrounded by kneeling figures, her Child Redeemer in her arms.

Through Preti's frescoes, Naples gave herself a vision of her own death. The hovering saints, the children, the wondering angels who throng the Baroque paintings speak the only language that could be understood by the men living at that time.

Mattia Preti, an artist from Calabria whose early years remain a mystery, was probably influenced by the "tenebristi" at first. He seems to have studied Veronese's frescoes and to have drawn upon the works of Domenichino and Guercino. But from all this, he evolved a personal style of his own, admirably shown in *The Element of Air*, a fresco painted on the ceiling of a room in the Palazzo Doria-Pamphili in Valmontone.

In spite of these tremendous achievements, Preti left Naples for Malta, where painting succeeded painting in a fantastic burst of activity which soon filled the churches with his pictures.

63

Georges de La Tour
The Newborn
Rennes Museum

Luca Giordano

In terms of speed, Mattia Preti was overhauled by Luca Giordano *, whose astonished contemporaries nicknamed him "Luke paint quickly" *(Luca fa presto)*. This rapidity, coupled with his prodigious precocity, has done him much damage, as much with his contemporaries as with posterity. His output was so abundant that no one has even dreamed of starting to catalogue it—but even if art historians smile to themselves when they see the endless procession of his paintings, they must in honesty admit that few works have the same brilliance or liveliness or sheer technical skill; especially remarkable are those painted before he was twenty years old. He may have started as a pupil of Ribera, but he soon gave up the dramatic "tenebroso" of his first paintings to strive for the clear brilliance of Veronese, whose paintings he must have seen on his travels through Rome, Florence and Venice. Of all his contemporaries, Pietro da Cortona influenced him the most, as can be seen from the frescoes he painted between 1682 and 1683 in the Palazzo Riccardi in Florence. The following year, he painted the frescoes for the Corsini chapel in Santa Maria del Carmine, also in Florence.

In 1692 he went to Spain as court painter to Charles II and decorated the Escorial with very fine frescoes and painted over fifty pictures, now in the Prado Museum.

His best fresco, *Christ turning the Money-changers out of the Temple* (1684), is in Naples. His frescoes on the subject of the life of St Benedict in the Abbey of Monte Cassino were unfortunately destroyed during the second world war.

He returned to his birthplace in 1702 and started work on the ceiling of the Treasury Chapel in the Charterhouse of San Martino; he finished his painting in April 1704, only a few months before his death on 12 January 1705.

Solimena

The last great Neapolitan Baroque painter, Solimena *, seemed at first to be a natural successor to Luca Giordano. *The Fall of Simon Magus*, one of the most luminous frescoes of his early period, was painted for San Paolo Maggiore. Gradually, however, the gravity of Mattia Preti had its effect. A trip to Rome put him in direct contact with Maratta and this too led him towards a more ordered type of Neo-Classicism. He soon had a reputation throughout Europe and got commissions from France, Germany and England.

Sicily and Novelli

Sicilian churches contain many masterpieces, but few of them are the work of native Sicilian painters.

Caravaggio, the Flemish artist Matthias Stomer and Van Dyck all left outstanding works on the island. Pietro Novelli, known as Il Monrealese *, seems to have been most influenced by Van Dyck; his best painting is a large picture devoted to St Benedict in the Monastery of Monreale.

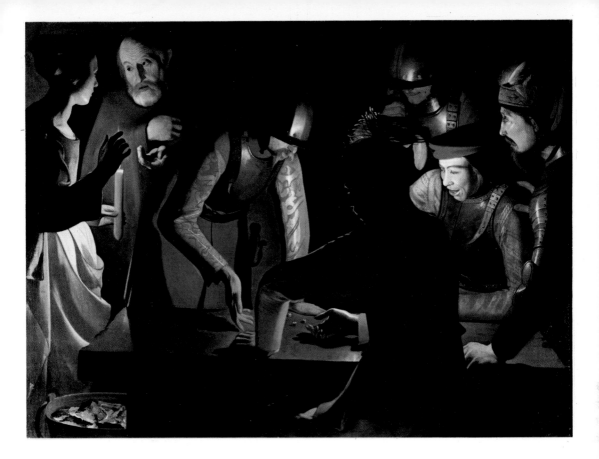

France

A French Painter in Rome: Poussin

Poussin's life was straightforward, his destiny paradoxical. His art was peculiarly French, but he could not bring himself to paint in France. He settled in Rome and, once established there, refused to associate himself with the grand style of the Roman school and instead devoted himself to the easel-painting which Italians held in small esteem; his greatest admirer was a Parisian, Paul Fréart de Chantelou *.

To all appearances, no artist ever took so little pleasure in the act of painting. He always claimed that his work was totally dependent on subject matter, his colours governed solely by reason. But the restraining influence of his temperament never deprived even the soberest of his compositions of life and underlying animation. Painters everywhere have always understood him. After David and Ingres, Cézanne and Picasso have acknowledged him as their master.

"I neglected nothing," Poussin said as an explanation for his style. And indeed, arrogant though this statement may be, its truth is echoed throughout the painter's life.

He had a naturally reserved temperament and in addition was possibly one of the most intellectual artists of his time. He read Descartes and Montaigne, though the literature of Classical antiquity was always his favourite and provided him with much of his source material. Ovid's *Metamorphoses*, which he illustrated for the Italian poet G. Marino in 1624 with a series of engravings, was much closer to his imagination than the Latin writers of the Classical period. To appreciate Poussin's taste for antiquity properly, his passion for Classical poetry must be borne in mind. He was always more of a dreamer than a scholar, more attracted to poetry than to archaeology.

65

Before he left Paris for Rome, he had been friendly with the free-thinking philosophers who claimed associations with Epicureanism (Gassendi*, for instance) and who offered a foretaste of the rationalism of the Encyclopaedists: Guy Patin was one of the most outstanding. This rationalism, a genuine love for the wisdom of the ancients, and a system of morals nearer to the Stoicism of Epictetus or Marcus Aurelius than to the philosophy of Epicurus, moulded Poussin's loyal Catholic temperament. His first painting teachers—and especially the mediocre Mannerist Quentin Varin* or Noël Jouvenet, in Rouen—had scarcely any influence on him at all. During his stay in Paris, he visited a few studios, in particular that of another Mannerist, Georges Lallemand*, but studied in none.

It was probably Courtois, Marie de' Medici's *valet de chambre*, who arranged for him to have access to the royal library where he grew to know the work of Raphael and Giulio Romano through prints of their paintings. At the same time he would have seen originals by Raphael and Titian from the king's private collection.

The efforts Poussin made to get to Italy were typical of the obstinacy and application he brought to all his enterprises, as well as of his scorn for uncertainties. At his first attempt, he got as far as Tuscany, but his money ran out and he had to come back. In about 1621, he got to Lyons, but debt kept him in France. He did not finally leave for Rome until the beginning of 1624, and that was thanks to the poet Marino. In 1622, he had returned from Lyons to Paris and had painted for the Jesuits in the Rue St Antoine six large pictures depicting the life of St Ignatius Loyola and St Francis Xavier at the rate of one painting per day. It was on this occasion that Marino noticed him and commended him to Philippe de Champaigne. He worked with him on the decoration of the Luxembourg. Thanks to the money earned from these various commissions, he was at last able to leave for Rome.

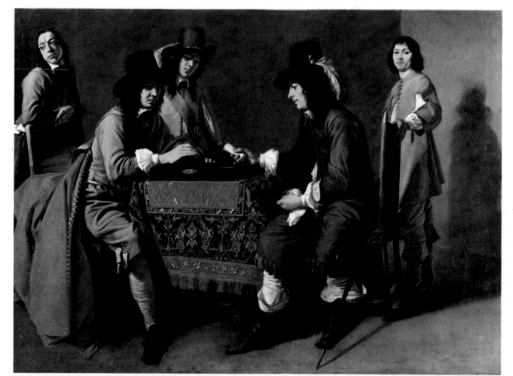

Marino was not able to help his protégé for very long; he died in 1625, but not until he had introduced "this wild young man" to Marcello Sacchetti who in turn introduced him to Cardinal Barberini.

At first he had lodgings with Simon Vouet near the Piazza di Spagna and worked in Domenichino's studio, copying the master's *Martyrdom of St Andrew*.

This opening period of his career in Rome saw him subject to several influences: the Bolognese painters, Baroque lighting, Caravaggesque "tenebroso". He committed himself to none of them. His most romantically Baroque painting of the period is that marvellous geometry of grief, *The Death of Narcissus*, yet his *Inspiration of the Poet* offers a clear manifesto of a completely original concept of Classicism.

But it was an indication and nothing more. *The Martyrdom of St Erasmus*, painted for the Vatican Gallery in 1629, showed that he had come to the end of this particular field of research: it was as disappointing for him as for that official public surrounding the Pope and his cardinals which made or broke an artist's reputation.

We are not sure exactly what it was which finally made him leave this battlefield of artistic endeavour, his own personal disappointment or some severe illness, but leave it he did. He found the climate best suited to his temperament around the Commendatore Cassiano del Pozzo, secretary to Cardinal Francesco Barberini and a fanatical collector of antiquities. Not satisfied with collecting Greek and Roman works of art, Cassiano del Pozzo knew and acquired works by the best painters of the period: Pietro da Cortona, Lanfranco, Testa, Mola and many others besides.

Freed from the terrible necessity of pleasing his ecclesiastical protectors and thanks to the eager patronage of the new "cognoscenti", Poussin's talent expanded superbly in the warmth of a Baroque Classicism which drew its inspiration from the Venetians, and in particular from Titian. From 1629 to 1633 he concentrated on warm,

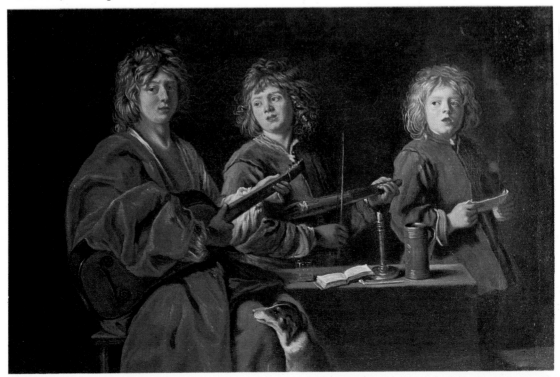

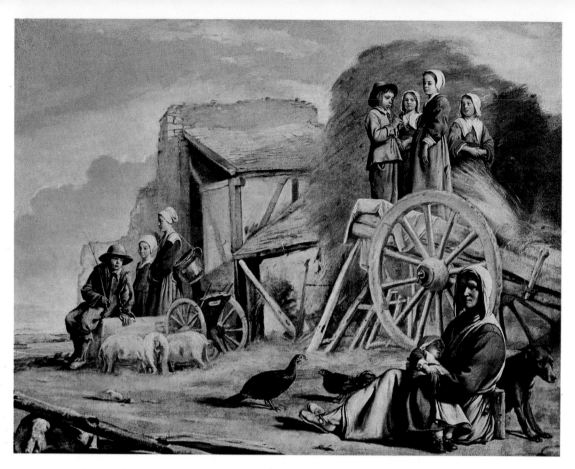

Classical themes—it was in particular his Bacchic period and he painted *The Childhood of Bacchus* and *The Bacchanals*, followed by *The Arcadian Shepherds* (1629), *Rinaldo and Armida* (1629) and *Cephalus and Aurora* (1630). Gradually, the restrained warmth of some of the works from this period gives way to an elegiac tinge. A delicious sadness with no hint of pathos or self-indulgence colours even the happiest scenes. The brilliant and vigorous *Rape of the Sabines* also comes from this period.

In about 1635, a new direction. Poussin deliberately came back to Raphael and his compositions acquired a geometrical arrangement. His simplified landscapes were based on a meeting of horizontals and verticals. An architectural arrangement allowed him to correct the irregularity of nature—which now responded to his needs and wishes, apparently without very great effort from him. This tension and deliberate limitation are simultaneously the inspiration and the restraint for Poussin's Classicism. Like Malherbe, a naturally Baroque temperament whose means of expression was purified deliberately the better to achieve a distinctly modern vocabulary, Poussin, too, directed his attention to Classical antiquity in order to express an internal order. If he subordinated himself completely to a subject, it was because he had deliberately chosen that subject: and if he had chosen it, he had not done so casually, but had selected it to express his thoughts, to illustrate his cosmogonic mission, to suggest a moral.

Comparisons have been made between Poussin and Corneille because they both express an ideal of heroism, but Poussin was closer to Rotrou. Corneille's grandiose concept of religion is often blind: with Poussin, greatness is always the fruit of reason. But this reason is—as in Rotrou's plays—the source of a sad lyricism, sad because the first lesson reason can teach us is its own non-existence in the face of death.

Henceforward he painted only scenes with a real meaning: *The Gathering of Manna*, *The Adoration of the Golden Calf*. He did not hesitate to explain what he was

68

Louis Le Nain
The Return of the Harvest or *The Haywain*
Paris, Louvre

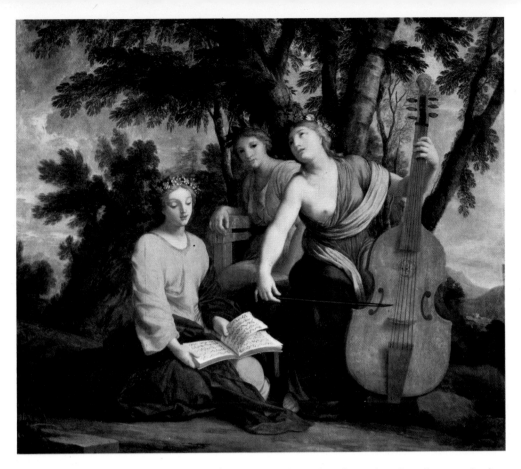

trying to do in these pictures. Later, by forgetting what he painted and remembering only his commentary, the Academy opened the way to the worst excesses. But Poussin was on the strait and certain way, and for those of his followers who really understood him this way lay clear and open. "Poussin", wrote Sir Kenneth Clark, "was one of those rare artists whose influence has been entirely beneficial." *The Seven Sacraments*, which he painted for Cassiano del Pozzo, is a perfect synthesis of Classical beauty and Christian truth.

By now, Poussin's art was so universally admired that Cardinal Richelieu tried to persuade him to return to France, along with a group of minor artists. After a long period of hesitation, Poussin accepted, took ship at Civitavecchia, sailed to Genoa in November 1639, and reached Paris in December. Presented to the King—whose official painter he now became—and to Cardinal Richelieu, he was nobly treated. But he was soon discouraged by the multiplicity of tasks given to his charge: illustrations for books, cartoons for tapestries, altar-pieces. When he started his decorative scheme for the main gallery of the Louvre, intrigue reared its head. Poussin could ignore intrigue, but not waste of time or feelings of uselessness. On the pretext that his wife—who had remained in Rome—had fallen ill, Poussin got permission to leave France; he never came back.

This involuntary excursion into decorative trifles seems to have confirmed Poussin in his visionary austerity. In the period 1640-50, his taste for heroic subjects grew stronger, to the exclusion of everything else. His heroes constantly preferred virtue to vice, reason to folly: they were Coriolanus, Scipio, Diogenes and Phocion.

His self-portrait, painted in 1650 (Louvre), sums up the whole of this didacticism. Here is Poussin's face, grave, almost forbidding, but his demeanour has a striking dignity. Behind the painter, several pictures form a perfect and exquisitely simple composition based on a synthesis of horizontals and verticals.

Eustache Le Sueur
Melpomene, Erato and Polymnia
Paris, Louvre

This taste for Antiquity which Poussin's detractors—especially Roger de Piles *—see as a fault gradually became second nature to him. His *Rest during the Flight to Egypt* evokes ancient Egypt as vividly as the Holy Family.

Poussin's last picture—unfinished—was *Apollo and Daphne* and shows for the last time that Poussin's vision of Antiquity was truly the paradise of painting, the golden age of humanity.

Claude or Perfect Harmony

Parallels drawn between Lorraine and Poussin are almost as fatal and just about as false and useless as comparisons between Corneille and Racine.

Claude Gellée was not French at all. He was born in Lorraine before that duchy ever got itself absorbed into French territory and if he has to have a nationality, then he was a citizen of the Holy Roman Empire. But much more than Poussin, he was primarily a Roman. He was in Rome from the age of fourteen onwards and it was there that he learnt to paint; it was the Roman countryside that he most loved to sketch.

We know little of his life or his character. A German painter, Sandrart, who left a short biography of Claude Lorraine, claimed to have taught him to set up his easel out of doors.

He went to Rome as an apprentice-pastrycook and took service with Agostino Tassi, whose pupil he very soon became. It is possible that he was working on the ceiling of the Palazzo Pamphili in about 1630 along with his master. In about 1623, he went to Naples. Throughout his life, he retained a vivid impression of what the bay looked like—not the modern bay with its rim of mills and hideous new buildings, but a seascape and landscape of beauty which he painted again and again.

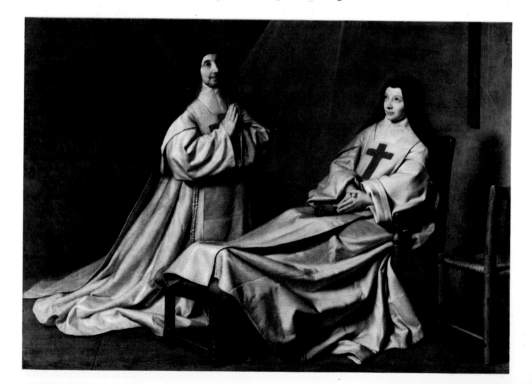

In 1625, he went back to Nancy and stayed for two years. His second biographer, the Italian writer Baldinucci, says that he took a violent aversion to ceiling-decoration when a man working on the gilding alongside him fell and was badly hurt.

Whatever the truth of the matter, he was back in Rome in 1627—but not without a brief pause in Marseilles where he drew the Vieux Port and met the French painter Charles Errard * who was to become the Director of the Ácadémie de France in Rome. Cardinal Crescenzio had commissioned the frescoes for his palace from him and he also decorated the Palazzo Muti: both works have unfortunately disappeared.

In 1629, the French Ambassador to the Holy See, M. de Béthune, bought two paintings: ·*The Seaport* and *Campo Vecchio*. Connoisseurs, especially English art lovers, began to struggle to get landscapes by Claude.

The French artist Sébastien Bourdon eagerly copied one of Claude's paintings, while the master himself went on to get commissions from Cardinal Rospigliosi, Cardinal Bentivoglio and eventually Pope Urban VIII himself.

71

◄ Philippe de Champaigne
*Mère Catherine Agnès Arnauld
and Sœur Catherine de Ste Suzanne*
Paris, Louvre

▲
Charles Le Brun
Entry of Chancellor Séguier
Paris, Louvre

This was when Claude started his *Liber Veritas* (British Museum, London), a collection of drawings reproducing some of his paintings in the hope of guarding against the possibility of fraud or forgery.

This *Liber Veritas*, written in a brand of spelling which shows as well as anything ever could that French was not Claude's mother-tongue, is packed with annotations on his various works—" Landscape with country cottage ", " Seaport, sun veiled by mist ". This title seems in effect to sum up most of Claude's paintings: most of his landscapes or seascapes could equally well be called something like " Roman countryside in the early morning", " The coast at Sorrento, midday", " River at sunset ". Claude was a past master at catching the fleeting moment, at knowing every leaf on every tree at every moment of the day.

It has been said that he was hopeless at figure-drawing and that his attempts at mythology were only excuses for more landscapes. Sir Anthony Blunt commented accurately that Claude was not particularly keen on *subject-matter* so far as his pictures were concerned—he was only bothered about their *content*. He expressed himself through his treatment of landscape. Figures did not trouble him particularly; he was not especially interested in them. His mastery of drawing and colouring was such that he could, if he wanted, produce superb figures, but he did not want to. So why not let some other painter, like Jean Miel, tackle the least important part of the picture, the people who appear here and there in his paintings? As for his mythology, it is just as sincere and as truly felt as Poussin's, but it springs from other sources. After all, Virgil, too, sang of fields and the play of sunlight and shadows on the grass.

Claude was no child making masterpieces in a blur of happy ignorance. His pictures, wrote Sir Kenneth Clark, " are a perfect example of what old writers on art used to call Keeping. They are perfectly in keeping. There is no false note."

They are in keeping because Claude literally " invented " them—that is, he found them where no one else would have seen them. If, as Sandrart said, he chose to set up his easel in the open air, then it was for the sake of capturing the ineffable quality of one fleeting moment. His paintings themselves are carefully thought out beforehand.

The many English connoisseurs of Claude made no mistake. They had their great parks and country gardens designed to match his dream landscapes, all so gently wild, so carefully untended, that they look more like Claude countrysides than all the land around Rome.

Packed with scrupulous observation and detailed by a master, Claude's pictures transcend what is real, but so discreetly that at first sight they seem only to have absorbed it into themselves. It is by going back to nature that one can appreciate how much a spirit as pure as Claude's can add to its visualisation.

Paris, a Capital for Men

Rome was a capital for souls. Henri IV snatched Paris from the rule of faction and restored the royal authority, making it a capital for men.

When, on 13 April 1589, Henri signed the Edict of Nantes giving France religious toleration and on 5 June in the same year arranged the Peace of Vervins which obliged the Spaniards to return the territory they had conquered, the king's real reign started. He was no longer a doubtful claimant, but a king acknowledged throughout his lands and beyond his country's borders.

Europe was not properly stabilised for all that. The Hapsburgs, that is to say the formidable union of Austria and Spain, were in favour of world hegemony. The better to face this threat—for she was after all the most likely to suffer from it—France gathered her strength. A central, authoritarian government, founded by Henri IV and perfected by Louis XIV, settled her finances, organised her economy and based all her institutions on the concept of permanent war. Local uprisings, strikes and revolts were mercilessly crushed. Industry, long discouraged by the lack of outlets, and trade, brought to a standstill by variations in prices, was revived under the control of a state always short of money and on the look-out for new ways of increasing income.

Social pressure as strong as this is only conceivable when public opinion is firmly behind it.

But Protestants and later on Jansenists held firmly to free will and a spirit of inquiry, that is to say, they questioned the right of absolute power. It was inevitable that the Edict of Nantes would one day be revoked and the Jansenists condemned.

But on the other side to the Protestants stood the free-thinking Humanists and the anti-Christian deists, all weakening authority by their tolerance as surely as Protestants and Jansenists by their fanatical opposition.

The doctrine of compromise, born from the exhaustion of an aristocratic and bourgeois society eager for peace, brought reconciliation between rationalism, God

and the State, fortunately for the monarchy. Descartes created his system. He was soon abandoned in favour of Bossuet, a fashionable theoretician of divine right.

The arts developing from such trends of thought expressed the inherent contradictions of this society, but in a harmony which in the end and little by little blended Jansenist and bourgeois Classicism with free-thinking and aristocratic Baroque in an ambivalent expression of royal greatness.

So in the event, there was no war between Classicism and Baroque, but instead a fortunate union of these two aesthetic trends. The Paris of Henri IV and of Louis XIII, the Paris and the Versailles of Louis XIV were simultaneously Baroque and Classical.

In the last ten years of his reign, Henri IV carried out a master plan—he organised the building of the Place Royale, now the Place des Vosges, which became the heart of Paris's most aristocratic quarter under Louis XIII, the Quai de l'Horloge and the Quai des Orfèvres. He had the Pont Neuf finished (and on it, four years after his death, Marie de' Medici placed an equestrian statue of him). It was the king himself who took charge of planning and organisation. Louis Metezeau*, Baptiste Du Cerceau* and Chastillon* seem to have acted as building contractors rather than architects in this enterprise. Henri IV was the first to visualise a square as an architectural ensemble which was not restricted to religious and state buildings but which included private dwellings as well.

This idea, now at the basis of all modern town-planning, was taken up again at Charleville in 1608 and at Montauban in 1616. Covent Garden is an imitation of Henri IV's Place Royale. And it was the king himself who planned the link between the Tuileries and the Louvre and who built the Hôpital St Louis.

The royal will to build was copied by private citizens. The Hôtel of the Duc de Mayenne dates from 1605.

It was, however, during the regency of Marie de' Medici and under Louis XIII that this building boom expanded to its fullest extent.

In 1608, a shrewd businessman, one Marie, bought the lease for the Ile Notre-Dame—now the Ile St. Louis—on condition that he linked it to the *quai* by means of a bridge (which still bears his name).

More and more private houses were built: the Hôtel de Chalon-Luxembourg, the Hôtels de Sully and de Bretonvillier are typical examples.

Marie de' Medici had given the commission for the Palais du Luxembourg to the great architect Salomon de Brosse*; alongside the Seine, she laid out the Cours-la-Reine.

In 1636, Richelieu started building the Palais-Cardinal, now the Palais-Royal, and its garden. During the reign of Louis XIII the Jardin des Plantes was built.

But between 1630 and 1661, that is during the ministries of Richelieu and Mazarin, the outstanding fact which dominates the arts and architecture in France is the rapid growth of a wealthy bourgeoisie. Apart from the king and the princes of the blood, it was in the main the richer members of this class who had houses built and commissioned pieces of sculpture, tapestries and pictures. "If we draw up a list of those

who patronised Mansart*, or Le Vau* or Poussin* or Vouet", wrote Sir Anthony Blunt, "we should be hard put to find one name from the nobility."

The greatest art lover of all was Fouquet.*

The glory of Versailles will always overshadow all Louis XIV's building works in Paris. It has been said so often that he loathed Paris that one forgets the personal part he played in embellishing the capital during his reign.

He left the city in 1649 in full flight from the terrors of the Fronde and returned to the Louvre only three years later, in October 1652. It took nine years and the death of Mazarin to set him in his place as ruler of France. In 1667, the Colonnade of the Louvre was started; it was finished in 1674. A whole series of architectural masterpieces now began: one followed the other with increasing swiftness. The Tuileries were completely redecorated; the gardens around the palace were redesigned by Le Nôtre*, the avenue of the Champs-Elysées threw out its splendid ranks of trees and stretched its perspective right to the open country. The Observatory was built at the same time as Perrault's colonnade. The Collège des Quatre Nations, now the Institut de France —which Mazarin bequeathed to the crown—was opened to young men from countries conquered by the royal troops.

The old line of fortifications was replaced by a rampart of trees which was basically only a promenade. The Porte St. Denis was built in 1672 and the Porte St. Martin in 1674; the Hôtel des Invalides was started in 1670. A huge masonry *quai* was built where the Faubourg St. Germain came down to the Seine and in 1685 the new Pont Royal replaced the wooden bridge which led to the Rue de Beaune. In 1673 the Quai Pelletier was built to line the river from the Pont Notre-Dame to the Place de la Grève. The Sun King was given a superb statue of himself by the people of Paris, a fitting monument to his glory in the centre of the Place des Victoires, built in 1686. But this was not quite enough and another statue of the king was set in the middle of the Place Vendôme, finished in 1699.

Paris was more Paris than ever and even if the court was often in residence at Versailles, most people wanted to have a house of their own in the capital.

But it was still at Versailles that they spent the best part of their time. This was the only way to keep constantly under the eyes of the king, that source of all favour. There, the arts served their master's glory best. There, fashion, the arbiter of elegance, ruled supreme.

Versailles was the school for beauty. Everything started with Fouquet's marvellous entertainment to celebrate the completion of his superb *château* at Vaux-le-Vicomte on 17 August 1661. Nineteen days later, Fouquet was arrested for having tried to out-do the king. But the three artists who had made Vaux the most luxurious and modern country-house of the time all met again at Versailles: the architect Louis Le Vau, the painter Charles Le Brun and the garden designer André Le Nôtre. Versailles had another sponsor, though, a posthumous one: this was Mazarin. He had planned the superb *salle des Ballets* in the north wing of the Tuileries and its designers, Vigarani*, Gissey* and Berain*, were all called to work at Versailles.

Le Brun had already worked on the decoration of the Galerie d'Apollon in the Louvre; the painters Errard and Philippe de Champaigne and the sculptors Marsy and Anguier * had all done their earliest work for the king's old home in Paris.

The Marsy brothers went to Versailles when the Ménagerie was completed in 1664 and were instructed to build "enough projections to carry china and other similar things".

Between 5 May and 14 May 1664, "The Pleasures of the Enchanted Island" took place. Everyone had a hand in the preparation of this Baroque entertainment which was based on an episode from Ariosto's *Orlando furioso*—Le Brun (as always), Molière, Lully *, Vigarani and Gissey. In June 1665, Carlo Vigarani, by now almost a permanent resident at Versailles, had to build a theatre for Molière's *Amour Médecin* in only six days.

In 1664 or 1665, Louis XIV decided to build a "Casin", described to us in detail by Félibien. It was a grotto dedicated to the love of Psyche and Cupid. The entrance was closed by a grille made of iron and brass in the shape of a sunburst; within was the exhausted Apollo driving home his chariot at twilight, the work of the sculptor Gérard van Opstal. Inside the grotto, fountains, mirrors, shellwork, hydraulic organs and various furnishings created a mythological *mise en scène* far beyond the wildest Rococo dreams. But fifteen years later, Louis, who had designed it for Louise de la Vallière and finished it for Madame de Montespan, had it destroyed for Madame de Maintenon.

There was another great entertainment in 1668 to celebrate the peace of Aix-la-Chapelle: Carlo Vigarani, Le Vau, Molière and Lully all collaborated in a superb and incomparable display of talent.

Only a few drawings and sketch plans remain from the ceiling of the Grand-Escalier where Le Brun drew on his memories of the work of Cesare Ripa for his design—the four corners of the world and the Muses set against a *trompe-l'œil* architectural background.

Still in 1668, Louis XIV planned his "Trianon de porcelaines"—a marvellous collection of tiles from Holland, Paris, St Cloud, Lisieux and Rouen. In 1672, the Cabinet des Parfums was built.

Le Pautre and Chauveau left engravings showing the six days of entertainment, spread over two months, which was organised to celebrate the conquest of the Franche-Comté during the summer of 1676. Vigarani, Quinault, Molière, a setting on the lake, the *Fêtes de l'Amour et de Bacchus*, an opera by Lully with décor by Berain. Nothing was spared—as always.

So Versailles was created in the midst of revels and jollities. And the supreme moment of French Classical Baroque was born from memories of Italy, memories of the Palazzo Farnese in the Galerie des Glaces, memories, too, of the Palazzo Pitti.

La Quintinie *, Le Nôtre and Le Brun all visited Italy. Vigarani, main deviser of Louis's entertainments, was Italian-born. Torelli was in charge of the fireworks. Decorative sculpture was made by Temporiti * and Caffieri *, bronzes by Cucci *. Mosaics and mirrors were Italian-made.

If one examines Versailles closely, the well-known notion that French proportion stood in splendid opposition to the wild extravagances of Italian Baroque falls shattered to the ground. It is true that Louis XIV and Bernini could not see eye to eye—but did Poussin get on any better with Louis XIII? and he above all was the great French Classical artist. Borromini or even Guarini could never have invented anything as absurd as the grotto of Thetis.

Louis XIV-Phoebus, decked with feathers and dancing in a formal ballet: what Italian Duke, what Pope was ever able to present the world with such a superlatively Baroque image of himself?

France moved from Renaissance to Baroque, from Henri IV, conqueror of feudal lords by force of arms, through Louis XIII who brought the aristocracy to heel with the might of the executioner's axe, to end with Louis XIV, absolute ruler by virtue of his symbolic position. The Mannerism of Primatice's followers went on inspiring some painters. The run-of-the-mill artists obsessed with the problems of realism knew nothing of the great religious and political currents which threw 17th-century society into confusion. But everyone, Caravaggists, Bologna partisans, followers of Poussin or Rubens, supporters of Le Brun or Mignard, settled their differences in the midst of Henri IV's wild debaucheries, in the sumptuous palaces of Richelieu, Marie de' Medici and Mazarin, in the glamorous surroundings of gold and stucco and fountains which made up Versailles.

From Rome to Paris: Simon Vouet

Ambroise Dubois, Toussaint Dubreuil, Fréminet (creator of the roof of the chapel at Fontainebleau), Quentin Varin and Georges Lallemand: in France there was one Mannerist after another and even though each was different, they developed little.

One should, however, mention the Flemish painter Frans Pourbus* the Younger. Poussin admired a very fine *Last Supper* he had painted in Paris in 1618. It seems that one must also attribute to him a *Virgin of Victory* in Saint-Nicolas-des-Champs.

From this time onwards most young painters wanted to go to Rome to finish their training. They wanted two things: to see the great works of antiquity which had been praised ever since the Renaissance and to be taught by the great contemporary painters. Amongst these French expatriates in Rome, Simon Vouet soon showed himself the major artist. In 1624 he was elected president of the Academy of Saint Luke. A close study of the works he painted in Rome enable one to appreciate the evolution of his style which went from a Baroque similar to Lanfranco and Guercino to a more fluid, Classical approach in the wake of Domenichino and Reni.

He was much influenced by Caravaggio, but was no sooner back in France than he forgot this style for a much more comfortable Baroque—the *Diana* now in Hampton Court is a good example.

Called back to Paris in 1627 by Louis XIII, who promised that he could retire to Rome on a pension, he became court painter and, before Le Brun actually appeared

on the scene, exercised the same sort of control as his successor on all French painting for the next fifteen years.

His works at the Château de Chilly, inspired by Guercino's *Aurora*, show him in full mastery of the Italian art of *trompe-l'œil*. He also decorated the Hôtel Bullion and the Château de Richelieu at Rueil.

Most of the young painters of the time, F. Perrier, E. Le Sueur*, Pierre and Nicolas Mignard* and Le Brun, worked at some time in his studio.

The French Caravaggists and Georges de La Tour

The French artists who followed Caravaggio had the particular feature that most of them forgot all about him once they had returned to France. Once Vouet was back in Paris, his Roman manner was abandoned. Valentin, the only real French successor to Caravaggio, stayed in Italy permanently. Blanchard* was influenced by Caravaggio only through his teacher, the Lyonnais artist Horace Le Blanc. But once he reached Italy, it was Titian he most admired. Nicolas Tournier*, painting in Toulouse, took as much from Bologna as from Caravaggio. Lubin Baugin was more permanently influenced by Guido Reni—he was nicknamed "Little Guido", in fact. Finsonius* in Provence and the Tassel brothers in Langres were more obviously Caravaggesque. As for Vouet's pupils—the engraver Claude Mellan (another Lyonnais), Jacques Stella*, Aubin Vouet*, Simon's brother, and the Pérelle brothers—what influenced them was their teacher's "French style". It was exactly the same for François Perrier, who worked with Simon Vouet on the decoration of the Hôtel de la Vrillière.

No one is really sure whether or not the Lorraine artist Georges de La Tour* went to Rome. Many have seen him as a disciple of Caravaggio. If the only grounds for being a Caravaggist is the use of "tenebroso", perhaps the idea is justified; but if such a simplified judgement is rejected, then we must acknowledge that La Tour is astonishing in his unusual approach and his originality. Like Claude Lorraine, this painter, who was born at Vic-sur-Seille, and who spent all his life in Lunéville, is linked with the French school. It is true that in 1633 Louis XIII bought a *St Sebastian* from him and gave him the position of painter-in-ordinary to the king in 1639, but La Tour had little in common with the other French artists of his time. His heroes owe nothing to Classical antiquity or the Bible: they are typical Lorraine peasants. He could not be

79

further from the direct statement of the Le Nains' art. Georges de La Tour, ambitious, married to a wealthy wife and transferred thereby into a better class than the one he was born into, painted in solitary splendour the mystery of simple things.

It is almost impossible to give a firm date to any of his works other than *The Denial of St Peter*, which is dated 1650, two years before his death.

It is therefore difficult to follow the development of his style. He owed nothing to his Mannerist predecessors Bellange and Deruet, but in some of his works there is a faint echo of the engravings of Jacques Callot * and the paintings of Jean Leclerc. As for his tremendously strong lighting contrasts, they are much more reminiscent of the Dutch Caravaggists—Honthorst, Baburen and Terbrugghen—than of Caravaggio himself. La Tour started with naturalism filled with expression, but gradually his very special use of the single light source led him to simplify his compositions as much as he possibly could. They ended by becoming a geometrical arrangement of volumes in *trompe-l'œil* and of lines which he used for contour delineation in spite of the play of light and shade.

The almost unbearable immobility of his characters is the product of this contra-dictory association of volume and single dimension. It would have been nothing more than a rather old-fashioned artifice if the painter had not used it to express the sudden cessation of movement—not an accidental one, but a moment of absolute stillness caused by a deep religious feeling. The wondering contemplation of his characters when faced by the work of their Creator reflects a spiritual awareness which seems to be associated with the Franciscan revival which took place in Lorraine at that time.

The Le Nain Brothers

Three brothers, pictures painted as a communal effort, slight differences of style; art historians are still far from clear which brother painted which picture. The Le Nain brothers were linked by their work as well as by their family ties of blood. Antoine was born about 1588, Louis about 1593. Both died in 1648. Mathieu, born in 1607, lived until 1677. Antoine was particularly good at "miniatures and small portraits". In 1629, he became official painter to the Abbey of Saint-Germain-des-Prés. He was a naturalistic painter directly inspired by his 16th-century Dutch predecessors. Louis, known as "the Roman" because apparently he was the brother who went to Italy, painted peasant scenes in the Bamboccio (Pieter van Laer) style, but achieved something rather better than the usual genre painting. His *Vulcan's Forge* is not unlike Velasquez's *Apollo in his Forge*. As he may have been in Rome between 1628 and 1629, it is quite possible that he may have met the Spanish painter, who was also there in 1629.

Mathieu seems to have been the least personal of the three brothers, but since the attribution of their respective works is so debatable, it would be foolish to make too many categoric statements about their individual merits and demerits.

"Painters of reality", the Le Nain brothers fell from popularity into disrepute and then into oblivion: today, however, they are splendidly restored to favour. What

exactly is meant by the expression "painters of reality" is open to discussion. Just as Caravaggio's scenes of ordinary life are really only studio reconstructions which do not take into any account the terrible poverty and misery of the Roman people, the idyllic families in the Le Nain pictures also turn their backs on the real condition of the French peasantry of the time. They were destined for middle-class *salons* and have the same degree of truth as Theocritus' *Idylls* and Virgil's *Bucolics*. Their lyricism is sincere, but they are nevertheless transpositions and not true representations of reality.

The engraver Abraham Bosse * also gives a picture of idealised reality, not in a sentimental sense, but in the happy economy of a Classicism which transcends mere anecdote.

Eustache Le Sueur

A true Baroque painter, even though he never actually went to Italy, Le Sueur combined to the highest degree of skill religious conviction and a taste for scenery. His art resembled that of Lanfranco and showed little trace of the influence of Vouet, whose pupil he was. He shows in his paintings a refined version, simultaneously sensual and reflective, of Poussin's universe.

Sébastien Bourdon

A painter too endowed with talent, Bourdon could paint in any number of styles, but with such zest and freedom that his personality and his tremendous gifts are visible even when he painted straight pastiche. True recognition will come when his fine portraits are properly appreciated.

Laurent de La Hyre

The clear, luminous colours of Titian and Veronese, the restrained Romanticism of Poussin are joined together in the work of Laurent de La Hyre * to produce a warm and

original style. *The Children of Bethel* (Arras Museum) and *Christ appearing to the Two Maries* (Louvre) show the great compass of his art. The first picture has all the tender gravity of Poussin's finest works and the second is a great burst of joy at the glory of the Resurrection.

Philippe de Champaigne

The brilliant career of this painter should not conceal the weaknesses and the strength of an art which was at its best in portraiture.

The series of paintings which he did for the Carmelite Convent in the Rue St Jacques in Paris does not stand up well when compared to the ones painted alongside by Laurent de La Hyre. On the other hand, though, his *Portrait of Louis XIII* (1628) and the subsequent one of *The Monarch offering his Crown to Christ from the Foot of the Cross* are first-class works. Of all the portraits of Cardinal Richelieu painted by Philippe de Champaigne or by his studio, the one in the Louvre best deserves its reputation. It is treated in the finest Baroque tradition: the Cardinal's robe is spread out to fall in sumptuous folds and the combination of this opulence with the shrewd, intelligent face produces a superb union of psychological insight and the symbolism of power.

It was his relationship with Port-Royal * which gave the painter his most powerful and original source of inspiration. Basically worldly and by definition a court painter, there seemed no particular reason for him to be interested in Jansenism. When his wife died, however, he sent his two daughters to school at Port-Royal de Paris. The eldest, Françoise, died there in 1655; the youngest took the veil there in the following year. It was therefore a conjunction of circumstances rather than personal conviction which persuaded him in that painful year 1655 to intercede—unsuccessfully—with Mgr Péréfixe, Archbishop of Paris, when the Abbey was in trouble with the religious authorities.

On 22 October 1660, his second daughter, Sister Catherine de Sainte-Suzanne, was taken ill with a sudden paralysis of both legs. After a novena said by the whole community, the sick girl was able to get up and walk. It was an act of thanksgiving for this miracle which prompted the artist to paint his famous *Mère Agnès Arnauld and Sœur Catherine praying*[1]. The picture was hung in the chapter house of the Abbey. Some twenty religious paintings by Champaigne, listed in the inventory of the Abbey's

[1] Entitled "The 1662 ex-voto".

goods when the possessions of the clergy were nationalised at the Revolution in 1789, show the closeness of the artist's attachment to the convent.

The works show that there is no basic difference between a picture painted for the Jansenists—and moreover by a man who, even if he was not a Jansenist himself, at least felt great sympathy for them—and an art supposedly Jesuit-inspired.

This Baroque Classicism, perfectly exemplified by Poussin, developed successfully in Rome as well as in Paris. Philippe de Champaigne, court painter, skilful portrayer of the sworn enemies of Jansenism as well as of its friends, attempted the fusion of rationalism and of the official propaganda of which his paintings are one of the finest organs.

Claude Vignon

Brocades and gold and a feeling of movement: Vignon's compositions have the colour and rhythm of a dance. They whirl one away like a strain of music and offer a distinct foretaste of Rembrandt: indeed, Vignon had engraved some of Rembrandt's paintings. Charles Sterling wrote that Vignon was the only French painter who could be truly called Baroque. Possibly this is why he is so little appreciated in France. The tremendous richness of his painting and his fantastic verve should one day bring him the host of admirers which other far less gifted painters have already won to their side.

Charles Le Brun and the Academy

At the beginning of 1648, writes Roger de Piles, Martin de Charmois decided "to get the very best painters to join together so as to escape from the oppression of their masters and thus be able to exercise freely the freest of all the arts. He helped them to appreciate the nobility of their profession, and after giving the first flush of enthusiasm to the project of throwing off the yoke of servitude he used what credit and friends he had to help painting out of the decadent state it was in and to set it in a new and worthy position among the liberal arts."

Martin de Charmois was an amateur; the project was a sort of crusade for him—for the professional painters, he stood for the casting-off of shackles.

"The Royal Academy of Painting" was originally a sort of painters' trade union formed with the aim of breaking out of the previous restrictions. Artists and artisans alike were still subject to the medieval ruling which allowed them to become full masters only after years as apprentices and journeymen. House-painters and general decorators were thus in a position to pass judgement on their so-called "equals"—who were, of course, infinitely more gifted; the situation was unbearable but painters had been obliged to put up with it or else avoid it by many devious means before the Academy was organised to set things right.

83

But like all unions based on a hierarchy, the Academy brought an even weightier authority to bear on the more liberally-minded artists. It became one cog more in the state apparatus created by Henri IV, Louis XIII and Richelieu and brought to perfection by Louis XIV. However, it does not seem that the Academy actually prevented the development of first-class talent. In periods of intense creative activity, restraint often acts as a firm hand on a wayward force. One strong impulse can carry with it the whole stream and every one of its tributaries. Strength can get the better of quiet reflection. The leader of this simultaneously simplificatory and dynamic task was Charles Le Brun.

The king's chief painter, Le Brun (still according to Roger de Piles) "was born with all the dispositions necessary for being a great painter. He began using his skill as soon as he began using his mind; he improved it by constant study; he made the most of what fate brought him and was favoured by his talent; he was always fortunate." This portrait is accurate in everything but one particular—at the end, he was not so fortunate and he literally died of grief.

But before that happened, there were years and years of hard work and fame, or marvellous unshared authority: and then Colbert died, Louvois did not like him and Le Brun was confined at last to a limbo from which he never emerged again.

"First of all, there must be the means...," wrote J. Thuillier in his preface to the superb Le Brun exhibition at Versailles in 1963. "Poussin needed only a canvas and a few paints in his little house in the Via Paolina. Le Brun needed royal residences, all the treasures of a wealthy country and the help of a throng of artists, a king's favour, a minister's patronage and everyone's admiration."

In fact there were plenty of means—his post as Director of the Gobelins tapestry works, his position as Director and Chancellor of the Academy. For two centuries, historians have tried to make him into the father of Academicism, but a close look shows that there is nothing less dogmatic or less conventional than his painting. Of course, the Academy gave a formal definition of art; the ancients represented an absolute aesthetic ideal, then came the others in the hierarchy of Absolute Beauty: Raphael first, then his followers, and finally Poussin. Students were warned particularly not to be attracted by the Venetian use of colour. When Le Brun went to Italy, he never even went near Venice. Flemish and Dutch painters were condemned because of their servile imitation of nature. Painting was an intellectual art for a cultured public. Its beauty should always be in harmony with reason.

All these statements are fine in their way, but one look at the splendid *Portrait of Chancellor Séguier* and *The Family of Darius before Alexander* shows one how Le Brun's principles and desire to achieve a true Classicism disappear under the influence of a truly Baroque temperament attracted by both what is splendid and what is pathetic. Alexander, endowed with all the radiance of a god of nobility and compassion, is Louis XIV, the Sun King, the Sun of Le Brun.

Louis XIV adoring the Risen Christ, painted in 1674, is Baroque in technique and spirit. As to the battle-scenes in the Gobelins tapestries, they glorify with order and excessive delight a magnificent triumph far from the melancholy meditations of Poussin.

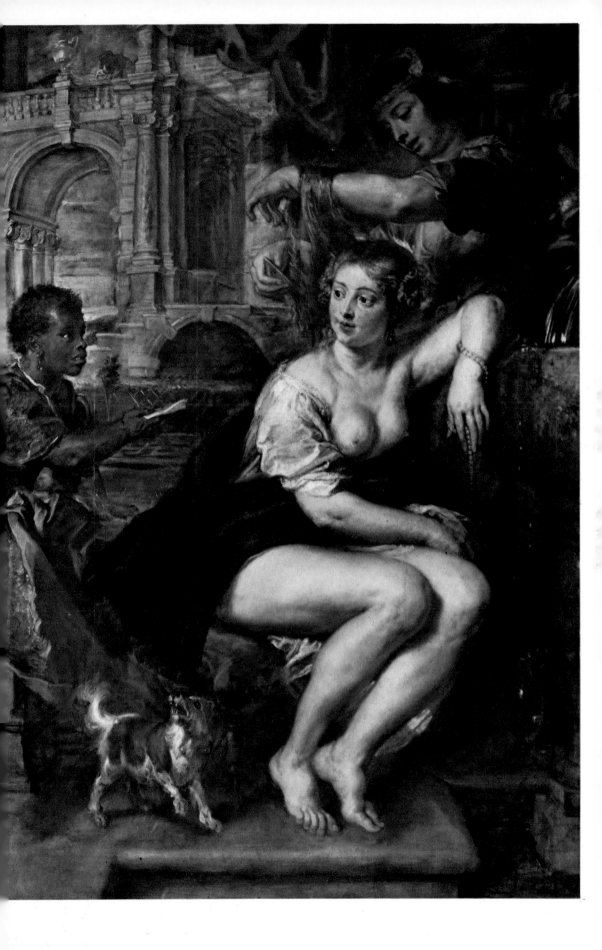

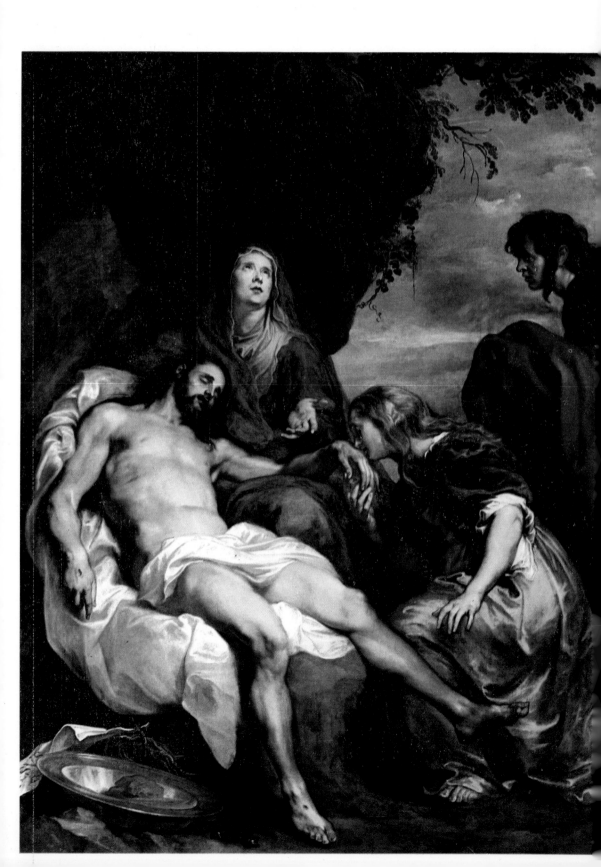

Mignard

He was another Le Brun, but born too late. Le Brun spent four years in Rome, Mignard nineteen. Le Brun admired Poussin: the feeling was mutual. Mignard admired Poussin, too, but the latter had a low opinion of his admirer; he wrote to his friend Chantelou in 1648, "I would have had my portrait painted for you but I do not particularly want to spend ten pistoles to have it done by someone like my lord Mignard. His heads are easily the best, but they are cold, heavily coloured and lack both talent and vigour."

Called back to France in 1657, Mignard refused to take his seat in the Academy because Le Brun was the Director. He eventually joined in 1690 when Le Brun was dead; he was seventy-eight years old and had just been appointed chief court painter.

Poussin's criticism of Mignard's portraits is severe, but stresses their very real weaknesses. They do not offer an idealised portrait of the sitters in the Classical manner, but they prettify them. It was Mignard much more than Le Brun who opened the door to Academicism.

The End of the Grand Siècle

Louis XIV grew older, Mme de Maintenon held the reins, France declined into sadness. No first-class painter came to take the place of the dictator Le Brun and the skilful Mignard. Antoine Coypel*, in his turn chief painter to the king, was a leader of men, like Le Brun. He had an intellectual approach to his art and gave lectures on the subject; he wrote various short comments on painters of the time, praising Rembrandt, Rubens, Poussin and Le Brun. Largillière*, Rigaud* and François de Troy* were primarily portrait painters. Realism and a sense of propriety make them excellent witnesses of their time.

Desportes* painted still-lifes which showed the quietness, sensitivity and realism which will be found again years later in the work of Millet.

Flemish Baroque

Rubens, Painter of Peace

Peace is a force. It is life against death, love against estrangement, the exaltation of happiness in defiance of suffering, the freeing of movement from the bonds of matter and the restrictions of the body. Peace is the supreme dignity. Rubens always longed to believe in peace. His brightest and most cheerful colours were set on canvas at moments when life passed before him in a sombre trail of mourning, malady and strife.

Baroque in his pictorial expression, Rubens was even more Baroque in his mental attitude, in his emotions and his general behaviour. He was deeply religious, mingling Nature and Divine Providence in the same act of worship. His providence could not make mistakes, it could only feel. Poussin learnt his stoicism through a study of antiquity, but Rubens learnt his by seeing the visible world through the illumination of religion. In this way he invented a Christian pantheism for himself.

87

Even a scene like the *Battle of the Amazons* is really only a fight for the sake of pleasure, a hymn to victorious peace. The beggar-women Rubens sets alongside St Bavo are all queens in rags, naked and bare to the winds of heaven; *The Fall of Icarus* is the victory of air over matter.

From the sombre hues of his early years to the stronger shades of his middle-age, ending with the insubstantiality of his maturity, Rubens saw the universal peace he sought grow clear and bright on his easel. The Academy saw colour as something to please the eye, but for Rubens it was a means to an end. Through colour all formal arrangements were possible. It was therefore the basis of all composition.

Rubens' use of colour is a marvellous riot—but is riot the right word? Few painters limited their range of colour as skilfully as Rubens. Pearly flesh, some browns, a few spots of red, a splash of clear blue. Pure colour, this is the secret of his economy; the impressionistic juxtaposition of pure colour spins out the range of half-tones to infinity; and finally, the use of complementary colours. Colour as a means of drawing; instead of classic black shadows, Rubens uses reddish and violet shadows which in turn create other forms by a series of transitions so subtle that they fade to invisibility.

In May 1600, at the age of twenty-three, Rubens, who had been painting for nine years already, felt sufficiently developed—but for what? Did he go to Italy to make

money or to improve himself still further? His biographers are divided on this subject, but it is not one of great importance. Naturally he had to earn enough money to live on, but at the same time, it was vital for him to see and study the paintings of the great masters of European art. Whatever the reason, he went off to Italy with Deodati del Monte, his first pupil. Influences play curious roles. Possibly because like Mantegna he had been his predecessor in the service of the Gonzaga family, the Dukes of Mantua, it was the cold and pompous Giulio Romano who most impressed the young Flemish painter.

Fortunately he demanded more than this. Once in Rome, the works of the Carracci and their pupils (Annibale was working on the Galeria Farnese at the time) led him to discover Michelangelo and Raphael. Before finding the secret of Titian, whose destiny it was to open to Rubens an infinity of inner horizons, he saw Venetian colouring in the paintings of Tintoretto and Veronese. But his eagerness to please led him to imitate all these artists one after the other—or, in other words, he completed his artistic education.

It was between 1604 and 1606, in the course of several visits to Genoa, that the first unmistakable signs of his individual genius were shown. He painted a series of portraits in which he broke with Renaissance tradition by depicting the great lords and ladies of Genoa on foot. A very low horizon in the background stressed the dominant position of these sumptuous figures. Some years later Van Dyck, too, passed some time in Genoa and he also painted some of his finest portraits there. Some of them, in fact, cannot be attributed to either painter with any certainty.

Back in Antwerp, Rubens continued with his careful eclecticism for a few years more. He had no wish to frighten away his new clientèle and had no hesitation in abandoning his Italian manner to adopt a style more like Janssens or else to collaborate with his senior Brueghel de Velours*, whom he admired and always was to admire.

It was, however, between 1618 and 1623, a period when commissions flowed in, that Rubens perfected his Baroque style. He married his first wife Isabella in 1609; in 1611 he was able to write that he had had to turn down over a hundred young artists eager to work in his studio. His assistants from now on were carefully selected and quite numerous. The part they played in Rubens' huge output has possibly been exaggerated. It is true that Rubens, like every other painter of the time, saw no harm in using assistants, but even though he allowed one of his pupils (two of whom were Van Dyck and Snyders*) to paint a landscape, an animal or a figure, it was always Rubens himself who saw to the final finishing of the picture and imparted his inimitable style to it—a style indeed inimitable, for it is extremely easy to distinguish between products of the school of Rubens and ones which he had personally supervised. Large numbers of canvases, enormous panels or sketches hastily completed represent an equal number of masterpieces executed by his hand alone. In 1622, when he accepted a commission to paint a series of pictures showing the life of Marie de' Medici for a gallery in the Luxembourg, he undertook to paint the main figures personally. When the twenty-one pictures were installed in Paris in 1625, he was accompanied by a pupil, but it was he

alone who finished the paintings—twenty-one examples of a superb and original talent. In the contract he signed on 29 March 1620 with the Antwerp Jesuits for the decoration of the ceilings and altars of the church of Saint-Charles Borromeo, it was arranged that thirty-nine paintings on selected subjects should be finished before the end of the year. All the preliminary sketches had to be done by him alone. The ceiling pictures could, if necessary, be painted by Van Dyck or some other of Rubens' pupils. The pictures for the high altar and one of the side altars had to be the personal work of Rubens, though another altar picture was to be the work of Van Dyck. Finally, Rubens was to paint four altar-pieces for the church. The ceiling was destroyed by fire in 1718, so we have no way of knowing how much collaboration he had for this part of the work.

Paintings like the *Great Last Judgement* and the *Little Last Judgement* bear outstanding witness to his vitality. There is no longer any question of any sort of influence on him, for his style by this time was completely formed. Only Titian's work could make any contribution. The Italian artist's style was in fact itself engaged in the way Rubens' work was heading. The *Fall of the Damned* demonstrates magnificently a verve which is in no way muted by the gravity of the subject-matter. The great stream of damned which rushes towards hell is above all a stream of life. It seems to create a vital current between the Kingdom of God and the Kingdom of the Devil.

The Rape of the Daughters of Leucippus offers a more peaceful version of the wild Baroque spirit found in *The Battle of the Amazons*. Its composition is so natural, the triple opposition of horses, descending Dioscuri and the fair bodies of Hilaeira and Phoebe is so harmoniously balanced that the rape seems more of a joyful revel than an attack. A painting like *The Last Communion of St Francis of Assisi* offers an equally perfect vision of the astonishing maturity achieved by Rubens. It is a marvellous symphony of shimmering browns composed and dedicated to deep and mysterious thought. In the Luxembourg paintings the richness of allegory transformed the dull Marie de' Medici into a queen of legend. The sparkling beauty of the sea-nymphs who welcome her at the port of Marseilles cast their glow for all time on to that dismal queen who was turned by Malherbe's rhetoric into " the wonder of the world " and " the queen of heaven ".

If Rubens' diplomatic missions did nothing to change the face of Europe, they did at least bring a new depth to his work by allowing him to copy the Titians in Madrid during his visit to Spain in 1627 and 1628. Marco Boschini, an Italian writer of the 17th century, noted the comments of Joost Susterman *, a Flemish painter who was a friend of Rubens, and these show how much Rubens admired the great Venetian painter: " Rubens was as much preoccupied with Titian as a lady full of passion for her lover. In Flanders, he and I were very close friends; I went to see him a great deal and when we talked of Titian, he said such amazing things. He would say in all sincerity—without passion, but with great conviction—that Titian was the spirit of painting and the greatest master that had ever been."

His diplomatic undertakings brought little benefit in so far as international relations were concerned, but they were extremely useful for him as an artist. In the

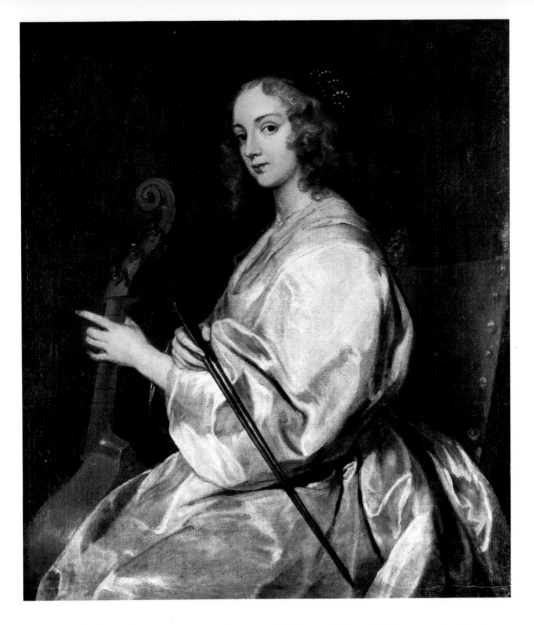

hope of bringing about a peace settlement which would establish a new link between Flanders and the United Provinces, Rubens worked at improving matters between England and Spain. In London, Charles I had received him with flattering attention, though this did not bring the end of the war. Worn out and disappointed, all that Rubens wanted when he was back in Antwerp was to be released from his diplomatic duties. " I obtained this favour with greater difficulty than I ever had before ", he wrote.

Fortunately his vitality was so great that far from sinking into a deep widower's melancholy he started a new life for himself. In spite of his age (he was now fifty-three), he married a young girl of sixteen, Hélène Fourment, who seemed to incarnate for him all the voluptuous and tender goddesses he had set in his paintings.

Her picture and the portraits of the children she bore him soon appeared in his paintings. His art had grown calmer over the last few years. Landscapes like *The Watering Place* or *Landscape with a Shepherd* invite silent meditation. But the deeply passionate love Rubens felt for his young wife brought new life to his old world of melancholy. Hélène appears in all his paintings—a classical goddess, a Virgin, a saint— and in that marvellous portrait *Hélène Fourment in a Fur Cloak* where she is half-naked

91

in a furred velvet cloak, on her way to the bath. This open demonstration of love—which at the same time serves as an act of homage to Titian who painted a similar picture—hung in his bedroom till the day he died.

In 1634 he bought the Castle of Steen which gave him the theme for some of his finest landscapes. *Landscape with a Rainbow* and *Sunset* prepared the way for *The Garden of Love*, which is the epitome of Baroque art. Hélène, their children, lords and ladies, a superb architectural background set in a park which is a little like that of Steen —this is Rubens' garden of happiness and offers a vision of the peace he sought above all things.

In spite of his "gout", which is in fact more likely to have been particularly painful rheumatism, Rubens ended his career in a burst of painting filled with ecstatic joy and happiness. Never did he manage to paint so swiftly. Never did his brush pass more nimbly over the canvas, each stroke indicating a shape, a movement. Never did such gladness pass from heart to fingertips. From *The Feast of Venus* (Vienna Museum) to the *Nymphs and Satyrs* in the Prado and the glowing *Kermesse* in the Louvre, it was love which he painted, the freedom which love brought with it—perhaps freedom itself. A freedom conquered only by death.

Anthony Van Dyck

For the last twenty years, Van Dyck has been fighting his way not out of purgatory but out of a sort of lesser paradise where he had been locked away by admirers of Rubens. He had been judged a mere follower, an imitator, a fashionable painter and nothing more. Today, this tendency has been reversed. Rubens' famous "negro heads" are now thought to be by Van Dyck and so are the paintings on the life of Decius Mus. One should, of course, beware of such startling rehabilitations—and the involved process of re-attributing pictures has made a fool of experts too many times for one to accept new information without a little initial reserve.

In any case, Van Dyck's talent has no need of support from hypothetical catalogues of paintings. The *Head of an Old Man* which he painted at the age of fourteen is sufficient proof that he was to be a great artist, and this was confirmed a few years later by *The Continence of Scipio* (Oxford) in which the influence of Rubens can hardly be discerned at all. With a masterly touch he used a diagonal composition for his *Rinaldo and Armida* (Louvre). In his religious paintings from the period 1627-32 a proper unity is lacking, however. Their elegance is somehow insubstantial and occasionally seems affected. Unlike Rubens, Van Dyck never achieved a pictorial lyricism—he was never carried away by his emotional responses.

Fortunately, just before this Antwerp period, Van Dyck spent five years in Genoa (from 1622 to 1627), a moment in his career critics tend to forget, but one which may have been his finest as a portrait painter. Could it be that the ostentatious yet mean splendour of the great commercial and republican ruling class of Genoa first awakened the true genius of Van Dyck? What is certain is that the fifty-odd pictures he painted

there set him at once in the front rank of great modern painters. He met Italian arrogance with Flemish exuberance; he offered the inhibited members of a closed social class the mirror of a psychology which enfolded truth in its stylisation, which prevailed on its sitters without either offending them or betraying them.

It is still possible to see some of these portraits in their original positions—and all portraits should indeed be seen this way: in the famous Palazzo Rosso hang *The Marchese and Marchesa Brignole-Sale* and *Anton Brignole-Sale*. *The Blue Child* is in the Palazzo Doria and *Paolo Adorno*, too, is still in Genoa, but most of these marvellous pictures have gone to American museums. Like Rubens in his Genoese portraits, Van Dyck uses the same low horizon line which stresses the height of his characters and clothes them in majestic dignity. He moves from the softness of the human hand to the bold architecture of costume with a remarkable sobriety of means. The delicacy of expression, brilliance of jewels, transparency of lace are for him only a subtle commentary, sometimes with a spice of humour, on these stately ships of majesty at anchor in their home port.

In England, the commentary, a sort of witty counterpoint, is sometimes more important than the composition, but this never suffers unduly. Some of its geometrical austerity is sacrificed for the sake of genuine shrewdness. The famous *Portrait of Charles I* is the crowning achievement of this period. It has every possible charm and possibly a premonition of melancholy as well. Van Dyck certainly had no idea that this gentle king would lose his head, but he knew that elegance—real elegance—is always the court dress of deep sadness.

Jacob Jordaens

Jordaens painted fertility with unceasing enthusiasm. His was the hearty salacious fertility of those drinking bouts which end in an embrace, the fertility of a painter in love with painting, who brings forth pictures with a short-lived but nonetheless enjoyable pleasure. Jordaens* was a sturdy bourgeois character. The passionate tenderness of Rubens was completely foreign to him. The veiled irony of Van Dyck must have irritated him. He knew that colour and colour alone was truth, and so were the brush and the canvas. The model was only a means to an end—painting.

Before he came under the influence of Rubens, he was affected by Bassano and Caravaggio. His religious paintings—*The Adoration of the Shepherds* and *The Triumph of the Eucharist*—are as convincing, or as unconvincing, as his great drunken bawds.

If he had not been so dedicated a painter, Jordaens might have been one of the great decorators like Le Brun. He lacked the dignity which arises from a feeling of transcendent authority. Towards the end of his life he became a Protestant. He had the same wilful blindness as an artisan. Linseed oil and turpentine were his ambrosia. Trapped like a bird in lime in the soft paints of his palette, all he could do was pile up his pictures on his shoulders like Atlas carrying the world, or, more accurately, like an ordinary market porter. "Satyrs", "Peasants", "The king drinking", the themes

93

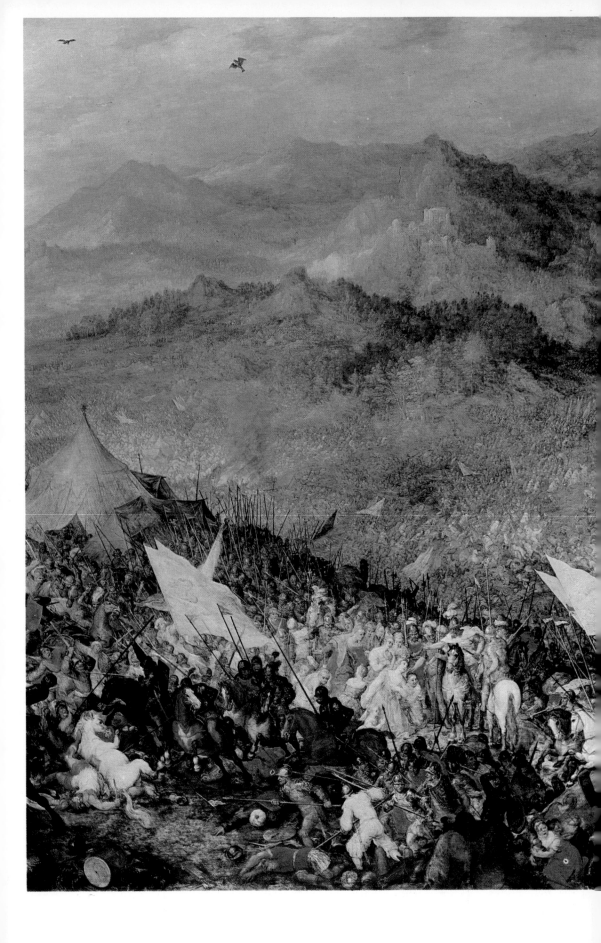

are banal and vulgar but this does not matter so long as they provide a pretext for painting of an edible nature. This song of praise to gluttony is a hymn to reality, a reality which for this painter was painting itself.

Jan Brueghel I—Velvet Brueghel

Rubens adored Brueghel. He liked him as a man, he bought any number of his paintings and was proud to paint some pictures in collaboration with the artist in his old age. Jan specialised in reality with a touch of the marvellous and was not really very far removed from the art of his father, a painter of reality with a touch of the absurd. They started from the same premise, their technique was equally perfect; the difference lies in the way they looked at things. Jan's battles are bunches of flowers: his bunches of flowers are landscapes. The whole of his work distils a charm—it is an earthly paradise which Rubens (God before the Fall) peopled with creatures of his own devising.

Frans Snyders, Paul de Vos and Jean Fyt

The high degree of specialisation found in Flemish painting has something slightly dull about it, but in itself it offered no obstacle to the development of strong, personal styles. Frans Snyders, who restricted himself to hunting scenes and vast still-lifes where fruit, game and foodstuffs lay heaped in artistic harmony, went far beyond mere decoration. His taste is sure and firm and it is well served by great skill in performance and freedom of composition. There is nothing vulgar or affected in his tumbling falls of grapes and feathers, his wildly leaping hounds and dying stags and does. He moves effortlessly from the shimmering effects of his *Concert of Birds* to the dramatic *Fight between a Swan and a Dog*. Ch. R. Bordier thought that quite a few works usually attributed to Rubens were probably by Snyders and it is certain that he did collaborate with Rubens. He was much involved in the *Prometheus unchained* (Philadelphia) and *Pythagoras* (Buckingham Palace, London). He owned sixteen paintings by Rubens.

Paul de Vos* never achieved the same lavish displays as Snyders, but his still-life paintings have breadth and colours. His hunting scenes are filled with life and movement. Jan Fyt*, a pupil of Snyders, worked in Paris, Venice and Rome before returning to Antwerp. His compositions are more unbalanced than Snyders'. By the same token, they are on a larger scale, compelling attention by their great flood of objects and colours. His hunting scenes have a violence and cruelty which on occasion are curiously shocking.

From Still-life to Bunches of Flowers

Clara Peeters* painted her first still-life at the age of fourteen: fruit and shrimps. Nothing more exotic than a cat, nothing more mysterious than a fish ever appeared in the tiny, exquisite paintings from the brush of an artist who can truthfully be called " the

Spirit of the Home". Jacques van Hulsdonk*, Isaac Soreau*, Ambrosius Bosschaert* the Elder showed in their versions of fruit and everyday objects all the skill of intense myopia obsessed with precision.

This minutely detailed skill did not soften and start to glow till the appearance of Adriaen van Utrecht*. It was, however, with a Flemish artist—Abraham Ryngraaf* known as Brueghel—that a new concept of the still-life appeared. The opulence of his fruit, the freshness of his flowers burst into splendid life in the open air. What could be more superbly artificial than these products of nature theatrically displayed in natural surroundings? Abraham Bosschaert* also painted sprays of flowers with the same attention to detail.

Landscape Artists and Genre Painters

Joos de Momper*, in spite of a technique of considerable competence, produced landscapes which seem to draw their poetry from scene-like arrangements. The foreground looms over a vast plain which disappears into a distant horizon lost in a faint blue haze. In Roelant Savery*, the countryside opens out and takes on the dimensions of a dream-world.

David Teniers II, known primarily as a genre painter, was originally a landscape artist of outstanding talent. Subtle back-lighting, cloud effects in the Dutch manner alternate with and sometimes replace the subtle light of a landscape from which every trace of "the picturesque" has disappeared. His colours grew gradually more and more simple and some of his works achieved a sense of poetry which gave a foretaste of Corot. On the other hand, his interiors and inn-scenes never got near the truculent spirit of Adriaen Brouwer*. Sebastian Vrancx* knew how to paint open-air scenes and specialised in battles. Joos van Craesbeeck*, Gillis van Tilborch and David Ryckart never achieved more than routine repetition of scenes of general jollity in a style which grew ever more stereotyped.

The Portrait Painters

Louis Primo never got beyond a somewhat superficial skill full of brio, but his portraits were always elegant, even if rather stereotyped. He settled in Rome where he specialised in soldiers and ecclesiastics, generally posing against pilasters with foregrounds packed with personal allusions, usually battle trophies. The painter most in fashion in Antwerp was Cornelius de Vos*. He had the gift of disposing families in pleasing groups, but without flattering his proud clientèle over-generously. However, his work shows a certain chill unless he is actually painting children. Gonzales Coques* specialised in small-scale work. His greatest successes lay in elegant, glowing portraits—all admirable but instantly forgettable. Pieter Meert*, Jacques van Oost I—one should not miss his unusual *Young Boy with a Muff*—the Franchoys* brothers and Victor Boucquet* practised successfully in the principal towns of Flanders an art which was quite indispensable to a society eager to gaze admiringly at its own image on its drawing-room walls.

Evidence and Documents

Fundamental Principles

The fundamental principle which forms the basis of the art of the Italian Renaissance is that of perfect proportion. In architecture as in statuary, this period tried to give form to the idea of static perfection. Each form tends to constitute a reality which is closed and free in its articulations: more than this, each part has an independent existence. The mind, conscious of a sensation of infinite well-being, sees in this art the image of a higher, freer reality, but one in which it is able to participate.

The *Baroque* uses the same system of forms; only instead of seeking total perfection, it seeks movement and change; instead of what is restricted and tangible, it seeks the unrestricted and immense. The ideal of beauty of proportion disappears; what counts is not what *is*, but what is in process of change. The mass begins to move, a mass only vaguely defined.

...It is clear that Italian Baroque art gives expression to a new ideal of life.

The relationship of the individual to the universe is thereby transformed, a new world of sensation is opened, the soul abandons itself to a feeling of boundless infinity. *Emotion and movement at any price*, this concise formula was chosen by J. Burckhardt to characterise Baroque in his *Cicerone*.

...The Baroque represents neither the decline nor the perfection of Classical art because it is by its very origins of totally different character.

...The development of art...(from the 16th century to 17th century Baroque)... can with the possibility of error be provisionally reduced to five pairs of contrasts:

1. *The transition from the "linear" to the "painterly"*, that is from the consideration of the line as a guide for the eye to the growing devaluation of the line.

In the first place, the aim is to contain distinct corporeal features and give them a stable, tangible reality; in the second place (i.e., in the Baroque) the aim is the production of what is seen as a whole, "a form that takes flight".

2. *The transition from presentation by planes to presentation by depth.* Classical art arranges the different parts of a picture in parallel planes; but Baroque art leads the eye ever backwards. In Classical art, the development of line is linked with distinction between different planes, and juxtaposition on the same plane assures the greatest visibility. In the Baroque, the reduced importance of the line affects the plane similarly and the eye therefore relates things as it moves from foreground to background.

3. *The transition from closed form to open form.* It is true that a work of art should constitute a "closed" unity and the fact that a work is not complete in itself is always a proof of weakness. However, the interpretation of this definition changed considerably during the 16th and 17th centuries until the art of closed forms was taken to be the converse of Baroque art, which sought the dissolution of form in so far as it imposed boundaries on the artist. The relaxing of this rule, the breaking of the strict "tectonic" law do not signify merely that the artist is seeking for new means to charm the spectator; they constitute a new and absolutely consistent method of presentation

(or whatever term one likes to choose to describe this phenomenon), and for this reason the method must be counted amongst the fundamental categories.

4. *The transition from multiplicity to unity.* In the system of Classical art, each separate part demanded an independence even though it was still firmly a section of the whole.

The observer is able to apprehend the individuality of each item and the way it links itself to the others and this is in direct contrast to the total visual unity the 17th century sought to impose on its creations. In both styles, there is of course a true unity, but in one case it is attained by the harmonising of parts which remain independent and in the other case by the convergence of the different parts on to *one* motif, or by the subordinating of all elements to one particular element which is not in fact deliberately dominant.

5. *Absolute clarity as opposed to relative clarity—or even obscurity.* This contrast is related to the opposition of the linear and the non-linear: on one side, there is the representation of things as they are, apparently ready to be touched; on the other side, the representation of things as they seem to be, considered in their general effect or rather in their non-plastic quality. What is remarkable is that the Classical period formed an ideal of absolute clarity which the 15th century had barely suspected and which the 17th century deliberately abandoned. I do not wish to indicate that works of art become obscure, which has a bad effect on the spectator, but that the clarity of the motif ceases to be the principal aim of representation; it is no longer necessary to offer the totality of the form to the eye of the beholder, the basic details are all that are needed. Composition, colour and light no longer have the prime function of acting as supports to form, they have an existence of their own. Doubtless there are many instances where the partial weakening of this absolute clarity has been used simply to please the eye, but it is still true that this question of "lesser clarity" as a characteristic of all kinds of representation appeared at a moment in the history of art when what was especially sought was reality in appearances of quite another kind. This does not necessarily indicate a difference of quality. When Baroque moved away from the ideals of Dürer and Raphael, it moved towards a completely new concept of the world.

For the first time, the non-linear or "painterly" style reveals the world as *something seen* and for this reason it has been called "illusionism".

Heinrich Wölfflin
Kunstgeschichtliche Grundbegriffe
1915

The Cosmic Meaning of the Baroque

The further we go in our knowledge of the history of culture, the more this truth becomes apparent: that pantheism is not just one school of philosophy amongst many others, but instead it is a sort of common denominator, a generic basis towards which the mind glides as soon as it abandons the difficult and always precarious positions of rigorous discrimination, pluralism and preference for discontinuity and rationality.

...The Baroque has a cosmic meaning, clearly demonstrated by the fact that it always has a predilection for landscape. For landscape and folklore.

We have frequently compared the relations between the Classical and the Baroque in culture as a whole with the relations in the realm of language between what philologists call "a language" and what they term "dialects". The primary substance of a language, of any language, is dialectal. Just as dialects are *natural idioms*, so the Baroque is the *natural idiom* of culture, the idiom by which culture imitates the processes of nature.

There is always something rural or peasant-like in the structure of the Baroque. Pan, god of the fields, god of nature, presides over every authentic Baroque work.

...The relations between the Baroque *aeon* and the Classical *aeon* are nothing more than one single chapter—or possibly a corollary—in the question of the relations between reason and life itself.

...Classicism is to Baroque what reason is to perception, the enzyme to the foodstuff. Or, in other words: the *aeon* of Classicism is a look; the *aeon* of the Baroque is a matrix. Without a matrix, there is no fecundity; but without a look, there is no nobility. And for a culture to gather its wealth of looks and ideas it must germinate in the rich darkness of impulses and matrices. Germinate there and, from time to time, go back there.

...The Gothic is an "historical style" and nothing else; Baroque, on the other hand, is a "cultural style" and this is seen more clearly as time goes on. The proof of this? The first is restricted to fixed intellectual achievements—there is no "Gothic prose", for instance, but there is indeed "Baroque prose" and "Baroque behaviour" (bull fighting, for instance).

And even more conclusive proof? Gothic is a style written in the past, a dead style. If it were to be revived, it would be simply a matter of restoration, by means of plagiarism or imitation: every Viollet-le-Duc that ever lived knows about this, however clever they were. On the other hand, Baroque style can easily come to life again and can translate the same inspiration by still newer forms without falling into the necessity of literal copying.

<div align="right">

Eugenio d'Ors
On Baroque Art

</div>

Genre : barocchus

Species

Baroque pristinus
Baroque archaicus
Baroque macedonicus
Baroque alexandrinus
Baroque romanus
Baroque nordicus (Northern Europe)
Baroque palladianus (Italy, England)
Baroque rupestris
Baroque Maniera
Baroque tridentinus, sive romanus
Baroque sive jesuiticus

Baroque buddhicus
Baroque gothicus
Baroque franciscanus
Baroque mannelinus (Portugal)
Baroque orificenis (Spain)
Baroque " Rococo " (France, Austria)
Baroque romanticus
Baroque finisecularis
Baroque posteabellicus
Baroque vulgaris
Baroque officinalis

Eugenio d'Ors

Religious Art

Seventeenth-century religious art seems to move far back beyond the Renaissance to join the art of pathos as found in the last centuries of the Middle Ages. In this way the Church left the old legends behind and quietly, peacefully transformed Christian art. This church of the Counter-Reformation, ardent, passionate, too well acquainted with anguish, struggle and martyrdom, this church of the new saints, the great ecstatics, fashioned art in its image.

 . . . The single figures of St Ignatius have this ecstatic appearance almost always. At Manresa, the Jesuits decorated the grotto where their order was born and the sanctuary where their founder had experienced his long ecstasies; a statue on the floor slabs of the chapel of the Holy Ecstasy shows St Ignatius, eyes closed, hand on heart, *the soul out of this world*. In Rome, the silver-clad statue in the Gesù, the statue of St Apollinaris, the statue of St Peter are typical of the saint with his eyes raised to Heaven, contemplating some apparition. There is, however, nothing comparable to the figure of St Ignatius which Baciccia painted on the ceiling of the Gesù just above his altar. He chose the moment when the saint passed into the realms of eternity; above him opens a great world of light; his head thrown back, dazzled by splendour, the great fighter for Christ at last comes into possession of his dream; he seems wild with joy, enraptured by a spectacle a thousand times more beautiful than he had ever dreamed.

 . . . Of course, this iconography was by no means simple. Studying it closely, I saw that it enfolded within itself two distinct forces: the tradition of the past and the

spirit of the new present. In some pictures, I rediscovered the Middle Ages; in others, the spirit of the Counter-Reformation. Curiously enough, the same artist could sometimes be a man looking backwards and sometimes a man of his time. Just as the iconography of the High Middle Ages shows two distinct trends, one Hellenistic and the other Syrian, so the art of the 18th century reveals the inspiration of both the past and the present.

Conclusion

Born at a time when the reformed church stood ready to shed its blood and conquer both the Old World and the New World with its ardent faith, this art shared its enthusiasm: it praised martyrdom and set the Christian face to face with death to teach him not to fear it. But at the same time, it opened Heaven before him. The great saints of the 16th century, possibly the most passionate the Church has ever known, seem to have lived right on the outer limits of our world: sometimes they crossed them to join themselves with God. Ecstasy seemed to be not only the reward granted in return for their love, it was also the proof of their mission; heresy never came near to Christ, never saw the light of his countenance, never heard his voice. Ecstasy was the crowning experience of Christian life and the supreme effort of art. It sought to impart to ecstasy its highest achievements, all its magic of light and shade. Religious art had never before tried to do this: like the saints, art tried to attain furthest limits. The art of the Counter-Reformation contributed something to the means of expression available to Christian art. It gave it chords which no one had ever heard before.

Emile Mâle
L'Art religieux après le Concile de Trente
Armand Colin, Paris 1932

Caravaggio

In Rome, there is a certain Michelangelo Caravaggio who does truly marvellous things. . . . His maxim is: if what is drawn and painted is not taken from truth, then it is childish nonsense. . . . For him, nothing is better or finer than following nature.

Caravaggio is not a steady worker. When he has worked for a fortnight, he spends the next month enjoying himself. A sword at his hip and a page at his back, he goes from one place to another, always spoiling for a fight; it is truly not very pleasant to keep him company. . . . This is hardly in keeping with our profession of artist: Mars and Minerva have never been good friends!

Carel van Mander
The Book of Painting
1604

He started painting the way he thought with no word of praise or even a glance for the marvellous marbles of antiquity or the famous paintings of Raphael.

Giovanni Pietro Bellori
Le Vite
Rome 1672

N. Poussin could not bear Caravaggio and used to say that he had been born to destroy painting.

André Félibien
Vie de Nicolas Poussin, suivie de lettres de Nicolas Poussin
R. and J. Wittmann, Paris 1945

About the Messina *Nativity:*
The "tenebroso", which in Raphael's paintings is emotion and inspiration, is all method and procedure in Caravaggio's.... This statement arises from criticisms made in the past and repeated over and over again without any attempt to test their truth or otherwise.... Caravaggio's paintings are every bit as true in feeling as Raphael's.... Rembrandt is Caravaggio's true heir.

Sacca
Archivio storico Messinese
1906

The Carracci

They say that one day they were all three together in a place where they could be neither seen nor heard: " I hope to God ", said Agostino to Lodovico, " that we make no mistake in pursuing this style of painting which is true to nature; nobody shares our opinion at all and the path the rest are following is the one which brought such praise to Vasari, Zuccheri and Salviati. If Correggio, Titan, Tibaldi and Paul Veronese went another way, then it was because they were following the inclination of their character; but we are only copying them—and how many things which are admirable in those who do them naturally become unbearable in those who do them in imitation...! "

He spoke in the same vein for some time and abandoned himself to a fit of melancholy which allowed him to see only faults in their ways and insurmountable obstacles to be conquered.

"I do not know as much as you," replied Lodovico, "I cannot argue like you who have seen so much; but a certain natural inspiration tells me that we are doing exactly what we should do. If only one of us pursued this path, then perhaps that one

103

might be mistaken; but I cannot in truth believe that all three of us can be equally wrong in our convictions. We are criticised for the number of nude figures we paint; indeed, if I had not seen the Roman school praise the great Michelangelo's *Last Judgement* over and over again for naked figures of exactly the same kind and in even greater numbers, and if Raphael had not used them so successfully in the Palazzo Chigi and elsewhere as we have seen from prints and drawings, then I would indeed acknowledge defeat; but let us not forget that even our enemies, so eager to blame us for putting these figures in our paintings, are filled with pride and pleasure when they find a way of getting one into their own pictures.

"As for their colours and their finicking ways, let them say what they like; the painters from Lombardy will always come out best."

Annibale, who rarely said anything and who until now had done no more than listen and nod from time to time, called excitedly:

"Then let us carry on in the same way and stop worrying. If the way we paint pleases no one now, then it will surely please later. Poor Baldasare di Siena was unknown and unappreciated till after his death. Columbus was judged an idiot when he said he would discover a new world; and when Brunelleschi told the Florentines that he would give a dome with a double shell to Santa Maria dei Fiori, in spite of all his arguments, they sent him packing and said he was mad. If they praise Correggio and Titian so much —and, after all, they stand as high in esteem as Raphael—why should we too not please at some time, we who follow the path all three have trod?"

<div style="text-align:right">

Stendhal

Ecoles italiennes de Peinture
Le Divan, Paris 1932

</div>

Nicolas Poussin

Like Ingres at a later date, Poussin could have said: "My works acknowledge no disciplines beyond those of the ancients, of the great masters of that century of glorious memory in which Raphael gave sublime art its eternal and undeniable boundaries. I think I have proved in my paintings that my only ambition is to be like them and to take art further along the path that they have started."

<div style="text-align:right">

André Gide

"Poussin", in his *Journal*
© Gallimard 1948
Bibliothèque de la Pléiade

</div>

Delacroix considered Poussin "one of the boldest innovators in the history of painting"; "Poussin appeared in the middle of the Mannerist schools in which the act of painting was more highly esteemed than the intellect behind it. He broke with all this falseness.

Unlike other painters—not excluding even the greatest—he never allowed himself to be carried away by his gifts, never gave them full rein."

Eugène Delacroix

" Essai sur Poussin "
Moniteur, June-July 1853

Yes, Poussin imitated—and so did La Fontaine, and Racine and Molière; and nowadays, so do Péguy and Claudel and Valéry. And this is something which must be said at a time like today when nothing more discredits an artist than saying he looks like someone else.... It was because he retained and restored existing traditions when they were going astray that Delacroix thought Poussin a healthy revolutionary.

André Gide

" Poussin ", in his *Journal*
© Gallimard 1948
Bibliothèque de la Pléiade

Domenichino, the only living painter that Poussin did not despise and would consent to hear, would say to his pupils: " No painter's hand should produce a line which he has not already painted in his mind."

André Gide

" Poussin ", in his *Journal*
© Gallimard 1948
Bibliothèque de la Pléiade

Poussin was a Norman, Claude from Lorraine. One was a great reader, the other could barely read a word and could only just write his name. The one a man of order, a steady mind, meditative, slightly doctrinaire, given to intellectual generalisations and plastic abstractions, pursuing in the world the invisible plan he unfolded in his head, always master of his view of the universe, regular features, grave and strong, carved in a monumental fashion. The other a man with a rugged face, all irregular, clumsy and awkward, hastening to the dawn and the twilight like a thirsty animal to water, soaring high above hard work and a confused inspiration by a continuous lyric exaltation, able to cross without apparent effort the threshold of those higher harmonies where intuition and harmony fall into close communion.... But both in love with rhythm and proportion, both living at a time when the need for method and style reacted violently against the political and intellectual ferment which had snatched the 16th century out of medievalism, both eager to find in Italy the discipline offered by those masters who had already cast off the bonds of ancient servitudes.

Elie Faure

Histoire de l'Art
Jean-Jacques Pauvert, Paris 1964

Letters from Nicolas Poussin

To Cassiano del Pozzo (20 September 1641)
No one here studies or even observes the works of Classical antiquity or any other and anyone who wants to study or to do well should certainly keep away.

To Chantelou (from Paris, 20 March 1642)
The pretty girls you will have seen in Nîmes would not have pleased you more, I am certain, than the fair columns of the Maison Carrée, since the latter are only old copies of the former.

To Cassiano del Pozzo (from Paris, 4 April 1642)
...But the talents these gentlemen have found in me are the reason why I have no time either to please myself or to serve either friend or master, employed as I am with no respite on bits and pieces of nonsense-like designs for frontispieces for a book, designs for decorating cabinets and chimneypieces, book-bindings and other follies.

...He wanted me to paint a picture for the chapel of the Jesuit Fathers, but when I looked at the place where it was to go, I saw that the light was so poor and so sparse that I could do nothing really worthwhile.

To Chantelou (from Paris, 7 April 1642)
...Monsieur, I never really knew what the king wanted me to do and I genuinely believe that no one had ever told him what in fact I *could* do.

To Chantelou (from Rome, 24 November 1647)
...The good old Greeks who invented everything that is beautiful found a variety of modes by means of which they produced the most marvellous effects.

The word "mode" really means the method or the size and form we use to do or make something, which obliges us to stay within certain limits, makes us function with a certain competency and moderation and consequently such competency and moderation are really only a particular manner or fixed and definite order, within the process by which the thing is maintained as it really is.

Since the modes of the Ancients were a composition of several things put together, from their variety was born a certain difference of mode by means of which each of them kept in itself something slightly different, mainly when the things which formed the composition were put together proportionately, which in turn led the people who looked at them to experience various different feelings. From this arises the fact that the ancients attributed particular effects to particular modes. Therefore they thought the Doric mode was steady, grave and serious and used it for matters which were grave, serious and full of wisdom.

When they went on to pleasing and happy subjects, they used the Phrygian mode because its modulations were slighter than any other mode and its appearance

somewhat sharper. These two manners were praised and approved by Plato and Aristotle who judged the others of no value and who considered this mode vehement, full of fury, very severe and filling people with astonishment.

To M. de Chambray (1 March 1665, in Rome)
... Definition
It is an imitation made in lines and colours spread over a surface of all that can be seen beneath the sun; its aim is enjoyment.

Principles which any man capable of reason can learn.
Nothing can be seen without light.
Nothing can be seen without a transparent medium.
Nothing can be seen without fixed limits.
Nothing can be seen without colour.
Nothing can be seen without distance.
Nothing can be seen without tools.
What follows cannot be learnt.
They are the painter's essentials.
But first of all, the matter:
It must be noble and untouched by any quality natural to a labourer. To give the painter the opportunity to show his talent and skill, the matter should be capable of being given the most excellent form. Begin with arrangement, then proceed to ornament, decoration, beauty, grace, liveliness, costume, verisimilitude and judgement in every part. These last features are part of the painter's natural gifts and cannot be learnt. They are Virgil's Golden Bough which no man can find or pluck if he is not led there by Fate.

<div align="right">

Letters of N. Poussin
© Gallimard 1945

</div>

Rubens

Rubens had little need of advice from his two masters, the Italian-orientated Otto Vaenius and the Flemish Van Noort, to help him discover the inevitability of his destiny which he was to fulfil with a peerless generosity and a regal abundance, thanks to the eight years spent in Italy in close communication with the giant achievements of Tintoretto and Michelangelo, and to the constant voyages to Spain, France and England, the seven languages he spoke, the splendid life he led and the happiness he knew with his two beloved wives.

And what a life! He may well have been the only hero in human form able to unite the splendours of his external life to the splendid pictures he painted of it. He was helped in this by an aristocracy educated in artistic appreciation for the last 200 years, an aristocracy whose taste for high living fascinated him; this kept his moral health and his basic sensualism in a state of extraordinary equilibrium. In Flanders, he was like a king; he was his country's representative in the courts of kings. His great

dinners, his receptions, his fortune, his country houses, his luxurious living, his embassies—nothing could diminish him. He would never even admit any trace of unhappiness in his second marriage, at the age of fifty-three, with a girl of sixteen. His concern served to help him gather his strength and to hold out to the future the joy he could not ask from her and which she could not give him. He ended his triumphal existence by triumphing over the anguish he could not avoid feeling.

If one were to seek in this exceptional man only the highest expression of the Flemish character, which he joined to a universal nature, one would see only one aspect of his work, the one most accessible to the truth, but not the most essential.

Elie Faure
Histoire de l'Art
J.-J. Pauvert, Paris 1964

Georges de La Tour

Thirty years in the provinces, thirty years in Lunéville... nothing can explain La Tour to us, no influence, no chance conjunction of influences....

What is truly astonishing is that he managed to produce an art style which recalls Vermeer or Zurbarán. This proves that he expressed certain latent aspirations in contemporary art, that he followed paths parallel to those of the great European minds of his time. And seeing that he did this and at the same time retained his personal integrity, why should we not style him a real master? What do real masters do, if not find original expressions for the poetic anxieties which concern their period?

Charles Sterling
Exposition "Les Peintres de la Réalité
en France au XVIIe Siècle"

Charles Le Brun

Each gesture conceals a basic tension. For Le Brun's first reflex is impatience: only his will-power brought reason, charming good humour. As a young man, he never stopped protesting. Séguier had barely got him into Vouet's studio when he decided that they were giving him menial work to do and at the age of fifteen left the most illustrious master in Paris. He had been in Rome only six months when he felt that he had seen everything and learnt everything and wanted to return to France. If Fouquet dared to criticise any sketches for *The Rape of the Sabines*, " Le Brun flew into such a rage that he would gladly have left M. Fouquet and threw the torn-up drawing into a box he found on his way out."

Jacques Thuillier
Catalogue de l'Exposition Le Brun

When Bourdon, a friend of de Brosse, spoke sharply in front of the Academy, Le Brun made a crude reply and the assembled body were sad to see its two most illustrious members quarrelling coarsely.

<div align="center">

A. Testelin

Mémoires pour servir à l'Histoire de l'Académie royale de Peinture et de Sculpture

</div>

His pictures have rather more battles, blood and corpses than is quite usual in history paintings. His first works are really only martyrdoms and tortures.... What comes after is not much better. For the Hôtel Lambert, Le Sueur chose to do the Muses and love; Le Brun, Hercules and his battles.

Now *all this cruelty is not just theatrical rhetoric*.... It is odd that in Le Brun's work, from the *Diomedes* to the *Battles*, the old, old motif of aggression appears so frequently: jaws gaping, fangs threatening, the tearing bite.

How many people have noticed that in many of Le Brun's paintings no female presence appears to calm and pacify?

A curious feature: Le Brun does not paint women well. Almost alone of all the great French masters, he brought no new touch to the female face, no unthought-of tone to tenderness or delight.

Forcing an art limits its main methods: the more it frees itself from time, the more it longs to be complete in itself and the shorter the moment in which it reaches fulfilment—opera, ballet: short moments of perfection.

...Poussin transferred his solitary meditation on to a few inches of canvas: the work is available for all eternity. But *ceremony* demands such a concourse of honours and arts that its very echo disappears with promptitude. Le Brun had no hesitation in spending days brooding over the ephemeral décor to be set up in the oratory and which would have a meaning only for the brief moment of the funeral service. *Versailles only really existed* when the revels were in progress, when the lustres, the jewels, the solid silver vessels glimmered, when the flowers lay scattered far and wide, when the music echoed the gilding and the ceremonies answered the majesty of their setting. Empty, the Galerie des Glaces is silent: we can only guess at Le Brun's dreams and creations.

<div align="center">

Jacques Thuillier

Catalogue de l'Exposition Le Brun

</div>

Rubens

It has been said that he lacked nothing *apart from the purest and most noble instincts.* There are in fact a few intellects in the world of the Beautiful who have gone further, who have flown higher and who have as a result seen divine lights and eternal truths more closely. Similarly, in the moral world, in the world of emotions, visions and dreams there are depths which only Rembrandt has plumbed, where Rubens never went, nor

indeed ever dreamed of going. On the other hand, he took possession of the world like no-one else. All the pageant of life is his domain. His eye is the most marvellous prism that ever gave us light and the colour of things, ideas at once magnificent and true. Dramas, passions, the movements of the body, the expressions of the face; that is to say, man in his entirety in the various moments of the human act of being passed through his mind and during that journey take on stronger features, sturdier forms, grow fuller —they are not purified, but they are transfigured into something inexplicably heroic. Everywhere, he leaves the impress of his clear-cut personality, his warm blood, solid stature, the admirable equilibrium of his nerves, the magnificence of his day-to-day visions. He is uneven and out of proportion; he lacks taste when he draws, but never when he paints. He forgets himself, becomes slipshod; but from the first day to the last, he recovers from a mistake by means of a masterpiece. He makes good a lack of care, or gravity, or taste by an instant demonstration of self-respect, by an almost touching burst of hard work and by perfect taste.

<div style="text-align: right">

Eugène Fromentin
Les Maîtres d'autrefois
Librairie Floury, Paris 1941

</div>

Anthony van Dyck

There is always more sentimentality and often more deep feeling in the subtle Van Dyck than in the great Rubens; but is this absolutely true? It is a matter of nuance and temperament. All sons have—like Van Dyck—a feminine streak added to their father's characteristics. It is by this streak that the paternal trait is sometimes improved, made more beautiful, more tender and sometimes even is diminished. Between their two selves, by no means equal in stature, there is a sort of feminine influence; there is, as it were, a sex difference. Van Dyck lengthened figures which Rubens made too sturdy: he put in less musculature, less blood and less bone. He was less turbulent, never brutal; his expressions were less gross; he laughed little, but grew sentimental more often; he did not know the harsh sobs of violent men. He never raised his voice. He corrected much of his master's harshness; he took things easily because his talent was prodigiously natural and easy; he was free, alert but was never carried away.

Taken piece by piece, there are many things he drew better than his master, especially when his finest work is in question: an idle hand, a woman's wrist, a long finger wearing a ring. He is more controlled, more withdrawn; he seems better bred. He is more refined than his master because in fact his master trained himself and the sovereignty of rank discards and replaces a great many things.

<div style="text-align: right">

Eugène Fromentin
Les Maîtres d'autrefois
Librairie Floury, Paris 1941

</div>

Dates	Political events	Arts	Culture	Religion
1598	Edict of Nantes.	About 1598: Carracci: decoration of Palazzo Farnese, Rome, *Triumph of Galatea*.		
1600	Marriage of Henri IV and Marie de' Medici.	Birth of Claude Lorraine. 1600-1601: Caravaggio: *Crucifixion of St Peter; Conversion of St Paul*.	O. de Serres: *Théâtre d'Agriculture*. Reform of University of Paris. Malherbe's first *Odes*.	Giordano Bruno burnt for heresy.
1601				First French Carmel founded.
1602	Biron's conspiracy in France.	Birth of Philippe de Champaigne. Birth of Abraham Bosse. Death of Agostino Carracci.	Campanella: *The City of the Sun*. Shakespeare: *Hamlet*. Bayer: *Atlas of the Sky*.	St François de Sales in Paris.
1603	Jesuits back in France. Champlain in Canada.	Rubens: *Duke of Lerma*.		
1604	Spanish capture Ostend. Venetian decrees against ecclesiastical privileges.		Galileo: the laws of movement. Publication of Lope de Vega's *Comedias*.	
1605	The Dutch discover Australia.	Building of the Place Royale in Paris begins, now Place des Vosges. Lanfranco: *Magdalene carried to Heaven*. Caravaggio: *Death of the Virgin*.	Grotius: *De Jure praedae*. Shakespeare: *King Lear; Macbeth*. Cervantes: *Don Quixote*.	Leo XI and Paul V, Popes.
1606	Conflict between Venice and the Pope settled by Henri IV.	Birth of Rembrandt. About 1606: Caravaggio: *Madonna of the Rosary*.	Birth of Corneille.	
1607	Navarre joined to France. Jesuits in Paraguay. Dutch in Japan.	Place Dauphine built in Paris. Birth of Mathieu Le Nain. Caravaggio: *Flagellation*.	Beginning of *L'Astrée*, by Honoré d'Urfé. Kites as toys in Holland.	Meeting of St François de Sales and St Jeanne de Chantal.
1608	Evangelical union of German Lutherans and Calvinists. Alliance between England and the United Provinces.	El Greco: *Toledo*. Fréminet starts decorating the Trinité at Fontainebleau.	Monteverdi: *Ariadne*. Birth of Torricelli. The telescope.	St François de Sales: *Introduction to the Religious Life*.

Dates	Political events	Arts	Culture	Religion
1609	Catholic League of German princes.	Rubens: *Portrait of the Painter and His Wife.* Death of Annibale Carracci.	Kepler's laws.	
1610	Henri IV assassinated. Marie de' Medici, regent. Influence of Concini.	Death of Caravaggio. Birth of Pierre Mignard.	Galileo discovers Jupiter's satellites.	
1611		Rubens: *Descent from the Cross.* Reni: *Massacre of the Innocents.*	Góngora: *The Solitudes.*	
1612	Louis XIII betrothed to Anne of Austria. Turco-French trade pact.	S. de Brosse: Palais du Luxembourg Rubens: *Samson.* Birth of Le Vau.		J. Boehme: *Dawn at its Breaking.* Bérulle: Oratorians start in France.
1613		Birth of Claude Perrault. Reni: *Aurora.*	Galileo proclaims the rights of science.	
1614	Condé's revolt. Collapse of the States-General in Paris. Triumph of absolute monarchy. Russo-Swedish wars.	Scamozzi: façade of the Hradcany Palace, Prague. Domenichino: *Communion of St Jerome.* El Greco: *Assumption.*	First logarithm table.	
1615		About 1615: Rubens: *The Battle of the Amazons.* Domenichino: *St Jerome: Scenes from the life of St Cecilia*	D'Aubigné: *Les Tragiques.*	
1616	Dutch explore the Pacific. Richelieu in power.	J. Callot: *Battles of the Medici.* Hals: *The Arquebusiers.*	Copernicus condemned by the Church.	
1617	The Baltic-Swedish sea. Luyne, favourite of Louis XIII.	Velasquez: *The Water Carriers.* About 1617: Rubens: *The Great Last Judgement.*	Frescobaldi: *Toccata.*	Catholicism banned in Sweden.
1618	Protestant rising in Prague. Start of the Thirty Years War. Arrest of Barneveldt and Grotius.		Marquise de Rambouillet's salon. Harvey: the circulation of the blood.	Order of the Visitation founded.

ates	Political events	Arts	Culture	Religion
19	Ferdinand II, Emperor. Execution of Barneveldt.	Rubens: *The Daughters of Leucippus; Last Communion of St Francis.* Birth of Charles Le Brun. Death of Lodovico Carracci.	Rosicrucians started in Tübingen. Kepler: *Harmony.*	
20	France annexes Béarn. *Mayflower* sails for America.		Bacon: *Novum Organum.*	
21	Siege of Montauban.	Guercino: *The Funeral of St Petronilla.* Quirinal in Rome.	Birth of La Fontaine. Snell: refraction of light.	Gregory XV, Pope.
22	Richelieu made Cardinal. Peace of Montpellier.	Birth of Pierre Puget. About 1622: Fetti: *The Good Samaritan.*	Schütz: Oratorio: *Resurrection.*	Congregation De Propaganda Fide.
23	Treaty of Paris (France, Savoy, Venice).	Velasquez: *Olivares.*	Marino: *Adonis.* Birth of Pascal.	
24	Richelieu back in power. Charles I marries Henrietta Maria of France.	Velasquez: *The Drunkards.* Rubens: *Adoration of the Magi.*	The Précieux. Théophile de Viau: *Le Libertin.*	
25	Spinola takes Breda.	Bernini: *Apollo and Daphne.* Death of Brueghel de Velours.	Grotius: *De Jure belli et pacis.*	St Vincent de Paul founded Lazarist Order.
26	Peace of La Rochelle. Fortified castles to be destroyed.	Ph. de Champaigne: *Jansenius.* Maderno finishes Saint Peter's.	Birth of the Marquise de Sévigné.	
27	Franco-Spanish treaty. Siege of La Rochelle.	Jesuit church (Saint Paul) in Paris.	F. Bacon: *New Atlantis.* J. Callot: *The Siege of Breda.* Birth of Bossuet.	Company of the Holy Sacrament founded.
28	La Rochelle surrenders. Canada Company.	Van Dyck: *Ecstasy of St Augustine.* Birth of Girardon. Ph. de Champaigne: *Louis XIII.*	Descartes settles in Holland.	St François de Sales: *Entretiens spirituels.*
29	Richelieu, Chief Minister. The English capture Quebec.	Poussin: *Martyrdom of St Erasmus.*	Corneille: *Mélite.*	

Dates	Political events	Arts	Culture	Religion
1630	Louis XIII takes Savoy. Diet of Ratisbon.	P. de Cortona completes ceiling of Palazzo Barberini. Poussin: *The Rape of the Sabines*.	Tirso de Molina: *El Burlador*.	
1631	Revolt of Gaston d'Orléans Marie de' Medici flees to Netherlands. Gustavus-Adolphus on the Rhine. Elector of Saxony conquers Bohemia.	Lemercier builds Château de Richelieu. Longhena builds Salute in Venice. Claude Lorraine: *The Mill*.	Renaudot starts *La Gazette*. John Donne: *Poems*.	
1632	Gaston d'Orléans defeated. Execution of Montmorency. Lützen: death of Gustavus Adolphus.	Ribera: *The Holy Trinity*. Rembrandt: *The Anatomy Lesson*. Birth of Vermeer. Birth of Christopher Wren. Birth of Giordano.	Birth of Spinoza, Puffendorf, Locke, Bourdaloue. Galileo: *The Two Principal Systems*.	
1633	Reconstitution of the Protestant League.	Callot: *The Horrors of War*.	The Inquisition forces Galileo to abjure. Birth of Lully.	Saint-Cyran, spiritual director at Port-Royal.
1634	Wallenstein assassinated. Franco-Dutch alliance.	Ph. de Champaigne: *The Vow of Louis XIII*.	Milton: *Comus*.	Amyrant: Treatise on *Predestination*.
1635	Foundation of the Compagnie française des Iles d'Amérique. Franco-Spanish war. Treaty of Prague between the Emperor and Saxony.	Lemercier: Chapelle de la Sorbonne. Rubens: *Garden of Love; Kermesse*. Mansart: Hôtel de la Vrillière. Death of Tintoretto. Van Dyck: *Portrait of Charles I*.	Founding of the Académie française.	
1636	The Emperor declares war on France. Battle of Corbie.	Van Ostade: *Village interior*. Palais-Royal and garden, Paris. 1636-1640: Ph. de Champaigne: *Richelieu*.	Corneille: *Le Cid*. Birth of Boileau. First permanent opera-house in Venice. Descartes: *Discours de la Méthode*.	

Dates	Political events	Arts	Culture	Religion
37	Revolt in the Limousin. Slave markets in French Senegal. Prairie Indians attacked by English.	Birth of Libéral Bruant.		The recluses of Port-Royal.
638	Franco-Swedish treaty of Hamburg. Japan closed to foreigners.	Poussin's *Arcadian Shepherds*. Rubens: *Andromeda*. Ribera paints San Martino in Naples.	Birth of Racine.	Saint-Cyran imprisoned.
639	Revolt in Normandy. Swedes in Bohemia. English in Madras.	Velasquez: *Crucifixion*. Cortona: frescoes, Palazzo Barberini. Rubens: *Hélène Fourment in a Fur Cloak*.	Galileo: *The New Science*.	
640	Richelieu occupies Savoy and Turin. Arras taken. Portugal independent.	Van Ostade: *The Organ Player*. G. de La Tour: *The New-born*. Death of Rubens.	Corneille: *Horace*.	Jansenius: *Augustinus*. Jesuits ban Cartesianism in their schools.
641	Franco-Portuguese alliance. The Long Parliament.	Le Nain: *Venus in Vulcan's Forge*. Vouet: *Presentation in the Temple*. Death of Domenichino. Death of Van Dyck.	Descartes: *Meditations*. Corneille: *Polyeucte*.	
642	Death of Richelieu. Capture of Roussillon. Revolt against Charles I.	Rembrandt: *The Night Watch*. Mansart: Château de Maisons-Lafitte. Death of Guido Reni. Ribera: *The Club Foot*.	Pascal: First calculating machine. Birth of Newton. Hobbes: *De Cive*.	The Congregation of Saint Sulpice.
643	Death of Louis XIII. Regency of Anne of Austria. Mazarin. Battle of Rocroi.	Le Nain: *The Guard*. Borromini: San Carlo alle Quattro Fontane.	Molière creates Illustre Théâtre.	Arnauld: *Treatise on Frequent Communion*.
644	40,000 unemployed in London. Cromwell takes York.	Lorraine: *Port at Sunset*.	Torricelli: The barometer.	Innocent X, Pope.

Dates	Political events	Arts	Culture	Religion
1645	Turenne in Baden.	Mansart begins Val-de-Grâce. Le Sueur: *Life of St Bruno*.		
1646	Charles I captured in Scotland. French and Swedish in Bavaria.	Birth of J. Hardouin-Mansart. Lorraine: *The Embarkation of St Ursula*.	Corneille: *Rodogune*. Birth of Leibnitz.	Westminster Confession.
1647	Armistice between France and Bavaria. Great Britain: the Civil War. Insurrection in Naples.	Velasquez: *The Lances*. A. Le Nain: *Portrait in an interior*. Death of Lanfranco.	Pascal: the void. Vaugelas: *Remarques sur la Langue française*.	
1648	Fronde. Royal family flees. Spain crushes Naples revolt. Cromwell reforms Parliament. End of the Thirty Years War. The French in Alsace.	Founding of the Académie royale de peinture et sculpture. Ph. de Champaigne: *La Mère Angélique*. Rembrandt: *The Pilgrims of Emmaus*. Death of Antoine and Louis le Nain. Lorraine: *Embarkation of the Queen of Sheba*.		
1649	Peace of Rueil. Turenne's revolt. Cromwell in Ireland. Charles I executed.	Le Sueur: *St Paul*. Death of Simon Vouet. Ribera: *Paul the Hermit*.	Descartes in Sweden: *Treatise on the Passions*.	The Quakers.
1650	Arrest of Condé. Battle of Rethel. Cromwell in Scotland. Death of William II of Nassau.	Rembrandt: *The 100 Florins*. Bernini: *St Teresa*. Poussin: *Self-portrait*. G. de La Tour: *Denial of St Peter*.		
1651	Mazarin in exile. Turenne rallies to the king. Charles II, King of Scotland. Navigation Act.	Ribera: *The Communion of the Apostles*. Fyt: *Still-life with Game*. Bernini: Fountain of the Four Rivers.	The pneumatic machine. Corneille: *Nicomède*. Scarron: starts *Le Roman Comique*.	Society for Foreign Missions

Dates	Political events	Arts	Culture	Religion
1652	Louis XIV retakes Paris.	Death of La Tour.		
	Union of England and Scotland.	Jordaens: *Triumph of Frederick-Henry*.		
	Revolt of Barcelona.			
	Anglo-Dutch war.			
1653	End of the Fronde.	Borromini: *St Agnes*.	Molière: *L'Etourdi*.	Innocent X condemns Jansenism.
	Fouquet, Finance Minister.			
	Cromwell, Lord Protector.			
1654	Cologne alliance.	Murillo: *Street Urchins*.	Vondel: *Lucifer*.	
	Abdication of Christina of Sweden.			
1655	Jan de Witt: Grand Pensionary of Holland.	Amsterdam Town Hall.		Closing of Port-Royal.
		Velasquez: *Rokeby Venus*.		
1656	Religious war in Switzerland.	Velasquez: *Las Meninas*.	Pascal: *Lettres Provinciales*.	Spinoza excommunicated by Amsterdam Jews.
		Le Vau starts Château de Vau.		
		Death of Ribera.		
		Birth of Largillière.		
1657	Anglo-French alliance.	Birth of Solimena.		
		Death of Franz Snyders.		
1658	The Rhine League.	Rembrandt: *Portrait of the Artist*.		
	Death of O. Cromwell.			
	Leopold I, Holy Roman Emperor.			
	English capture of Dunkirk.			
1659	Richard Cromwell abdicates.	Birth of Rigaud.	Molière: *Les Précieuses Ridicules*.	
	Peace of the Pyrenees.		Lully: Ballets.	
1660	Charles II returns to London.	Vermeer: *The Letter*.	Boileau: *Satire I*.	Louis XIV burns *Lettres Provinciales*.
		Death of Albani.		
	Louis XIV marries Maria Theresa.			
1661	Death of Mazarin. Fouquet arrested. Colbert appointed to Council.	Le Vau starts work on Versailles.	Gobelins factory started.	
		Rembrandt: *Staal Meesters*.		

Dates	Political events	Arts	Culture	Religion
1662	Lorraine ceded to France. Créqui in Rome.	Le Brun, chief painter to the King. Ph. de Champaigne: *Mère Agnès Arnauld et Sœur Catherine*.	Molière: *L'Ecole des Femmes*. Walgenstein: magic lantern.	
1663	Louis XIV loses the Comtat-Venaissin. Diet of Holy Roman Empire becomes permanent.	Building of Nymphenburg. Le Nôtre: park at Versailles. Bernini: Scala Regia.		
1664	Fouquet condemned. Treaty of Pisa. Compagnie française des Indes.	Hals: *The Regents*.	Molière: *Tartuffe*. La Fontaine: first *Contes*.	Rancé reforms Trappists. Nuns of Port-Royal dispersed.
1665	Great Plague, London. Colbert, Finance Minister. Death of Philip IV.	Death of Poussin.	La Rochefoucauld: *Maxims*. Spinoza: *Ethics*.	
1666	Great Fire of London. Franco-English war. Louis XIV restricts rights of Parliament.	Claude Perrault starts Colonnade du Louvre. Death of Guercino.	Newton: gravity, light. Furetière: *Roman bourgeois*. Molière: *Le Misanthrope*.	
1667		Bernini: Colonnade, Saint Peter's. Death of Borromini. Birth of Magnasco.	Racine: *Andromaque*. Milton: *Paradise Lost*. Hooke: *Micrographia*. Paris Observatory.	Clement IX, Pope.
1668	Conquest of Franche-Comté. Peace between Spain and Portugal. Treaty of Aix-la-Chapelle.	Foundation of Académie de France in Rome.	La Fontaine: *Fables* (I-VI) Molière: *L'Avare, Amphitryon*. Dryden: *Essays*. Newton's first telescope.	
1669	Colbert, Secretary of State.	Death of Pietro da Cortona.	Racine: *Britannicus*. Bossuet: *Funeral Oration for Henriette d'Angleterre*. Brand: phosphorus.	

Dates	Political events	Arts	Culture	Religion
1670	Triple alliance.	Libéral Bruant: Hôtel des Invalides. Death of Claude Vignon. Murillo: decoration of Charity Hospital.	Spinoza: *Tractatus theologico-politicus*. Pascal: *Pensées*. Mme de Sévigné: *Letters*. Leibniz: electric spark.	Clement X, Pope.
1672	Louis XIV at Versailles. Alliance between Brandenburg and Holland. Murder of the de Witt Brothers. Utrecht taken by French.			
1673	Franco-Turkish pact renewed. Russian Embassy at Versailles.	Death of Salvator Rosa.	Death of Molière. Lully-Quinault: first French opera. Huygens: dynamics.	
1674	French in India. Revolt in Messina. The Diet declares war on Louis XIV.	Death of Ph. de Champaigne. Le Brun: *Louis XIV adoring the Risen Christ*.	Malebranche on truth. Boileau: *Art poétique*. Bayonets on guns.	
1675	Death of Turenne.	Wren: building of St Paul's begins.	Leeuwenhoek: infusoria and spermatozoids. Leibniz: infinitesimal calculus.	Spencer: Protestant pietism.
1676			Retz: *Mémoires*. Hooke: laws of elasticity.	Innocent XI, Pope.
1677		Ruysdael: *The Jewish Cemetery*. Death of Mathieu Le Nain.	Racine: *Phèdre*. Vauban's fortifications.	
1678	Catholics excluded from English parliament. Treaty of Nijmegen.	Death of Jacob Jordaens.	Mme de La Fayette: *La Princesse de Clèves*. Huygens: analysis of light.	
1679	Habeas Corpus Act in England. Treaties of Saint-Germain. French expeditions against Barbary pirates.	Hardouin-Mansart: Château de Marly.	Mariotte's Law.	

Dates	Political events	Arts	Culture	Religion
1680	French in Rhineland and Alsace.	Death of Bernini. 1680-1691: Dome of the Invalides.	Comédie Française founded. Purcell: *Dido and Aeneas*.	
1681	In France, repression of Protestants. Strasbourg annexed.		Bossuet: *Discours sur l'Histoire universelle*. Canal du Midi opened.	
1682	Peter the Great, Tsar. Franco-Moroccan trade agreement.	Puget: Milo of Croton. Galerie des Glaces, Versailles. Death of Claude Lorraine.	Newton: law of gravity.	Gallicanism.
1683	Death of Colbert. Louis XIV marries M^{me} de Maintenon. Franco-Spanish war.	Caratti: Czernin Palace, Prague.		
1684	Bombardment of Genoa. Luxembourg taken by France. The Holy League: Austria, Poland, Venice against Turks.	Birth of Watteau. Van der Meulen: *Siege of Namur*.		
1685	Revocation of the Edict of Nantes. Death of Charles II. Franco-Algerian treaty.		Birth of J. S. Bach. Birth of Handel.	Over 30,000 Protestants leave France.
1686	The Dragonnades (Protestant persecutions). Founding of St Cyr. League of Augsburg.	Puget: *Alexander; Diogenes*.	Fontenelle: *La Pluralité des Mondes*. Lully: *Armide*.	
1687	Deportation of non-converted Huguenots. Venetians in Corinth and Athens.	Mansart: The Grand Trianon.	Malebranche: *Entretiens sur la Metaphysique*. Perrault: *Le Siècle de Louis le Grand*.	
1688	William of Orange lands in England. Louis XIV takes Avignon and invades Germany. War with Netherlands.		La Bruyère: *Characters*. Birth of Marivaux. Birth of Swedenborg. Leeuwenhoek: red corpuscles and capillary vessels.	

Dates	Political events	Arts	Culture	Religion
1689	William and Mary crowned. Revolt in Ireland. Europe against Louis XIV.	Wren: part of Hampton Court Palace. 1689-1690: Solimena: *Fall of Simon Magus*.	Bernouilli: integral calculus. Racine: *Esther*. Birth of Montesquieu.	Alexander VIII, Pope.
1690	Battle of Fleurus.	Death of Charles Le Brun. Birth of Tiepolo.	Huygens: *Treatise on Light*. Papin: steam-pressure.	
1691	Death of Louvois. French invade Piedmont.	1691-1694: Pozzo: frescoes for Saint Ignatius, Rome.	Racine: *Athalie*.	Innocent XII, Pope.
1692	Founding of the Compagnie de St Gobain. Battle of Hungary. Invasion of Savoy.			
1693			Scarlatti's operas. M. A. Charpentier: *Médée*. First *Dictionary* of Académie française. La Fontaine: twelfth book of *Fables*. Birth of Voltaire.	
1695		Death of Pierre Mignard.	Bayle: *Dictionary*.	
1696	Louis XIV gives up Alsace.	Largillière: *The Magistrates of Paris*.	Perrault: *Mother Goose Tales*. Bernouilli: variation calculus.	Fénelon in favour of Quietism.
1697	Treaty of Ryswick. Peter the Great travels in the West.			
1698		R. de Cotte: chapel in Versailles. Hardouin-Mansart: Place Vendôme, Paris.	Fénelon: *Télémaque*.	Arnold: *History of the Church*.
1699	Defeat of Turkey in Europe.	Girardon: *Louis XIV on Horseback*.		
1700	Louis XIV's grandson King of Spain.		Founding of the Academy of Sciences in Berlin.	Clement XI, Pope.

Museums

Name	Town	Museum	Title	Year	Type	Dimensions (in inches)
Alban, Francesco (1578-1660)	Bologna	Church of Santa Maria dei Servi	*Noli me tangere*	1644	Canvas	
			Martyrdom of St Andrew	1639-1641	Canvas	
	Bologna	Santa Bartolomeo	*Annunciation*	1633		
	Fontainebleau	Château Museum	*Apollo guarding Admetus' flocks*	1625-1630	Canvas	35 × 40
	Fontainebleau	Château Museum	*Triumph of Cybele*	1625-1630	Canvas	35 × 40
	Madrid	Prado	*Toilet of Venus*		Canvas	45 × 67
	Mantua	Villa La Favorita	Decoration	1621-1623		
	Paris	Louvre	*Venus and Vulcan*	1621-1623	Canvas	80 × 100
	Paris	Louvre	*Toilet of Venus*	1621-1623	Canvas	80 × 99
	Rome	Galleria Doria	*Assumption*	1602-1603	Canvas	47 × 75
	Rome	Santa Maria della Pace (roof)	*Assumption*	1611	Fresco	
	Rome	Galleria d'arte antica	Allegory of a pontificate		Canvas	32 × 21
	Turin	Santa Maria di Galliera	Decoration	1630-1632	Frescoes	
Baschenis Evaristo (1617-1677)	Bergamo	Gall. Acad. Carrara	*Musical instruments*		Canvas	30 × 43
	Bergamo	Casa Agliardi	*Self-portrait*			
	Brussels	Musée des beaux-arts	*Musical instruments*		Canvas	39 × 58
Brueghel de Velours (1568-1625)	Amsterdam	Rijksmuseum	*View of a village on a river*	1604	Copper	
	Amsterdam	Rijksmuseum	*Latona and the Lydian peasants*	1601	Wood	15 × 22
	Dresden	Pinakothek	*Temptation of St Anthony*	1604	Canvas	10 × 14
	Dresden	Pinakothek	*Canal in Holland*	1612	Canvas	15 × 24
	London	National Gallery	*Adoration of the Magi*	1598	Canvas	13 × 19
	Madrid	Prado	*The Four Elements*		Canvas	20 × 25
	Madrid	Prado	*Garland of Flowers*		Canvas	32 × 26
	Madrid	Prado	*Meal in the Country*		Canvas	65 × 65
	Madrid	Prado	*Smell*		Wood	26 × 43
	Munich	Pinakothek	*Fish Market*	1603	Canvas	23 × 36
	Munich	Pinakothek	*Garland*		Canvas	50 × 36
	Paris	Louvre	*The Earth or Earthly Paradise*	About 1621	Canvas	18 × 26

Name	Town	Museum	Title	Year	Type	Dimensions (in inches)
	Paris	Louvre	*Battle of Arbela*	1602	Wood	32 × 54
	Paris	Louvre	*Air*	1621	Canvas	18 × 24
Caravaggio (1573-1610)	Berlin	Kaiser-Friedrich-Museum	*St Matthew writing to the Angel's Dictation*		Canvas	88 × 72
	Copenhagen	Museum	*The Gamblers*			
	Florence	Uffizi	*Bacchus*	About 1590	Wood	37 × 33
	Florence	Uffizi	*Sacrifice of Isaac*	About 1592	Canvas	41 × 53
	Leningrad	Hermitage	*Crucifixion of St Peter*		Canvas	93 × 79
	Messina	Mus. nazionale	*Resurrection of Lazarus*	1609	Canvas	150 × 108
	Milan	Gal. Ambrosina	*Basket of Fruit*		Canvas	18 × 25
	Milan	Brera	*Meal at Emmaus*	1606	Canvas	57 × 75
	Naples	Pio Monte della Misericordia	*Seven Works of Mercy*	1607	Canvas	154 × 102
	Naples	San Domenico Maggiore	*Flagellation*	About 1607	Canvas	113 × 84
	New York	Metropolitan Museum	*The Concert*			
	Palermo	Oratory San Lorenzo	*Nativity with St Francis and St Lawrence*	1609	Canvas	66 × 77
	Paris	Louvre	*Fortune Teller*	About 1590	Canvas	39 × 52
	Paris	Louvre	*Death of the Virgin*	1605	Canvas	145 × 97
	Rome	Gall. Doria	*The Magdalene*	About 1590	Canvas	50 × 39
	Rome	Gall. Doria	*Rest during the Flight to Egypt*	1590	Canvas	51 × 63
	Rome	Gall. Borghese	*David*		Canvas	49 × 40
	Rome	Gall. d'arte antica	*St John the Baptist*	About 1598	Canvas	38 × 52
	Rome	Gall. d'arte antica	*Narcissus*		Canvas	44 × 37
	Rome	Gall. d'arte antica	*Boy with Basket of Fruit*		Canvas	28 × 26
	Rome	San Agostino	*Madonna of the Pilgrims*	About 1603	Canvas	102 × 59
	Rome	San Luigi dei Francesi	*St Matthew and the Angel*	Between 1590 and 1600	Canvas	118 × 77

Name	Town	Museum	Title	Year	Type	Dimensions (in inches)
	Rome	San Luigi dei Francesi	*Martyrdom of St Matthew*	Between 1590 and 1600	Canvas	127 × 133
	Rome	San Luigi dei Francesi	*Calling of St Matthew*	Between 1590 and 1600	Canvas	127 × 133
	Rome	Santa Maria del Popolo	*Conversion of St Paul*	About 1599	Canvas	91 × 69
	Rome	Santa Maria del Popolo	*Crucifixion of St Peter*	1600	Canvas	91 × 69
Carracci, Annibale (1560-1609)	Bologna	San Niccolo	*Crucifixion*	1583	Canvas	
	Bologna	San Gregorio	*Baptism of Christ*	1585	Canvas	
	Bologna	Palazzo Magnani	*Story of Romulus and Remus*	1588-1591	Frieze	
	Bologna	Pinacoteca	*Madonna and St John*		Canvas	108 × 68
	Bologna	Pinacoteca	*Assumption*		Canvas	96 × 69
	Dresden	Art Gallery	*Assumption*	1587	Canvas	150 × 97
	Dresden	Art Gallery	*Charity of St Roch*	1595	Canvas	130 × 188
	Florence	Uffizi	*Man with a monkey*	About 1590	Canvas	28 × 23
	London	National Gallery	*Domine, quo vadis?*		Canvas	30 × 21
	Madrid	Prado	*The Magdalene swooning*		Canvas	15 × 11
	Milan	Brera	*Woman of Samaria at the Well*		Canvas	70 × 89
	Naples	Museo nazionale	*Hercules between Vice and Virtue*	About 1595	Canvas	66 × 93
	Naples	Museo nazionale	*Pietà*	About 1600	Canvas	61 × 59
	Paris	Louvre	*Fishing*		Canvas	54 × 100
	Rome	Palazzo Farnese	Decoration	1595-1597	Frescoes	
	Vienna	Kunsthistorisches Museum	*The Dead Christ*	About 1600	Canvas	17 × 25
	Vienna	Kunsthistorisches Museum	*Woman of Samaria at the Well*		Canvas	24 × 58
Carracci, Agostino (1557-1602)	Bologna	Palazzo Fava	Decoration	1584		
	Bologna	Palazzo Sampieri	Decoration	1593-1594		
	Bologna	Pinacoteca	*Assumption*		Canvas	130 × 78
	Bologna	Pinacoteca	*Last Communion of St Jerome*		Canvas	138 × 106

Name	Town	Museum	Title	Year	Type	Dimensions (in inches)
	Milan	Brera	*The Woman taken in Adultery*		Canvas	70 × 88
	Rome	Palazzo Farnese	*Aurora carrying off Cephalus*	About 1598	Canvas	
	Rome	Palazzo Farnese	*Triumph of Galatea*	About 1598	Canvas	
Carracci, Lodovico (1555-1619)	Bologna	Pinacoteca	*Annunciation*	1580	Canvas	83 × 91
	Bologna	Pinacoteca	*Madonna of the Scalzi*	About 1590	Canvas	84 × 57
	Bologna	Pinacoteca	*Martyrdom of St Peter*	About 1600	Canvas	61 × 46
	Bologna	Palazzo Magnani	*John the Baptist preaching*	1592	Canvas	107 × 66
	Mantua	San Maurizio	*Martyrdom of St Margaret*	1616	Canvas	122 × 79
	Milan	Brera	*The Woman of Cana*		Canvas	70 × 89
	Paris	Louvre	*Annunciation*		Canvas	19 × 13
Cesari, Giuseppe (Cavaliere d'Arpino) (1568-1640)	Naples	San Martino	Decoration of dome	1589-1591		
	Naples	Capodimonte Museum	*St Michael hurling Satan into the Abyss*		Canvas	
	Naples	Capodimonte Museum	*Angel Choir*		Canvas	
	Paris	Louvre	*Adam and Eve driven out of Paradise*		Canvas	21 × 15
	Rome	Santa Maria Maggiore	Decoration of Pauline Chapel		Frescoes	
	Rome	Baptistery, St John Lateran	*Story of St John*		Canvas	
	Rome	Palazzo Conservatori	Decoration	1596		
	Rome	San Prassede	*Assumption*		Fresco	
Champaigne, Philippe de 1602-1674)	Amsterdam	Rijksmuseum	*Jacobus Govaerts*	1665	Canvas	53 × 43
	Amsterdam	Rijksmuseum	*Portrait of a Gentleman*		Canvas	25 × 22
	Brussels	Musée des beaux-arts	Self-portrait	1668	Canvas	37 × 28
	Grenoble	Museum	*Portrait of Saint-Cyran*	1643	Canvas	29 × 22
	London	National Gallery	Triple portrait of Richelieu		Canvas	23 × 28
	Madrid	Prado	*Portrait of Louis XIII*	1628	Canvas	43 × 34
	Paris	Louvre	*The Dead Christ*		Canvas	27 × 78

Name	Town	Museum	Title	Year	Type	Dimensions (in inches)
	Paris	Louvre	Ex-voto	1662	Canvas	65 × 87
	Paris	Louvre	*Vanity*		Canvas	28 × 36
	Paris	Louvre	*The Merchants' Provost and the Aldermen of Paris*		Canvas	79 × 107
	Paris	Louvre	*Richelieu*	About 1635	Canvas	87 × 61
	Paris	St Severin	*Nativity*		Canvas	
	Paris	Val-de-Grâce	*The Magdalene at the Feet of the Lord*		Canvas	
	Paris	Saint Germain l'Auxerrois	*The Assumption; St Germain; St Vincent*			
	Rheims	Musée des beaux-arts	*The Montmort Children*	1649	Canvas	48 × 73
	Versailles	Musée National	*Mère Agnès*		Canvas	30 × 23
Cortona, Pietro da (1596-1669)	Florence	Pitti	Decoration	1640	Frescoes	
	Madrid	Prado	*Feast in honour of Lucina and the God Pan*		Canvas	93 × 144
	Paris	Louvre	*Venus and Aeneas*	1635	Canvas	47 × 69
	Paris	Louvre	*Virgin and Child*		Canvas	50 × 63
	Rome	Galleria Capitolina	*View of the Alun and Tolpa Mines*	About 1625	Canvas	24 × 30
	Rome	Galleria Capitolina	*Rape of the Sabines*	1629	Canvas	109 × 167
	Rome	Galleria Capitolina	*Battle of Issos*		Canvas	
	Rome	San Bibiana	Decoration	1624-1626	Frescoes	
	Rome	Villa Saccheti at Castel Fusano	Decoration	1626-1629	Frescoes	
	Rome	Palazzo Barberini	Decoration of *salone*	1633-1639	Frescoes	
	Rome	Santa Maria Vallicella	Decoration	1633-1665	Frescoes	
	Rome	Palazzo Pamphili	Decoration	1651-1654	Frescoes	
Coypel, Antoine (1661-1722)	Madrid	Prado	*Susanna accused by the Elders*		Canvas	59 × 80
	Paris	Louvre	*Esther before Ahasuerus*		Canvas	41 × 54
	Paris	Louvre	*Democritus*		Canvas	27 × 23
	Paris	Louvre	Self-portrait		Canvas	51 × 38

Name	Town	Museum	Title	Year	Type	Dimensions (in inches)
	Tours	Museum	*The Anger of Achilles*		Canvas	46 × 82
	Versailles	Chapel	*The Eternal Father in Glory*		Fresco	
Desportes, Alexandre-François (1661-1743)	Grenoble	Museum	*Flowers, Fruit, Animals*	1717	Canvas	72 × 91
	Munich	Pinakothek	*Still-life with Dog*		Canvas	29 × 36
	Paris	Louvre	Self-portrait		Canvas	78 × 64
	Paris	Louvre	*Diane and Blonde, Louis XIV's Hunting Dogs*		Canvas	64 × 79
	Paris	Louvre	*Portrait of a Huntsman*		Canvas	58 × 45
	Paris	Louvre	*Wolf Hunt*		Canvas	104 × 135
	Paris	Louvre	*Boar Hunt*		Canvas	132 × 138
	Paris	Louvre	*Game, Flowers and Fruit*		Canvas	65 × 53
Domenichino Domenico Zampieri) (1582-1641)	London	National Gallery	*St Jerome and the Angel*		Canvas	20 × 15
	Madrid	Prado	*St Jerome writing in the Desert*		Canvas	72 × 51
	Madrid	Prado	*Sacrifice of Abraham*		Canvas	58 × 55
	Naples	Duomo	Decoration	After 1631	Frescoes	
	Paris	Louvre	*St Cecilia*	Before 1621	Canvas	63 × 46
	Paris	Louvre	*Hercules and Cacus*	About 1621	Canvas	48 × 59
	Rome	San Gregorio Maggiore	*Flagellation of St Andrew*	1608	Canvas	
	Rome	Abbey of Grottaferrata	*Life of St Nilus and St Bartholomew*	1608-1610	Frescoes	
	Rome	San Luigi dei Francesi	Scenes from the life of St Cecilia	1615	Frescoes	
	Rome	Sant' Andrea della Valle	*The Evangelists*	1624-1628	Frescoes	
	Rome	San Silvestre	Decoration	1628-1630	Frescoes	
	Rome	Santa Maria degli Angeli	*Martyrdom of St Sebastian*		Frescoes	
	Rome	San Carlo ai Catinari	Decoration	1628-1630	Frescoes	
Furini, Francesco about 1600-646)	Florence	Pitti	*Creation of Eve*	1636-1637	Frescoes	
	Madrid	Prado	*Lot's Daughters*			48 × 47
	Rome	Gall. Spada	*St Lucy*			27 × 20

Name	Town	Museum	Title	Year	Type	Dimensions (in inches)
	Rome	Gall. Palatine	*Hylas and the Nymphs*			
Gentileschi, Lomi Orazio (1565-1647)	Ancona	Gesù	*Circumcision*			
	Florence	Pitti	*Judith with Holofernes' Head*		Canvas	46 × 37
	Genoa	San Siro	*Annunciation*			
	Madrid	Prado	*Moses saved from the Waters of the Nile*		Canvas	95 × 111
	Milan	Brera	*Ecstasy of St Cecilia*	1605	Canvas	139 × 85
	Paris	Louvre	*Rest during the Flight to Egypt*	1624	Canvas	62 × 89
	Rome	Santa Maria Maggiore	Decoration		Frescoes	
	Rome	Santa Maria della Pace	Decoration		Canvases	
	Rome	Saint John Lateran	Decoration		Frescoes	
	Turin	Gall. Sabanda	*Annunciation*	1623	Canvas	113 × 77
	Urbino	National Gallery of the Marches	*Virgin with Child and St Francesca Romana*	1613-1617	Canvas	106 × 62
	Vienna	Belvedere	*Flight to Egypt*			
Giordano, Luca (1632-1705)	Florence	Palazzo Riccardi	*Minerva holding out a Golden Key*	1682-1683	Fresco	
	Florence	Palazzo Riccardi	*Apotheosis of the Medici*	1682-1683	Fresco	
	Florence	Carmine	Decoration	1684	Frescoes	
	Madrid	Prado	*Jacob fighting with the Angel*		Canvas	99 × 44
	Madrid	Prado	*Allegory of Peace*		Canvas	76 × 30
	Madrid	Prado	*Death of Nessus*		Canvas	45 × 31
	Naples	San Martino	*Bronze Serpent*		Fresco	
	Naples	San Martino	*Judith*		Fresco	
	Naples	Santa Brigitta	Decoration of cupola	1682	Frescoes	
	Naples	San Filippo Neri	*The Merchants driven from the Temple*	1684	Fresco	
	Naples	Charterhouse, San Martino	Decoration of sacristy dome	1704	Frescoes	
	Naples	Museo nazionale	*Tarquin and Lucrece*		Canvas	
	Naples	Museo nazionale	*St Francis Xavier baptising the Pagans*	1663	Canvas	

Name	Town	Museum	Title	Year	Type	Dimensions (in inches)
	Paris	Louvre	*Marriage of the Virgin*		Canvas	45 × 54
	Venice	Accademia	*The Deposition*		Canvas	180 × 97
Guercino, Francesco Barbieri (1591-1666)	Bologna	Pinacoteca	*St William of Aquitaine*	1620	Canvas	136 × 91
	Brussels	Musée des beaux-arts	*Four Saints commending Luigi Gonzaga to the Virgin*		Canvas	122 × 76
	Florence	Uffizi	*St Peter*		Canvas	26 × 20
	Florence	Pitti	*St Sebastian*		Canvas	100 × 62
	Florence	Pitti	*Resurrection of Tabitha*	1618	Canvas	52 × 61
	Madrid	Prado	*Susanna bathing*		Canvas	69 × 82
	Madrid	Prado	*The Magdalene in the Desert*		Canvas	48 × 39
	Madrid	Prado	*Susanna and the Elders*	1620	Canvas	69 × 80
	Modena	Galleria Estense	*Martyrdom of St Peter*	1619	Canvas	
	Paris	Louvre	*St Benedict and St Francis*	1620	Canvas	110 × 72
	Paris	Louvre	Self-portrait		Canvas	30 × 24
	Piacenza	Duomo	*Prophets and Sybils*	1626	Frescoes	
	Rome	Casino della Villa di Gregorio XV	*Aurora*	1621	Frescoes	
	Rome	Casino della Villa di Gregorio XV	*Fame*	1621	Frescoes	
	Rome	Galleria d'arte antica	*Et in Arcadia ego*		Canvas	32 × 36
	Rome	Galleria Capitolina	*Burial of St Petronilla*	1621	Canvas	
Guido Reni (1575-1642)	Berlin	Kaiser-Friedrich-Museum	*St Paul and St Anthony in the Desert*		Canvas	19 × 15
	Bologna	San Domenico	*Apotheosis of St Dominic*	1615	Canvas	
	Bologna	Church of the Mendicanti	*Deposition*	1616	Canvas	
	Bologna	Pinacoteca	*Portrait of the Artist's Mother*	1611	Canvas	25 × 22
	Bologna	Pinacoteca	*Samson victorious*	1611	Canvas	102 × 92
	Bologna	Pinacoteca	*Massacre of the Innocents*	1611	Canvas	106 × 67
	London	National Gallery	*Ecce Homo*		Canvas	35 × 29
	Madrid	Prado	*Lucrece killing Herself*		Canvas	28 × 22
	Naples	Capodimonte Museum	*Atalanta and Hippomene*	1625	Canvas	75 × 104

Name	Town	Museum	Title	Year	Type	Dimension (in inches)
	Paris	Louvre	*Hercules killing the Hydra of Lerna*	1621	Canvas	104 × 78
	Paris	Louvre	*Rape of Helen*	1628-1631	Canvas	100 × 104
	Paris	Louvre	*David, Conqueror of Goliath*		Canvas	87 × 63
	Paris	Louvre	*The Magdalene*		Canvas	26 × 22
	Rome	San Gregorio Maggiore	Decoration	1608-1609	Frescoes	
	Rome	Quirinal	Decoration of dome	1610	Frescoes	
	Rome	Santa Maria Maggiore	Decoration of Pauline Chapel	1612	Frescoes	
	Rome	Casino Rospigliosi	*Aurora*	1613-1614	Fresco	
	Rome	Church of the Pilgrims	*Crucifixion*	1625	Canvas	
	Rome	Church of the Conception	*St Michael the Archangel*	About 1635	Canvas	
	Rome	Galleria d'arte antica	*Salome*	About 1630	Canvas	54 × 38
	Vienna	Kunsthistorisches Museum	*Ecce Homo*		Canvas	35 × 29
Jordaens, Jacob (1593-1678)	Amsterdam	Rijksmuseum	*Satyr*		Canvas	53 × 69
	Amsterdam	Rijksmuseum	*The Stater found in the Fish's Mouth*		Canvas	47 × 78
	Antwerp	Saint Paul	*Christ crucified*	1617	Canvas	
	Antwerp	Augustines	*Martyrdom of St Apollonia*	1628	Canvas	
	Antwerp	Saint James	*St Charles Borromeo*	1655	Canvas	
	Antwerp	Musée des beaux-arts	*Atalanta and Meleager*	About 1620	Canvas	60 × 47
	Antwerp	Musée des beaux-arts	*Family Concert*	1638	Canvas	47 × 76
	Brussels	Musée des beaux-arts	*Susanna and the Elders*		Canvas	74 × 69
	Brussels	Musée des beaux-arts	*St Yves, Patron Saint of Lawyers*	1645	Canvas	41 × 51
	Dublin	Museum	*Triumph of the Eucharist*		Canvas	
	London	National Gallery	*Holy Family with St John*		Canvas	48 × 37
	London	National Gallery	*Adoration of the Shepherds*		Canvas	
	Madrid	Prado	*Three Strolling Musicians*		Wood	19 × 25

Name	Town	Museum	Title	Year	Type	Dimensions (in inches)
	Madrid	Prado	*Mystic Marriage of St Catherine*		Canvas	48 × 68
	Madrid	Prado	*Family Scene in a Garden*		Canvas	46 × 74
	Madrid	Prado	*Meleager and Atalanta*	1628	Canvas	59 × 95
	Milan	Brera	*Sacrifice of Abraham*		Canvas	96 × 59
	Paris	Louvre	*The King drinks*		Canvas	60 × 80
	Paris	Louvre	*The Four Evangelists*		Canvas	53 × 46
	Paris	Louvre	*Portrait of Admiral de Ruyter*	About 1635	Canvas	37 × 29
	Stockholm	National Museum	*Adoration of the Shepherds*	1618	Canvas	49 × 37
	Stockholm	National Museum	*The Wife of Candaules*	1648	Canvas	76 × 62
	Vienna	Kunsthistorisches Museum	*The King drinks*	1659	Canvas	97 × 120
Lanfranco, Giovanni (1580-1647)	Florence	Pitti	*St Margaret of Cortona*			
	Madrid	Prado	*The Burial of Julius Caesar*		Canvas	132 × 192
	Naples	Gesù	Decoration of dome	1634-1635	Frescoes	
	Naples	San Martino	Decoration	1637-1639	Frescoes	
	Naples	Santi Apostoli	Decoration		Frescoes	
	Naples	Duomo	Decoration of Saint Januarius chapel	1641-1644	Frescoes	
	Naples	Capodimonte Museum	*Angel holding Satan in Chains*		Canvas	
	Naples	Capodimonte Museum	*St Peter walking on the Water*		Canvas	
	Paris	Louvre	*Hagar in the Desert*		Canvas	54 × 63
	Rome	San Carlo ai Catinari	*Annunciation*	About 1615	Canvas	117 × 72
	Rome	San Carlo ai Catinari	Decoration of apse	1646	Frescoes	
	Rome	San Agostino	Decoration of Buon Giovanni chapel	1615-1616	Frescoes	
	Rome	San Paolo fuori le Muri	Decoration	1621-1625	Frescoes	
	Rome	San Giovanni dei Fiorentini	Decoration	1621-1625	Frescoes	
	Rome	Villa Borghese	Decoration	1621-1625	Frescoes	
	Rome	San Andrea della Valle	Decoration of dome	1625-1627	Frescoes	

Name	Town	Museum	Title	Year	Type	Dimensions (in inches)
Largillière, Nicolas de (1656-1746)	Dijon	Museum	*Portrait of a Man*		Canvas	36 × 28
	London	National Gallery	*Portrait of a Man*		Canvas	31 × 25
	Paris	Louvre	*Portrait of Le Brun*	1686	Canvas	91 × 74
	Paris	Louvre	*Portrait of the Painter, his Wife and Daughter*		Canvas	59 × 79
	Paris	Louvre	*Portrait of Nicolas Coustou*		Canvas	38 × 30
	Paris	Saint-Etienne-du-Mont	Ex-voto		Canvas	
La Tour, Georges de (1593-1652)	Berlin	Kaiser-Friedrich-Museum	*Lamentation over St Sebastian*	About 1649	Canvas	63 × 51
	Besançon	Museum	*St Joseph, Carpenter*		Canvas	49 × 42
	Nantes	Museum	*Lute Player*	Before 1640	Canvas	64 × 41
	Nantes	Museum	*Denial of St Peter*	1650	Canvas	47 × 63
	Nantes	Museum	*St Joseph and the Angel*	1630-1645	Canvas	37 × 32
	Paris	Louvre	*Adoration of the Shepherds*		Canvas	42 × 54
	Paris	Louvre	*The Magdalene with the Night-light*	1630-1635	Canvas	50 × 37
	Rennes	Museum	*The New-born*	After 1635	Canvas	30 × 36
Le Brun, Charles (1619-1690)	Florence	Uffizi	*Jephtha's Sacrifice*	1656	Canvas	52 dia.
	Florence	Uffizi	*Self-portrait*	1684	Canvas	32 × 25
	Lyons	Museum	*Louis XIV adoring the Risen Christ*			
	Moscow	Pushkin Museum	*Christ crucified*		Wood	20 × 16
	Paris	Louvre	*Martyrdom of St Andrew*	1647	Canvas	
	Paris	Notre-Dame	*Martyrdom of St Stephen*	1651	Canvas	158 × 123
	Paris	Saint Nicolas du Chardonneret	*Crucifixion of St Andrew*	1646	Canvas	42 × 39
	Paris	Louvre	*Crucifix with Angels*	1649	Canvas	69 × 50
	Paris	Louvre	*Christ in the Desert*	1653	Canvas	154 × 99
	Paris	Louvre	*Infant Jesus sleeping*	1655	Canvas	34 × 46
	Paris	Louvre	*Descent of the Holy Spirit*	1656	Canvas	125 × 104
	Paris	Louvre	*Chancellor Séguier*	About 1657	Canvas	116 × 138

Name	Town	Museum	Title	Year	Type	Dimensions (in inches)
	Paris	Louvre	*Meleager's Hunt*	1658	Canvas	122 × 201
	Paris	Louvre	Life of Alexander: *Triumph of Alexander* *Passage of the Granica* *Battle of Arbela* *Alexander and Porus*	1666-1668	 Canvas Canvas Canvas Canvas	 177 × 279 185 × 476 185 × 498 185 × 498
	Venice	Accademia	*The Meal in the House of Simon*	About 1653	Canvas	158 × 131
	Versailles	Musée National	*Conquest of the Franche-Comté*	1674	Canvas	37 × 55
	Versailles	Musée National	*Portrait of Turenne*		Canvas	26 × 20
Le Nain, Antoine (1588-1648) Louis (1593-1646) Mathieu (1607-1677)	Cologne	Wallraf-Richartz Museum	*The Gardener*		Canvas	26 × 20
	London	National Gallery	*A Woman and Five Children*	1642	Canvas	9 × 11
	Madrid	Prado	*Episcopal Benediction*		Canvas	38 × 46
	Paris	Notre-Dame	*Crucifixion*	1646	Canvas	
	Paris	Louvre	*Peasants' Meal*	1642	Canvas	38 × 48
	Paris	Louvre	*Peasant Family in an Interior*	About 1643	Canvas	45 × 63
	Paris	Louvre	*Henri de Montmorency*		Canvas	25 × 21
	Paris	Louvre	*The Smith in his Forge*		Canvas	27 × 22
	Paris	Louvre	*The Cradle*		Canvas	113 × 55
	Paris	Louvre	*The Haywain or the Harvest Home*	1641	Canvas	23 × 29
	Rheims	Museum	*Venus in Vulcan's Forge*	1641	Canvas	59 × 45
	Rome	Galleria d'arte antica	*The Young Singers*		Canvas	12 × 16
	Rotterdam	Boymans-Van Beuningen Museum	*Two Girls*		Canvas	16 × 12
Le Sueur, Eustache (1616-1655)	Brussels	Musée des beaux-arts	*Christ blessing*		Canvas	19 × 15
	Munich	Pinakothek	*Christ in the House of Martha*		Canvas	64 × 51
	Paris	Louvre	*St Paul preaching at Ephesus*		Canvas	135 × 129
	Paris	Louvre	*Jesus carrying His Cross*		Canvas	24 × 49
	Paris	Louvre	*St Scholastica appearing to St Benedict*	1645	Canvas	57 × 51
	Paris	Louvre	*Death of St Bruno*	1645-1648	Canvas	76 × 51
	Paris	Louvre	*Terpsichore*	1645-1648	Canvas	44 × 30

Name	Town	Museum	Title	Year	Type	Dimensions (in inches)
	Paris	Louvre	*The Angel of the Lord appearing to Hagar*		Canvas	63 × 45
	Paris	Louvre	*Hail, Mary!*		Canvas	117 × 89
	Paris	Louvre	*The Descent from the Cross*		Canvas	53 × 52
	Paris	Louvre	*Martyrdom of St Lawrence*		Canvas	69 × 38
	Paris	Louvre	*Melpomene, Erato and Polymnia*	1645-1648	Wood	51 × 51
Lorraine, Claude (1600-1682)	Berlin	Kaiser-Friedrich-Museum	*Italian Landscape*	1642	Canvas	38 × 52
	London	National Gallery	*Seaport*	1648	Canvas	59 × 79
	Madrid	Prado	*Landscape*		Canvas	82 × 57
	Madrid	Prado	*Wild Mountainous Landscape*		Canvas	63 × 93
	Paris	Louvre	*Seaport at Sunset*	1639	Canvas	41 × 54
	Paris	Louvre	*Village Party*	1639	Canvas	41 × 53
	Paris	Louvre	*View of a Seaport*	1646	Canvas	47 × 59
	Paris	Louvre	*David crowned King by Samuel*	1647	Canvas	47 × 59
	Paris	Louvre	*Louis XIII takes the Pas de Suse*	1651	Canvas	50 × 17
	Paris	Louvre	*Disembarkation of Cleopatra*	About 1647	Canvas	47 × 67
	Paris	Louvre	*Ulysses returns Cressida to her Father*		Canvas	47 × 59
	Paris	Louvre	*View of the Campo Vecchio, Rome*		Canvas	22 × 28
	Paris	Louvre	*View of a Port*	1646	Canvas	22 × 28
Magnasco, Alessandro (1667-1749)	Genoa	Palazzo Bianco	*Garden Scene*		Canvas	
	Milan	Museo-Poldi-Pezzoli	*Apotheosis of the Charity of St Charles Borromeo*		Canvas	
	Venice	Brass Coll.	*Stories of Polichinello*		Canvas	
	Venice	Brass Coll.	*Bacchanal*		Canvas	
	Venice	Brass Coll.	*The Novices*		Canvas	
Mignard, Pierre (1610-1695)	Berlin	Kaiser-Friedrich-Museum	*Portrait of Marie Mancini*	1661	Canvas	30 × 24
	Dijon	Museum	*The Artist and a Painter*		Canvas	32 × 28
	London	National Gallery	*The Marquise de Seignelay and her Two Children*	1691	Canvas	76 × 61

Name	Town	Museum	Title	Year	Type	Dimensions (in inches)
	Madrid	Prado	*Mademoiselle de Fontanges*		Canvas	41 × 35
	Madrid	Prado	*John the Baptist in the Desert*		Canvas	58 × 43
	Madrid	Prado	*Maria-Theresa of Austria*		Canvas	41 × 34
	Paris	Louvre	*The Virgin with Grapes*		Canvas	48 × 37
	Paris	Louvre	*Jesus on the Way to Calvary*		Canvas	59 × 72
	Paris	Louvre	*St Luke painting the Virgin*		Canvas	48 × 40
	Paris	Louvre	*Hope*		Canvas	19 × 24
	Paris	Louvre	*Louis de France, his Wife and Children*		Canvas	91 × 120
	Paris	Louvre	*Madame de Maintenon*		Canvas	51 × 37
	Paris	Saint-Eustache	*Circumcision*		Canvas	
	Versailles	Museum	*Mademoiselle de Blois blowing Bubbles*	About 1673	Canvas	52 × 38
Poussin, Nicolas (1594-1665)	Berlin	Kaiser-Friedrich-Museum	*The Nurture of Jupiter*	About 1639	Canvas	38 × 52
	Berlin	Kaiser-Friedrich-Museum	*Landscape with St Matthew*	1642	Canvas	39 × 53
	Chantilly	Musée Condé	*The Holy Family*		Canvas	27 × 20
	Chantilly	Musée Condé	*The Childhood of Bacchus*	1630-1635	Canvas	53 × 66
	Dresden	Art Gallery	*Flora's Kingdom*	1638-1640	Canvas	52 × 71
	Leningrad	Hermitage	*Tancred and Herminia*	About 1635	Canvas	39 × 58
	Leningrad	Hermitage	*Rest during the Flight to Egypt*		Canvas	
	Leningrad	Hermitage	*Landscape with Polyphemus*	1649	Canvas	59 × 75
	London	National Gallery	*Bacchanal before Pan*	Before 1630	Canvas	39 × 56
	London	National Gallery	*Cephalus and Aurora*	1630	Canvas	38 × 51
	London	National Gallery	*Adoration of the Golden Calf*		Canvas	61 × 84
	Madrid	Prado	*Parnassus*	About 1625	Canvas	56 × 77
	Madrid	Prado	*Meleager's Hunt*		Canvas	63 × 142
	Munich	Pinakothek	*Bacchus and Midas*		Canvas	39 × 53
	Paris	Louvre	*Philistines stricken with the Plague*	1630	Canvas	57 × 76
	Paris	Louvre	*Inspiration of the Poet*	About 1636	Canvas	72 × 84

Name	Town	Museum	Title	Year	Type	Dimensions (in inches)
	Paris	Louvre	*Rape of the Sabines*	1630	Canvas	63 × 81
	Paris	Louvre	*The Israelites gathering Manna*	1639	Canvas	59 × 79
	Paris	Louvre	*Winter*	1660-1664	Canvas	46 × 63
	Paris	Louvre	*Ruth and Boaz*		Canvas	46 × 63
	Paris	Louvre	*Moses saved from the Nile*	1647	Canvas	37 × 48
	Paris	Louvre	*Eliezer and Rebecca*	1648	Canvas	46 × 78
	Paris	Louvre	*Judgement of Solomon*	1649	Canvas	39 × 59
	Paris	Louvre	Self-portrait	1650	Canvas	39 × 26
	Paris	Louvre	*Orpheus and Eurydice*	About 1650	Canvas	49 × 79
	Paris	Louvre	*Death of Narcissus*			
	Paris	Louvre	*Arcadian Shepherds*	1638-1640	Canvas	34 × 47
	Paris	Louvre	*Apollo and Daphne*	1665	Canvas	
	Paris	Louvre	*Summer*	1660-1664	Canvas	46 × 63
	Rome	Vatican Gallery	*Martyrdom of St Erasmus*	1629	Canvas	
Preti, Mattia (1613-1699)	Madrid	Prado	*The Waterfall*		Canvas	69 × 82
	Madrid	Prado	*John the Baptist bids his Parents Goodbye*		Canvas	71 × 104
	Naples	National Museum	*Judith*		Canvas	
	Naples	National Museum	*St Nicholas of Bari*		Canvas	
	Naples	National Museum	*Prodigal Son*		Canvas	
	Naples	National Museum	*Jesus overcomes Satan*		Canvas	
	Naples	National Museum	*Absalom's Banquet*		Canvas	
	Naples	National Museum	*Belshazzar's Feast*		Canvas	
	Valmontone	Palazzo Doria-Pamphilj	*Element of Air*		Fresco	
Ribera, Jusepe (1588-1656)	Madrid	Prado	*Jacob's Dream*	1639	Canvas	71 × 92
	Madrid	Prado	*Archimedes*	1630	Canvas	50 × 32
	Madrid	Prado	*Martyrdom of St Bartholomew*	1630 or 1639	Canvas	92 × 92
	Madrid	Prado	*The Saviour*		Canvas	30 × 26
	Madrid	Prado	*The Burial of Christ*		Canvas	80 × 102
	Madrid	Prado	*The Holy Trinity*		Canvas	89 × 74

Name	Town	Museum	Title	Year	Type	Dimensions (in inches)
	Madrid	Prado	*Immaculate Conception*		Canvas	87 × 63
	Madrid	Prado	*St Peter, Apostle*		Canvas	30 × 25
	Madrid	Prado	*The Apostle St Paul*		Canvas	30 × 25
	Madrid	Prado	*St Andrew, Apostle*		Canvas	30 × 25
	Madrid	Prado	*St John the Evangelist*		Canvas	30 × 25
	Madrid	Prado	*St James the Greater*		Canvas	30 × 24
	Naples	National Museum	*The Communion of the Apostles*	1615	Fresco	
	Naples	Charterhouse, San Martino	*Descent from the Cross*	1637	Canvas	
	Naples	Charterhouse, San Martino	*The Twelve Prophets*	1643	12 frescoes	
	Naples	Cathedral	*St Januarius saved from the Flames of the Furnace*	1647	Canvas	
	Naples	National Museum	*St Bruno*		Canvas	
	Naples	National Museum	*St Sebastian*		Canvas	
	Naples	National Museum	*Drunken Silenus*	1626	Canvas	
	Paris	Louvre	*Adoration of the Shepherds*	1650	Canvas	90 × 71
	Paris	Louvre	*The Club Foot*	1642	Canvas	65 × 36
	Vienna	Kunsthistorisches Museum	*Jesus at the Age of 12 amongst the Teachers of the Law*	About 1625	Canvas	51 × 69
Rigaud, Hyacinthe (1659-1743)	Dijon	Museum	*Portrait of A. Coysevox*		Canvas	17 × 13
	Dijon	Museum	*The Sculptor Girardon*	1705	Canvas	31 × 26
	Dresden	Art Gallery	*Augustus III, Elector of Saxony*	1715	Canvas	99 × 68
	Madrid	Prado	*Louis XIV*		Canvas	93 × 59
	Paris	Louvre	*Bossuet*	1699	Canvas	95 × 65
	Paris	Louvre	*Philip V, King of Spain*	1700	Canvas	91 × 61
	Paris	Louvre	*Louis XIV in his Coronation Robes*	1701	Canvas	110 × 75
	Paris	Louvre	*Cardinal de Polignac*	1715	Canvas	55 × 43
	Paris	Louvre	*Le Brun*		Canvas	51 × 57
	Paris	Musée Carnavalet	*Portrait of an Unknown Man*		Canvas	21 × 16
	Perpignan	Musée Rigaud	*Cardinal de Bouillon*	1708	Canvas	108 × 85
	Perpignan	Musée Rigaud	*Crucifixion*	1696	Canvas	38 × 26

Name	Town	Museum	Title	Year	Type	Dimensions (in inches)
Rosa, Salvatore (1615-1673)	Florence	Pitti	*The Bridge*	1640	Canvas	42 × 50
	Florence	Pitti	*Cavalry Engagement*		Canvas	99 × 138
	Florence	Pitti	Self-portrait	1660	Canvas	29 × 24
	Florence	Uffizi	*Allegory of Peace*		Canvas	53 × 80
	Florence	Uffizi	*Battle*		Canvas	58 × 38
	London	National Gallery	Self-portrait		Canvas	45 × 36
	Madrid	Prado	*Seashore*		Canvas	67 × 102
	Milan	Brera	*St Paul the Hermit*		Canvas	132 × 136
	Milan	Brera	*Purgatory*		Canvas	113 × 72
	Paris	Louvre	*Battle*		Canvas	
	Paris	Louvre	*Saul and the Witch of Endor*		Canvas	
	Rome	Galleria Capitolina	Scenes of Witchcraft		Canvas	
	Rome	Galleria d'arte antica	*Portrait of Lucrezia, the Artist's Wife*	1650	Canvas	26 × 20
Rubens, Peter-Paul (1577-1640)	Amsterdam	Rijksmuseum	*Anne of Austria*	About 1620	Wood	41 × 29
	Antwerp	Cathedral	*Descent from the Cross*	1615	Canvas	
	Antwerp	Musée des beaux-arts	*Incredulity of St Thomas*	About 1613	Canvas	56 × 48
	Antwerp	Musée des beaux-arts	*Last Communion of St Francis*	1619	Canvas	166 × 89
	Antwerp	Musée des beaux-arts	*Christ between the Two Thieves*	1620	Canvas	169 × 123
	Berlin	Kaiser-Friedrich-Museum	*Charles V's Conquest of Tunis*	1620	Canvas	30 × 47
	Berlin	Kaiser-Friedrich-Museum	Landscape	About 1630	Canvas	24 × 39
	Brussels	Musée des beaux-arts	*Negro Heads*		Canvas	20 × 26
	Brussels	Musée des beaux-arts	*Venus in Vulcan's Forge*	1622	Canvas	71 × 79
	Brussels	Musée des beaux-arts	*Martyrdom of St Lievin*	1635	Canvas	179 × 137
	Dresden	Pinakothek	*Judgement of Paris*	1625	Canvas	19 × 25
	Florence	Pitti	*George Villiers, Duke of Buckingham*	1625	Canvas	25 × 19

Name	Town	Museum	Title	Year	Type	Dimensions (in inches)
	London	National Gallery	*Le Chapeau de Paille*		Wood	31 × 22
	London	National Gallery	*Conversion of St Bavo* (3 panels)		Wood	43 × 65
	London	National Gallery	*The Fall of the Damned*		Canvas	
	Madrid	Prado	*Adoration of the Magi*		Canvas	136 × 192
	Madrid	Prado	*Judgement of Paris*		Canvas	78 × 149
	Madrid	Prado	*The Garden of Love*	1635	Canvas	78 × 112
	Madrid	Prado	*Adam and Eve*	1628-1629	Canvas	93 × 58
	Madrid	Prado	*St Paul*		Wood	43 × 33
	Milan	Brera	*Institution of the Eucharist*		Canvas	120 × 99
	Munich	Pinakothek	*Ferdinand of Spain*	1628-1629	Canvas	46 × 25
	Munich	Pinakothek	*Hélène Fourment*	1630-1631	Canvas	38 × 27
	Munich	Pinakothek	*Landscape with Rainbow*	About 1635	Wood	37 × 48
	Munich	Pinakothek	*Battle of the Amazons*	About 1615	Wood	48 × 65
	Munich	Pinakothek	*Last Judgement*	About 1620	Wood	60 × 47
	Munich	Pinakothek	*Drunken Silenus*		Canvas	84 × 84
	Munich	Pinakothek	*The Rape of the Daughters of Leucippus*		Canvas	87 × 82
	Munich	Pinakothek	*Meleager and Atalanta*	1635	Canvas	78 × 56
	Paris	Louvre	*Disembarkation of Marie de' Medici*	1622	Canvas	155 × 116
	Paris	Louvre	*Flight of Lot*	1625	Canvas	30 × 47
	Paris	Louvre	*Kermesse*	About 1635	Wood	59 × 103
	Paris	Louvre	*Portrait of Hélène Fourment with her Children*	About 1636	Wood	45 × 32
	Paris	Louvre	*Resurrection of Lazarus*		Wood	15 × 11
	Rotterdam	Boymans-Van Beuningen Museum	*Portrait of a Monk*	About 1610	Wood	16 × 11
	Rotterdam	Boymans-Van Beuningen Museum	*All Saints*	About 1612	Wood	23 × 15

Name	Town	Museum	Title	Year	Type	Dimensions (in inches)
	Rotterdam	Boymans-Van Beuningen Museum	*The Three Crosses*	About 1620	Wood	38 × 24
	Rotterdam	Boymans-Van Beuningen Museum	*Coronation of the Virgin*	1620	Wood	7 × 11
	Rotterdam	Boymans-Van Beuningen Museum	*Story of Achilles* (7 panels)		Wood	
	Rotterdam	Boymans-Van Beuningen Museum	*Minerva and Mars*	1628-1632	Wood	16 × 11
	Rotterdam	Boymans-Van Beuningen Museum	*Diana's Bath*	1635-1640	Canvas	60 × 47
	Vienna	Kunsthistorisches Museum	*Jesus with St John and Two Angels*	About 1620	Canvas	30 × 48
	Vienna	Kunsthistorisches Museum	*Angelica sleeping*	1626	Wood	18 × 26
	Vienna	Kunsthistorisches Museum	*Magdalene and Martha*	About 1616	Canvas	81 × 62
	Vienna	Kunsthistorisches Museum	*St Ignatius curing the Possessed*	1619	Wood	41 × 29
	Vienna	Kunsthistorisches Museum	*Hélène Fourment in a Fur Cloak*	1639	Wood	69 × 38
Sacchi, Andrea (1599-1661)	Berlin	Kaiser-Friedrich-Museum	*Supposed Portrait of Alessandro del Borro*		Canvas	80 × 48
	Berlin	Kaiser-Friedrich-Museum	*The Drunken Noah*		Canvas	50 × 64
	Berlin	Kaiser-Friedrich-Museum	*Allegory*		Canvas	32 × 40
	Madrid	Prado	Self-portrait			26 × 20
	Rome	Capucins	*Miracle of St Anthony*		Canvas	
	Rome	Palazzo Sacchetti	Decoration		Frescoes	
	Rome	Palazzo Barberini	*Divine Wisdom*		Fresco	
	Rome	San Carlo ai Catinari	*St Anne*		Canvas	
	Rome	Vatican Museum	*Vision of St Romuald*			
Saraceni, Carlo (1585-about 1625)	Frascati	Hermitage: Camaldolites	*Rest during the Flight to Egypt*	1606	Canvas	71 × 49

ame	Town	Museum	Title	Year	Type	Dimensions (in inches)
	Rome	Santa Maria dell' Anima	*Miracle of St Beno*	1617-1618	Canvas	
	Rome	Santa Maria dell' Anima	*Martyrdom of St Lambert*	1617-1618	Canvas	
	Rome	Sant' Adriano	*Preaching of St Romuald*	About 1614	Canvas	
	Rome	Galleria d'arte antica	*St Cecilia*	1610	Canvas	68 × 55
nyders, Frans 579-1657)	Antwerp	Musée des beaux-arts	*Swans and Dogs*		Canvas	54 × 77
	Antwerp	Musée des beaux-arts	*Still-life*		Canvas	46 × 41
	Antwerp	Musée des beaux-arts	*Still-life: fish*		Canvas	79 × 133
	Brussels	Musée des beaux-arts	*Animals and Fruit*		Canvas	56 × 93
	Brussels	Musée des beaux-arts	*The Larder*		Canvas	66 × 113
	Brussels	Musée des beaux-arts	*Stag Hunt*		Canvas	87 × 165
	Leningrad	Hermitage	*The Fishwife*		Canvas	
	Leningrad	Hermitage	*The Fish Stall*		Canvas	
	Madrid	Prado	*The Vixen and the Cat*		Canvas	71 × 41
	Madrid	Prado	*The Boar Hunt*		Canvas	43 × 76
	Madrid	Prado	*Two Dogs in a Larder*		Canvas	39 × 57
	Madrid	Prado	*A Dog with its Prey*		Canvas	41 × 69
	Madrid	Prado	*The Hare and the Tortoise*		Canvas	44 × 33
	Madrid	Prado	*The Lion and the Rat*		Canvas	59 × 41
	Madrid	Prado	*Cock Fight*		Canvas	62 × 79
	Madrid	Prado	*The Cook*		Canvas	74 × 100
	Madrid	Prado	*Stag Hunt*		Canvas	48 × 61
	Paris	Louvre	*Concert of Birds*			
limena, ancesco 657-1747)	Florence	Uffizi	*Diana and Callisto*		Canvas	65 × 54
	Madrid	Prado	*St John the Baptist*		Canvas	33 × 28
	Naples	San Paolo Maggiore	*Fall of Simon Magus*	1689-1690	Frescoes	

Name	Town	Museum	Title	Year	Type	Dimensions (in inches)
	Naples	San Domenico	Decoration of ceiling	1709	Frescoes	
	Naples	San Paolo Maggiore	*Conversion of St Paul*	1689-1690	Frescoes	
	Naples	Gesù	*Heliodorus driven from the Temple*	1725	Fresco	
	Paris	Louvre	*Heliodorus driven from the Temple*		Canvas	59 × 79
van Dyck, Anthony (1599-1641)	Amsterdam	Rijksmuseum	*Mary Magdalene*		Canvas	67 × 59
	Amsterdam	Rijksmuseum	*Frans van der Borght*	1630-1632	Canvas	81 × 54
	Amsterdam	Rijksmuseum	*William II and his Wife Mary Stuart*	1641	Canvas	72 × 56
	Antwerp	Musée des beaux-arts	*Martin Pepyn*	1632	Canvas	28 × 22
	Antwerp	Musée des beaux-arts	*Pietà*	1636	Canvas	45 × 82
	Berlin	Kaiser-Friedrich-Museum	*Portrait of a Genoese Lady*	About 1632	Canvas	79 × 46
	Berlin	Kaiser-Friedrich-Museum	*Deposition*		Canvas	103 × 80
	Brussels	Musée des beaux-arts	*Martyrdom of St Peter*	About 1619	Canvas	80 × 46
	Brussels	Musée des beaux-arts	*Drunken Silenus*	About 1620	Canvas	52 × 43
	Florence	Pitti	*Charles I of England and Henrietta Maria*		Canvas	26 × 32
	Florence	Pitti	*Rest in Egypt*		Canvas	53 × 63
	London	National Gallery	*Charles I on Horseback*		Canvas	144 × 114
	London	National Gallery	*Crucifixion*		Canvas	26 × 20
	Madrid	Prado	*Charles I of England*		Canvas	48 × 33
	Milan	Brera	*Portrait of a Man*		Canvas	26 × 22
	Munich	Pinakothek	*George Patel*	About 1622	Canvas	29 × 22
	Munich	Pinakothek	*Flight into Egypt*	1627-1630	Canvas	53 × 45
	Paris	Louvre	*Charles I*	1635	Canvas	107 × 84
	Paris	Louvre	Self-portrait		Canvas	27 × 23
	Paris	Louvre	*Virgin with Donors*		Canvas	99 × 73
	Paris	Louvre	*Rinaldo and Armida*		Canvas	99 × 73

me	Town	Museum	Title	Year	Type	Dimensions (in inches)
	Vienna	Kunsthistorisches Museum	*St Rosalie*	1629	Canvas	109 × 83
	Vienna	Kunsthistorisches Museum	*Carolus Scribani*	1629	Canvas	47 × 41
	Vienna	Kunsthistorisches Museum	*Jacopo de Cachiopin*	1634-1635	Canvas	44 × 33
	Vienna	Kunsthistorisches Museum	*Venus in Vulcan's Forge*	1630-1632	Canvas	46 × 61
gnon, Claude 593-1670)	Dresden	Art Gallery	*Adam and Eve after the Fall*		Canvas	
	Dresden	Art Gallery	*Adam and Eve driven from Paradise*		Canvas	
	Grenoble	Museum	*Jesus among the Doctors*	1623	Canvas	60 × 88
	Paris	Louvre	*Esther before Ahasuerus*	1624	Canvas	
	Rennes	Museum	*St Catherine the Martyr*		Canvas	42 × 32
uet, Simon 590-1649)	Lyons	Musée des beaux-arts	Self-portrait	About 1627	Canvas	42 × 32
	Lyons	Musée des beaux-arts	*Love and Psyche*	Before 1636	Canvas	44 × 65
	Lyons	Musée des beaux-arts	*Christ Crucified*		Canvas	85 × 58
	Madrid	Prado	*Portrait of a French Princess*		Canvas	74 × 33
	Munich	Pinakothek	*Judith*		Canvas	38 × 28
	Paris	Louvre	*Christ Crucified*		Canvas	43 × 31
	Paris	Louvre	*Faith*		Canvas	76 × 54
	Paris	Louvre	*Presentation in the Temple*	1641	Canvas	155 × 99
	Paris	Louvre	*Wealth*	About 1640	Canvas	67 × 49

Principal Exhibitions of Baroque Art

1922 Florence, Pitti Palace, "Italian painting in the 16th and 17th centuries".

1925 London, Royal Academy, "Rembrandt, Frans Hals and the Dutch 17th-century masters".

1925 New York, "Dutch 17th-century masters".

1927 Berlin, "Italian painting in the 17th and 18th centuries".

1933 Dresden Art Gallery, "Baroque painting".

1935 Paris, Petit Palais, "Exhibition of Italian art from Cimabue to Tiepolo".

1935 Wiesbaden, "Italian painting of the 17th and 18th centuries".

1937 Marseilles, "Dutch painting in the 17th century".

1938 Naples, "Neapolitan painting in the 17th century".

1938 Genoa, "Genoese painting in the 16th and 17th centuries".

1941 Aix-en-Provence, "Caravaggio and European Caravaggism".

1945 Florence, "French painters in Italy and Italian painters in France".

1946 Rome, "French painters in Italy and Italian painters in France".

1952 Paris, Orangerie, "The still-life from Classical antiquity to the present time".

1954 London, Arcade Gallery, "Italian influence on French, Flemish and Dutch painting from 1550 to 1650".

1954 São Paolo, "From Caravaggio to Tiepolo, Italian painting in the 17th and 18th centuries".

1954 Bologna, "Guido Reni exhibition".

1955 London, "17th-century artists in Rome".

1955 Rome, "Caravaggio and the Caravaggists".

1955 Paris, Heim Gallery, "Caravaggio and French painters of the 17th century".

1955 Bordeaux, "Painting in Spain and France around Caravaggio".

1956 Bologna, "Carracci exhibition".

1956 Rome, Cortona, "Pietro da Cortona exhibition".

1958 Paris, Petit Palais, "17th-century French masterpieces from provincial museums".

1958 Munich, "Rococo".

1959 Bologna, "17th-century Emilian masters".

1960 Paris, Louvre, "Poussin exhibition".

1960 Washington, National Gallery of Art, "French art from 1600 to 1715".

1961 London, National Gallery, "From Van Eyck to Tiepolo".

1961 Rouen, "Nicolas Poussin and his times".

1961 Paris, Louvre, "Carracci drawings".

1961 Sarasota, "Baroque paintings in Naples".

1962 London, Hazlitt Gallery, "Baroque and Rococo paintings".

1962 Bologna, "Classicism and landscape painting".

1962- Dayton, Hartford, Sarasota, "Genoese
1963 masters from Cambiaso to Magnasco".

1963 Versailles, "Le Brun exhibition".

1963 Turin, "Piedmontese Baroque".

1963 Naples, "Caravaggio and the Caravaggists".

1964 Athens, "Caravaggio and the Caravaggists".

1964 Memphis, "Luca Giordano in America".

1964 Naples, "Still-life painting in Italy".

1965 Paris, Louvre, "Caravaggio and Italian 17th-century painting".

Dictionary

Albani (Francesco Albani) (1578-1660)

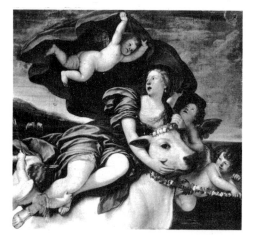

A Bolognese painter and pupil of Annibale Carracci, he retained from his master's teaching only what could charm. Much patronised by the aristocracy, he started his career in Bologna with a *St Catherine* and a *Magdalene* as well as *The Adventures of Aeneas* in the Palazzo Fava. He went to Rome, where he started a period of intense activity in the decoration of the sumptuous Roman palaces. He worked with Domenichino and Annibale Carracci on the paintings in the Aldobrandini Chapel (1602-1603) which are now in the Galeria Doria—*The Virgin and St Joseph looking for Shelter* and *The Assumption*. He collaborated with Annibale Carracci on the frescoes for San Giacomo degli Spagnoli (now in Madrid and Barcelona). He worked in the Quirinal, in 1611 painted an *Assumption* for Santa Maria della Pace in Rome, designed some medallions for the Palazzo Veraspi on the Corso and decorated the Palazzo Giustiniani in Bassano di Sutri (1609-1610). In Mantua, he decorated the

Villa Favorita (1621-1623) and at the same time started the vast series of mythological scenes from the lives of Venus and Diana, now in the Louvre. Between 1625 and 1628, he worked for Maurice of Savoy and produced the *Four Elements* and the frescoes of Santa Maria di Galliera in Turin (1639-1641) and the *Noli me tangere* for the Servite church in Bologna. He lost all the considerable wealth he had earned and was obliged to work till the day he died, painting endless repetitions.

Anguier (The Anguier Brothers)
French 17th-century sculptors

Anguier, François (1604-1669)

He completed his training in Rome. Amongst his best works are the statues of *Hope* and *Security* in the Musée Carnavalet in Paris, the Henri de Chabot monument and the mausoleum of the Duke of Montmorency (Moulins, Lycée chapel), without doubt his finest work.

Anguier, Michel (1614-1686)

Born at Eu, died in Paris. He was a much finer artist than his brother François. He stayed in Rome for ten years. He worked with his brother on the Montmorency mausoleum. In Moulins, he produced a *Crucifix*, a *Virgin* and a *St John*. Fouquet was one of his patrons and commissioned from him a considerable number of statues for his château at Vaux. In 1665, Anne of Austria asked him to undertake all the sculpture for the small gallery in the Louvre. He also worked for the Queen on the Val-de-Grâce and carried out the high-reliefs on the Porte Saint-

Barocci
*Portrait of Prince Federigo
of Urbino as a child*
Lucca, Pinacoteca

Denis (1672-1674). He shows tremendous elegance and movement in his sculpture.

Apuzzo (Pietro d')

Seventeenth-century Neapolitan architect. He rebuilt the church of Saint Marcellus in Naples; the work started in 1626 and was finished in 1633.

Ávila (St Teresa of) (1515-1582)

Sixteenth-century Spanish saint, born in Ávila, died in Alba de Tormes, famous for her visions and ecstasies. She reformed the Carmelite order and with St John of the Cross founded several monastic establishments (seventeen for women, fifteen for men). Her writings are masterpieces of Christian mysticism and she has been judged worthy of enrolment as a Doctor of the Church. She is the patron saint of Spain. One should mention amongst her writings her *Life, Book of Foundations*, and *The Way of Perfection*. For the church of Santa Maria della Vittoria in Rome, Bernini produced his famous statue of the saint in ecstasy.

Azzolini, Giovanni Bernardo (about 1560-?)

Italian painter born in Naples. His greatest activity was in Genoa, where he arrived in 1610. He painted a variety of works in churches, convents and private houses. He did an *Annunciation* for the high altar of the Monache Turpini and a *Martyrdom of St Apollonia* in the church of San Giuseppe. One of his specialities was the modelling of small wax figurines, then much in demand.

B

Bamboccio (Pieter van Laer, known as) (between 1582/1613 to about 1642)

Painter of landscapes and everyday life in Italy, he was born in Haarlem. He came from a rich family and was a pupil of Adam Elsheimer. He went to Rome when he was quite young and became closely acquainted with Poussin and Claude Lorraine. His nickname (Bamboccio) apparently springs from the subjects he chose to paint. When he was in Haarlem, he worked with Gerrit Dou. In his lifetime, he was very successful and today his works are difficult to find and much appreciated. *The Herdsmen* is in the Louvre, *The Fountain* in the Dresden Museum and *Village Feast in the Roman Campagna* is in Vienna.

Barocci, Federico (1528-1612)

Italian painter and engraver, born in Urbino. He studied under Baptista

147

Franco, a talented Venetian artist. He did most of his work in his birth-place, Milan, in Genoa and Rome. When he was twenty, he went to Rome where he had much encouragement from Michelangelo. He admired Correggio for the charm of his style and tried to imitate him. In 1560, he became associated with Federico Zucchero, and Paul IV employed the pair of them on the decoration of the Palazzo del Bosco di Belvedere. His style of painting has great delicacy and his colours are subtly harmonious. In *The Deposition* (Perugia, 1569), he used colours of great purity. *The Madonna of the People* (1579, Pieve d'Arezzo) and *The Rest in Egypt* (Vatican) are charming though somewhat mannered compositions. In the Louvre, his *Circumcision*, all grey-blues and pinks, has fascinated painters for centuries. The *Madonna of the People* in the Uffizi is considered his masterpiece. He was the first artist from central Italy to use pastels. He is considered one of the exponents of Jesuit art. His *chiaroscuro* effects are sometimes slightly too emphasised.

Baroque

True meaning:

The word "Baroque" comes from the Portuguese *barroco* or *barrueco* (*berrueco* in Spanish), used to describe an irregularly shaped pearl or a roughly shaped rock.

The term "baroco" appears in a list of 13th-century syllogisms.

In 1531, it appeared in the French inventory of Charles V's inheritance: "97 gros ajorffes dictz barroques enfilez en 7 filletz".

In 1519, Erasmus and Vives attacked what they called "Baroque scholasticism".

Scholarly definition:

In the 18th century, M^{me} Roland wrote in a letter (6 April 1788): "I don't know if you argue *en baroco* or *en friscous*."

All 18th-century French dictionaries disagree as to the correct meaning of the term "baroque".

In 1727, Furetière wrote: "Jeweller's term used only for pearls which are not perfectly round."

In 1728, Richelet noted: "Jeweller's term. This word is used for pearls which are not properly round."

But in 1740, the *Dictionnaire de l'Académie* (3rd edition) said: "Also used in a figurative sense for irregular, peculiar, uneven. A baroque mind, a baroque expression, a baroque figure."

In 1777 the *Dictionnaire de Trevoux* stressed the scholastic meaning of the word "baroque": "We speak of a baroque turn of mind. In painting, a picture or a figure in a baroque manner, where the rules of proportion are ignored and where the representation follows the whim of the artist." In his "Memoire on the influence of Scholasticism on the French language", Rémusat wrote that "baroco" is "the probable etymology for baroque".

Italian also uses the adjective "baroque" in the figurative sense from the 18th century onwards. There are many examples: *discorsi barocchi* (D. Caracciolo, in 1763); *giudizio barocco* (P. Veri, in 1767).

J.-J. Rousseau defined Baroque music and added: "It seems that this word

148

comes from the term 'baroco' used as a term of logic."

Tuscan meaning:

The Tuscan expressions *barocci*, *baroccolo* and *barocchio* all relate to usury.
Aloïs Riegl, the Austrian art historian, brought this to light in 1905. Lionello Venturi also refers to this Tuscan meaning and gives the term "baroque" a link with cheating or deception. He quotes a book on perspective: *The Deceit of the Eyes*, published in 1625 by Pietro Accolti.

Dialect meanings:

The Latin etymology *barridus* and the Greek παρακόπτω seem unlikely. *Barrocus* is the name of a plant in *De Viribus Herborum* by Odo de Meung. Certain Italian dialects use the following expressions: *barrocchio pistoiese* (meaning a hook [?]), *barrocchio* or *birrocchio*. *Barroche* is used in the Abruzze.
The word *barocca* occurs in Catalan.
The *Grand Larousse Universel* has an example of the word "barocho" (in reality, "baiscco"), meaning a coin used in Sicily.
Bruno Migliorini (Il Vignola): "Etymologia e 'storia del termino 'Barocco'".

Other meanings:

The German linguist Klige-Götze (1936) accepts the relationship with Federico Barozzi or Barocci of Urbino.
One should also note the similarity with Giacomo Barozzi.
The Italian word *parrucca* has sometimes been suggested instead of the Portuguese *barrocco*.
In the *Grande Encyclopédie* the terms "baroche" and "barochée" occur as "painting terms used to signify that the brush has not followed the outline clearly and has splashed the background colour; as for instance: "Vous barochez toujours vos contours."

Definitions:

Littré: "Baroque: Of a displeasing strangeness; Baroque accoutrement; Baroque style. Formerly a jeweller's term: "... a necklace of Baroque pearls."
Larousse du XIXᵉ siècle: There are two quotations: "Average minds find the Baroque and the original very similar". "Baroque is a nuance of bizarre: it is, as it were, its refinement and indulgence."
P. Robert (1953) refers to the definitions: "bizarre, distorted, displeasing, peculiar, eccentric".
"All this tiny Japanese world, Baroque at birth and growing ever more so the older it became...." (Loti).
"Has a special reference to architecture. Baroque style departs from the accepted rules of Renaissance Classicism, seeks what is irregular, and misshapen, is striking in its strangeness. Baroque started in 16th-century Italy and later spread to other countries."

Baschenis, Evaristo (1617-1677)

Born in Bergamo, was in Holy Orders for a time and devoted himself exclusively—apart from a few portraits, such as the one in which he painted himself playing the spinet (Bergamo, Casa Agliardi)—to the depiction of fruit, animals, kitchen utensils and, above all, musical instruments; there is a clearly indicated source in Caravaggio: *Musical Instruments* (Bergamo, Galeria della Accademia Carrara)

149

and *Musical Instruments* (Brera Museum, Milan). This definite specialisation guarantees him a place in the history of the still-life as much for the severity of his compositions as for the delicate use of light.

Bellori, Giovanni Pietro (1636-1696)

Italian archaeologist, born in Rome, appointed by Clement X " Antiquario di Roma ". He was specially interested in Classical antiquity and had a fine collection of pieces. He wrote many works of which the most important is *The Lives of Modern Painters, Sculptors and Architects* (1672). He studied Caravaggio especially carefully.

Berain, Jean (1637-1709)

Architect, draughtsman and engraver. Born at St. Mihiel, died in Paris. In 1674 he was appointed official designer to the king and in his lifetime enjoyed a very fine reputation. He followed Lebrun in decorating various items for the king and made engravings of various ballets. His arabesques appear in the works of goldsmiths and wood-carvers and in marquetry, for he gave them patterns for all kinds of furniture.

Berenson, Bernhard (1865-1959)

Art historian and critic writing in English, born in Lithuania (Vilna), died in Florence. He studied in Boston and Harvard

where he met William James and studied at the universities of Berlin and Paris; in 1920 he settled in Florence. Amongst his many works one should mention: *Venetian Painters of the Renaissance* (1894), *Italian Painters of the Renaissance* (1931), *Sassetta* (1946) and *Sketch for a Self-portrait* (1955). His theories have made a considerable contribution to the history of art in the West. For him, art is sufficient unto itself; it is independent of time and background and establishes, as it were, a sort of language which enables the spectator to communicate and even collaborate with the artist.

Bernini (Gian Lorenzo) (1598-1680)

Italian architect, sculptor and painter, born in Naples, died in Rome, probably the most representative artist of the Baroque style. He came to Rome at the age of seven and was brought up there; he is truly a part of the city, for his tremendously imaginative projects have contributed extensively to its décor. His father, a somewhat mediocre Florentine painter and sculptor, gave him his first lessons; at a very early age he had his first commission from Cardinal Scipio Borghese—four statues (now in the Villa Borghese), in which he gave to the marble an appearance of flexibility and movement later to be made even more wonderful in his *Ecstasy of St Teresa* (1644-1651, Santa Maria della Vittoria). It was this same astonishing virtuosity which gave such intensity of feeling to the famous busts of Cardinal Borghese (1622), Costanza Banarelli (about 1632, Bargello, Florence) and Louis XIV (1665,

Versailles). But it is possibly in the architectural compositions which form the tombs of Urban VIII (1642-1647), Alexander VII (after 1671) and Clement IX, all three in Saint Peter's, that he gives free rein to his predilection for opulent sumptuosity.

To Bernini comes the praise for having finished Saint Peter's. A protégé of Urban VIII, he was put in charge of the work in 1629. He decorated the nave magnificently, blending marbles of different colours, amassing bronze and gold and false stucco curtains, liberally scattering enormous angels and huge restless saints. The baldaquin over the main altar, finished in 1633, and the enormous pulpit (1675) are the largest known works in gilded bronze. In the niches of the four pillars holding up the dome, the artist placed four huge statues.

Without forgetting the work he did in the Palazzo Barberini from 1629 onwards, it is during the period 1655-1667—the pontificate of Alexander VII—that Bernini showed his mastery of the architect's calling. Saint Peter's was given the setting it needed with the Scala Regia and its Ionic columns and the famous elliptical colonnade with its terraces supporting 162 gigantic statues. Bernini also stresses the solemnity of Baroque art in the churches he built: in 1658-1662, the one in Castel-Gandolfo; in 1658, San Andrea al Quirinale in Rome, his favourite work; and, in 1662-1664, the Collegiata in Ariccia.

His secular creations contributed equally to the beauty of Rome: his spectacular fountains (the Fountain of the Four Rivers in the Piazza Navona, as well as the fountains in the Piazza Barberini and the Piazza di Spagna) are superbly fantastical; on the Ponte Sant' Angelo stand his elegant Angels; at the end of the narthex of Saint Peter's looms the astonishing statue of Constantine.

Bernini was not too proud to help organise vast entertainments with fantastic décors, mechanical devices, chariots, portable stages and marvellous tricks with water and lighting. He drew caricatures, some of which are in the Galleria Nazionale at the Palazzo Corsini. He is said to have painted over two hundred pictures. His reputation spread all over Europe and Louis XIV summoned him to Paris, where he was received in great style. His sense of grandeur, his powerful imagination and his epic mind made his contemporaries compare him to Michelangelo.

Blanchard (1630-1704)

Court painter. He did a ceiling at Versailles and several pictures for the Trianon.

Boel or **Bol,** Pierre (1622?-1674?)

Artist specialising in animals and still-life. Born in Antwerp, died in Paris. He

151

stayed in Rome and Genoa before working in Paris and Antwerp where his etchings were very successful.

Borghese, Ippolito

Italian painter of the late 16th century. Born in Naples, he was a pupil of Francesco Curia. In Naples Museum hang an *After the Descent from the Cross* and a *Pietà*, which show the influence of Raphael and Andrea del Sarto.

Borrekens, Jean-Baptiste (1611-1675)

Born and died in Antwerp. Brother-in-law of David Teniers. There is an *Apotheosis of Hercules* by him in the Prado.

Borromeo, St Charles (1538-1584)

Scion of a famous family, nephew of Pius IV, he was appointed Archbishop of Milan at the age of twenty-two. He refused all his benefices and worked constantly to help the unfortunate and to care for the sick and needy. His devoted labours during the plague contributed to his early death at the age of forty-six. He made a major contribution to the Counter-Reformation.

Borromeo, Federigo (1564-1631)

Archbishop of Milan from 1595 to 1631. Like his cousin, he worked devotedly during the plague in Milan. He founded the Biblioteca Ambrosiana.

Borromini, Francesco Castelli (1599-1667)

Architect and sculptor, born in Bissone, died in Rome, considered the least restrained of the creators of the Baroque style. Of Lombard origin, he worked with Maderno and settled in Rome, where he worked on the monastery of San Philip Neri's Oratorians, building the clock-tower and the façade. For the Barberini family, he built San Ivo alla Sapienza (1642-1650) and gave the building the outline of the Barberini heraldic bee; he worked in Sant' Andrea delle Fratte (1654-1665) and at the Palazzo Falconieri; rebuilt the inside of San Giovanni in Laterano (about 1650); built San Carlo alle Quattro Fontane (1638-1641), a church composed of swaying, curving lines, Santa Agnese on the Piazza Navona (1635-1661), San Giovanni in Oleo (1658) and the Spada Chapel in San Girolamo. In his Baroque churches, the overall effect of great magnificence is increased by his habit of setting pieces of sculpture in unexpected places and by his use of polychrome marble. The dramatic tension of his architecture is due in part to the fact that he reaches a point of subtle disequilibrium. He is close to Caravaggio by virtue of his violent temperament and the general tendency of his art.

Bosschaert, Abraham (about 1586-after 1637)

Still-life painter, born in Antwerp. He lived in Amsterdam and many writers believe him to be the father of Abraham Bosschaert, born in 1612.

Bosschaert, Ambroise (about 1570-1721)

Flower painter, born in Antwerp. Dean of the Middleburg Guild from 1597-1617.

Bosschaert, Jean-Baptiste (1667-1746)

Painter of flowers and fruit, born and died in Antwerp.

Bosschaert or **Willeborts,** Thomas (1614-1654)

Painter of historical scenes and etcher, born in Bergen-op-Zoom, died in Antwerp where he had settled. He worked for the Stadtholders William II and Frederick-Henry.

Bosse, Abraham (1602-1676)

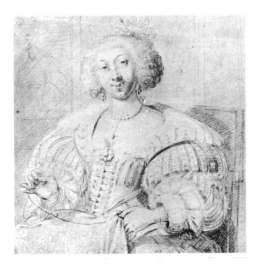

French engraver, born in Tours, died in Paris, equally famous as designer, architect, painter and writer. Son of a tailor, he went to work in Paris very early and in

1622 engraved *The Virgin and the Infant Jesus.* He was very attracted by Callot's work and soon showed admirable technical skill in his engravings. Some 1,450 are still in existence. Amongst his painted works are *The Foolish Virgins* (Musée Cluny, Paris) and an *Interior* in Douai Museum. He was, in addition, a notable architect and a writer of independent and caustic wit.

Boucquet, Victor (1619-after 1677)

Painter of portraits and historical scenes. There is a *Standard-Bearer* in the Louvre. Pictures in Nieuport and Ostend.

Bourdon, Sebastien (1616-1671)

French painter and engraver, born in Montpellier and died in Paris; he was the son of a Calvinist master glassmaker. He went to Rome at the age of eighteen. In 1643 he painted a votive picture for the chapter of Notre-Dame, *The Martyrdom of St Peter.* He was one of the founders of the Royal Academy of Painting and Sculpture and in 1652 was appointed official court painter to Christina of Sweden. Two years later, he returned to France, where his talent was unanimously acknowledged. In 1635 he painted the ceiling of the Hôtel de Bretonvilliers *(Fable of Phoebus and Phaeton)* and in the Tuileries painted *The Deification of Hercules.*

Brosse, Salomon de (1565-1626)

French architect, born in Verneuil-sur-Oise, died in Paris; he worked under

153

Henri IV and Louis XIII. In Paris, he built what is probably his masterpiece—the Luxembourg Palace—as well as the Salle des Pas-Perdus in the Palais de Justice, the Protestant church at Charenton, the Auteuil aqueduct, and the façade of Saint Gervais; the latter caused a sensation at the time. Brosse was a man of skill and intelligence, deeply imbued with a feeling for the architecture of ancient France.

de Brosses, Charles (known as Président) (1709-1777)

Magistrate and French writer, born in Dijon, died in Paris. He was twice exiled from Dijon, where he was the first Président of the Parlement, for showing too much independence. Voltaire had him dismissed from the French Academy. He led an agreeable Epicurean existence. He published a *History of the Roman Republic during the 7th Century* (1777) but owes his fame mainly to his *Family Letters*, which deal with the journey he made in Italy in his youth.

Brouwer, Adriaen (about 1605-1638)

Flemish painter and engraver, born in Oudenarde. Originally a pupil of Frans Hals who is said to have exploited his talents quite shamelessly, Brouwer went to settle in Amsterdam, then in Antwerp, where he led a very wild life. Imprisoned for debt, he was released on the intervention of Rubens and died of plague at the age of thirty-two. Drinking scenes, joyful revels, portraits of peasants show Brouwer to be a lively portrait painter full of fantasy and expressive power.

Brueghel, Jan (called Velvet Brueghel) (1568-1625)

Born in Brussels, died in Antwerp, he came to Antwerp when very young and stayed there till his death. He stayed in Italy for a short time in about 1593. The success of his paintings led the Archbishop of Milan to commission pictures from him (now in the Brera Museum, Milan). In 1597, he became Master of the Corporation of St Luke. Two sons, eight grandsons and four great-grandsons all became painters. Velvet Brueghel specialised in small paintings; his qualities were many—great technical skill, a vivid imagination, a talent for brilliant colours, a very real sense of poetry. Nature gave him the inspiration for several charming works. He tried most types of painting. Four museums have especially fine collections—Madrid (52 paintings), Munich

(41 paintings), Dresden (33 paintings) and Milan (29 paintings).. In Antwerp, he painted a number of pictures for the Archduke Albert and the Archduchess Isabella—*The Five Senses* and the *Four Elements* (Prado); next, he started on historical scenes such as *The Battle of Arbela* (Louvre) and *The Preaching of St Norbert* (Brussels); he did some genre paintings: *The Fish Market* (Munich) and many canvases of animals. He excelled in flower-painting: *Flora* (Genoa, Palazzo Durazzo) or *The Garland* (Munich); there were also such works as *Venus and Cupid* (Prado). He painted a number of Earthly Paradises, the best of which is in The Hague. He was a painter of great charm and a master of landscape.

Burckhardt, Jacob (1818-1897)

Swiss historian and writer, born in Basle. Professor at the Zurich Polytechnic and the University of Basle, he produced a number of works which established his reputation as an historian, specialising in the history of art and civilisation. The principal ones are *The Times of Constantine the Great* (1853), *Cicerone* (1855), *The Civilisation of the Renaissance in Italy* (1860), *The History of Greek Civilisation* (1868) and *Considerations on Universal History* (1890). In each art form he saw the reflection of a particular civilisation and he set aesthetic phenomena in their historical context.

Caffieri (The)

A family of artists of Italian origin, descendants of Daniel Caffieri, Papal Engineer (1603-1639). They settled in France in the 17th century and many of them held the post of master sculptor of the king's ships, which passed from father to son.

Caffieri, Philippe (1634-1716)

He held the post under Louis XIV. A wood carver, son of Daniel Caffieri, born in Rome, died in Paris. He was associated with Le Brun as director of works for the royal castles; he worked at Versailles, the Louvre, the Tuileries, St-Germain-en-Laye and Marly. He also made furniture and in particular the superb panels for the doors of the Escalier des Ambassadeurs (1678).

Cairo, Francesco del (1598-1674)

Italian painter, born in Varese, died in Milan, nicknamed the Cavaliere del Cairo. He was a pupil of Morazzone. He studied Classical painting in Rome and Venice. Summoned to Turin by Prince Victor-Amadeus I, he produced paintings for most of the palaces, villas and churches in the town. The most important are in the Dresden Museum (*Venus and Apollo*), the Brera Museum in Milan (*St Xavier*), and the Vienna Museum (*Portrait of a Man*). He specialised in portraits and historical subjects.

Callot, Jacques (1592-1635)

French engraver, born in Nancy, pupil of Claude Henriet and painter to the Duke of Lorraine. He ran away from home twice to get to Rome but each time was caught and brought back. In 1609, he got permission to go. He worked with a print-seller and familiarised himself with the use of the graving tool; next, he went to Florence where he was received by the Grand Duke Cosimo II. He engraved *Purgatory* and *The Battles of the Medici.* He entered the service of the architect Giulio Parigi and learnt the use of aqua-fortis for etching. In 1615 he engraved the plates for *The War of Love*; in 1619, he did those for *Florentine Fête* and some scenes for *The Tragedy of Suliman.* He was fascinated by picturesque poverty and luxurious clothing, but felt little attraction for bourgeois scenes, as can be seen from his *Caprices* (finished in 1617). He had much influence in Florence. When Cosimo II died, he returned to Lorraine at the request of the Duke Charles IV. He published his *Nobility* and *Beggars* series, the last of the *Hunchbacks* (*I Gobbi*) and the *Balli.* From this time onwards, he engraved only battle scenes, dramatic episodes and religious scenes; for the Infanta Clara Eugenia he engraved the huge *Siege of Breda.* Louis XIII commissioned him to engrave scenes of *The Siege of St Martin-de-Ré* and *The Siege of La Rochelle.* His *Miseries of War* offer a superb and tragic vision; his last work was a *Temptation of St Anthony.*

Caracciolo, Giovanni Battista
(about 1570-1637)

Born in Naples, he started as a pupil of Fabrizio Santafede, but later went to study with the Carracci and with Caravaggio. He specialised in altar-pictures and frescoes for churches in Naples. The museum there has an *Assumption* and a *St Cecilia.*

Caravaggio (Michel Angelo Merisi, known as) (1573-1610)

Lombard painter, born in Caravaggio, died in Pont'Ercole. Son of a mason, he went to Milan at an early age to learn painting from Simone Peterzano, himself keenly interested in problems of light. He soon reacted against art inspired by Classical antiquity and grew more absorbed in pictures typified by violent contrast. He was not initially very successful and lived in considerable poverty. In about 1589 he went to Rome and collaborated with the Cavaliere d'Arpino. His first success came with his religious pictures (*Rest during the Flight into Egypt* and *The Magdalene* in the Galleria Doria). His passionate, fantastical nature led him to seek tragic effects. Between

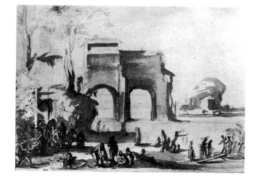

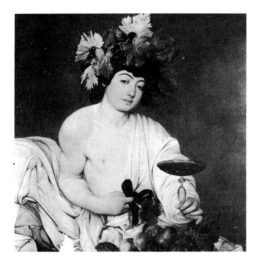

Caravaggio
The Young Bacchus
Florence, Uffizi

1590 and 1600 he was working in San Luigi dei Francesi on a series of paintings for the Saint Matthew chapel in which he tried to set his religious scenes in a context that was expressive, human and sometimes brutal. The two pictures in Santa Maria del Popolo, painted at the opening of the new century, are of an even greater luminous plasticity, whilst *The Madonna of the Pilgrims* (about 1603) bears the stamp of a broader social view. He painted a few genre pictures with street settings: fortune-tellers, card-players. His crude and violent imagination sometimes hints at a wilful desire for scandal, as for instance in the ambiguous *Bacchus* (Galleria Borghese) and the *Eros* (Berlin Museum). His new and extraordinary lighting effects stressed the contrast between deep shadow and bright light. His mature compositions show a feverish distress. His huge religious canvases are imbued with a deep spiritual feeling: *The Death of the Virgin*, painted for Santa Maria della Scala, and the *Seven Works of Mercy*, for Pio Monte della Misericordia in Naples. In *The*

Beheading (Malta), *The Entombment of St Lucy* (Syracuse) and *The Raising of Lazarus* (Messina), the idea of death pervades everything in the picture. Caravaggio's restless life ended in a series of adventures: imprisonment, duels, brawls. He fled towards Naples, Malta and Sicily. Wounded in the course of a scuffle, he was returning to Rome when he died of a fever. He was less than thirty-seven. His revolution, less radical than some have believed, sets him alongside the Carracci as one of the great innovations of the 17th century.

Carracci (The)

The brothers Annibale and Agostino with their cousin Lodovico have a place in the history of art as much for the Academy they founded in Bologna as for their works. Their teachings were in direct opposition to Mannerism and they trained some first-class painters, notably Guido Reni, Francesco Albani and Domenichino.

Carracci, Annibale (1560-1609)

The most gifted of the Carracci. Born in Bologna in 1560, died in Rome in 1609, he painted his first works at the age of eighteen, then, after a visit to Venice, he and Agostino, under the direction of Lodovico, started the decoration of the Palazzo Fava in Bologna (1584) inspired by the Vatican Loggie. He tried all possible genres: religious and profane pictures, genre painting, landscapes. The vast number of his experiments sets him

157

at the very heart of this period in which a new Classicism developed by means of newer and more revolutionary forms of Caravaggesque origin and in which the tradition of the Renaissance slowly matured. It was in this climate that his first important works were conceived: *The Assumption*, now in the Dresden Museum (1587), the one in Bologna Museum, the *Pietà* in Parma Museum, the Louvre *Resurrection*, and *The Woman of Samaria at the Well*, now in the Brera Museum. When he arrived in Rome in 1595, he was put in charge of the decoration of the Palazzo Farnese and his masterpiece took shape in the great gallery here, a work of admirable richness and breadth whose largest composition shows *The Triumphal Procession of Bacchus and Ariadne*, a mythological theme taken from Ovid (a collection of drawings now in the Louvre show how this was developed by Carracci). He spent four years on this task and at the end was paid a mere 500 *scudi*. This injustice almost sent him out of his mind and he died in Rome in 1609, practically poverty-stricken. Amongst his last works, one should mention *Christ and the Woman of Samaria* (Vienna Museum), *Pietà* (Louvre), *The Three Marys* (Castle Howard) and *Domine, quo vadis?* (National Gallery).

Carracci, Agostino (1557-1602)

Like Leonardo, he had an inquiring mind and at the Carracci Academy he taught general culture and theory of art. He was an engraver and by this means made Venetian painting better known. His

Crucifixion (after Tintoretto, 1582) was enormously successful. He worked in Bologna with Annibale and Lodovico on the Palazzo Fava (1584), the Gessi chapel, San Bartolomeo, the Palazzo Magnani and the Palazzo Sampieri (1593-1594) where his *Hercules and Atlas* and *Hercules and Cacus* are very fine, in spite of their extraordinary contorsions. He was involved, with his brother, in the decoration of the Palazzo Farnese in Rome, but a series of violent quarrels brought this partnership to an end; this was due to some extent to Annibale's excitable temperament. Agostino left Rome and painted a room in the Garden Palace in Parma. During this period, he painted the *Assumption* now in the Bologna Museum. His most famous painting, *The Last Communion of St Jerome*, also hangs there.

Carracci, Lodovico (1555-1619)

Slow and stodgy, the eldest Carracci made up for his lack of talent by sheer hard work. He is the true founder of the

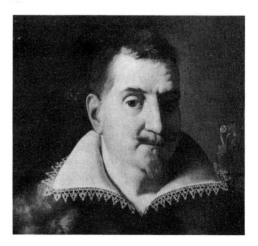

famous Academy which was frequented by scholars and writers as well as by artists. He worked with his cousins on various projects and, with his pupils, painted the cloister of San Michele in Bosco in Bologna (1604-1605). He was hard-working and produced plenty of paintings, but they are all cold. His main works are *The Conversion of St Paul* (1587, Palazzo Magnani), *The Adoration of the Magi* (Brera, Milan), the *Madonna degli Scalzi* (1588) and the *Madonna delle Convertite* (Bologna). He died in Bologna.

Castel Sant'Angelo, Rome

Built by Hadrian to house his remains and those of his successors. In the 6th century it was used as a fortress against the invading Goths. In the 7th century, Boniface IV built on the roof of the building a chapel dedicated to the Holy Angel in the Clouds. In the 14th century, the castle became the property of the Popes who linked it to the Vatican by means of a fortified corridor. Inside are the papal apartments decorated by Perino del Vaga, pupil of Raphael.

Cavagni, Giovanni Battista (?-1600)

Sixteenth-century Italian architect. In 1574 he redesigned the monastery and church of Saint Gregory, acknowledged as one of the most elegant in Naples. In 1588 he built the Monte di Pietà.

Cavallino, Bernardo (1622-1654)

Italian painter, born in Naples, pupil of Andrea Vaccaro. He was later influenced by Ribera, Velasquez and Van Dyck. Works by him may be seen in the Naples Museum, the Palazzo Corsini in Rome and the Verona Museum.

Cerano (Giovanni or Gian Battista, Crespi, known as Il Cerano) (1557-1633)

Milanese painter, he was appointed official court painter and from 1629 was in charge of the cathedral building operations. His charming pictures show the influence of Barocci, with skilful use of silvery light, but are possibly a little affected. The Brera Museum has a *Virgin between St Dominic and St Catherine*.

Ceresa, Carlo (1609-1679)

Italian painter, born in San Giovanni Bianco, died in Bergamo. He was the pupil of D. Crespi and probably also of Guido Reni; he specialised in painting portraits and historical scenes. He painted many pictures for churches in the Bergamo area; some of them may be seen in the Galleria Carrara in Bergamo.

Cesari, Giuseppe (known as the Cavaliere d'Arpino) (1568-1640)

Born in Arpino, died in Rome. Between 1589 and 1591 he painted the dome of San Martino in Naples. He was sent to Rome to work with other artists in the Vatican. He had commissions from many Cardinals, and many Popes (Sixtus V, Clement VIII, Paul V and Urban VIII) overwhelmed him with favour. He visited France. Later in his career he had

Philippe de Champaigne
Presumed portrait of Cardinal Bérulle
Rome, Coll. of Baron de La Tournelle

differences with the Carracci and Caravaggio. Amongst his best works were the fresco of the *Assumption* (Chapel of the Passion of St Prassede in Rome); the decoration in 1596 of the Conservatori Palace in Rome; the *Life of St John* in the baptistery of Saint John Lateran; and the fresco in the Paolina chapel in Santa Maria Maggiore. He also painted a number of altar-pictures for many churches in Rome. His use of colour was very pleasing, his composition fluent, but rather elaborate.

Champaigne, Philippe de (1602-1674)

French painter, born in Brussels, died in Paris. He started his apprenticeship at the age of twelve with the artist Bouillon, then moved on to study with the miniaturist Michel de Bourdeaux. In 1621 he set out for Rome, but stopped for a while in Paris where he became acquainted with Poussin, who had some influence on him. He painted Jansenius and became interested in his religious doctrines. In

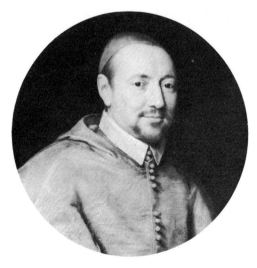

1628, he married Duchesne's daughter and was awarded the title of painter to Marie de' Medici. As director of the building works at the Luxembourg, his fame and fortune were ensured. He did his first large work in about 1630 when he painted six pictures for the Carmelites in the Rue St Jacques (*Nativity, Circumcision, Adoration of the Magi, Presentation in the Temple, Raising of Lazarus* and *Assumption*). Richelieu commissioned him to paint the ceiling in the Palais-Cardinal and he was later asked to decorate the dome of the Sorbonne. In 1631 came a large painting, *Louis XIII kneeling before Christ*, then *Louis XIII conferring the Order of the Saint-Esprit on the Duc de Longueville*. In 1649 and 1652 he painted two famous pictures for the Hôtel de Ville in which he portrayed the newly elected magistrates. His reputation grew. Portrait of *Cardinal Richelieu, Self-portrait, The Dead Christ*. He was deeply marked by the death of his wife and several of their children and sought consolation in religion. His links with Jansenism and Port-Royal became stronger. All his ardent belief is seen in the portraits of *Mère Angélique, St Cyran, Antoine Arnauld* and *The Last Supper* (Louvre). It was the strength of his piety which made the *Portrait of Mère Catherine-Agnès and Sœur Catherine de St Suzanne* a masterpiece of purity. The painting was an act of thanks for the miraculous recovery of his daughter, Sœur Suzanne.

Chapel of the Holy Shroud, Turin

Chapel attached to Turin Cathedral, built by Guarini in the period 1668-1694. The

cupola, something of an architectural curiosity, is about 170 feet high. The urn containing the Holy Shroud stands on the altar. The chapel was built to house this sacred relic, the winding sheet which is supposed to have wrapped the body of Christ and on which, it is believed, the image of his body may still be seen. The relic was the subject of considerable controversy during the 19th century.

Charterhouse of San Martino

Many paintings by Ribera are housed in this monastery near Naples: *The Twelve Apostles*, the pictures of *Moses* and *Isaiah* and two of his masterpieces, *The Communion of the Apostles* and *The Descent from the Cross*.

Châtillon or Chastillon, Claude (1547-1616)

French engineer, architect, designer and engraver, born at Châlons-sur-Marne, died in Paris. He is responsible for some extremely fine topographical drawings, notably those in *Topographie française* (1641).

Clement VIII (Hippolyto Aldobrandini) (1536-1605)

Born in Fano, died in Rome, elected Pope in 1592. He brought out an edition of the *Vulgate*. He gave absolution to Henri IV of France in 1592 and planned with him a secret alliance of Christian princes against the infidel Turk. He showed his respect for intellectual talents by raising Bellarmin, du Perron and Tolet to the cardinalate. His efforts to re-establish Roman Catholicism in England were unsuccessful.

Conforto, Giovanni di Giacomo (?-1631)

Italian architect. He finished the church of San Martino which Dosio had started. Apart from the campanile of the Carmine (1622), he built three churches in Naples: San Severo al Pendino, Sant' Agostino-in-Vincoli (1603-1610) and Santa Teresa (1602-1612).

Coninck or Koninck, David de (1646-after 1699)

Painter of animal pictures, born in Antwerp. He stayed in Rome for many years (hence his nickname *Romelaer*) and died in Brussels.

Corenzio, Belisario (about 1588-about 1643)

Italian painter, born in Greece, died in Naples. He was a pupil of Tintoretto in Venice and went to Naples in about 1590; here, he undertook an enormous composition, *The Feeding of the Forty Thousand*. He had a jealous nature and made life a misery for his contemporaries, especially Domenichino. He painted frescoes in three churches in Naples: San Marcello, San Martino and San Patrizio.

Corradini, Antonio
(end of the 17th century-1752)

Sculptor, born in Este, died in Naples, pupil of Tarsia. After 1718, he was extremely active in Italy, Austria and Germany. In 1720, he decorated the new Bucentaur in Venice. In 1730 he went to Vienna and the following year sculpted *The Marriage of Mary* for the Hohen Markt fountain (after a model by Fischer von Erlach) and also the tomb of St John Nepomuk, designed by the same architect. In Dresden, he worked on a number of decorative groups and marble vases. On his return to Italy, he worked in Rome and Naples where he sculpted the statue of *Modesty* for San Severino, his last and most famous work. He was an excellent designer and endeavoured to reproduce in marble the fluid effects of painting.

Cortona, Pietro Berretini da (1596-1669)

Born in Cortona, he went to Rome at an early age and became the pupil of Baccio Ciarpi; he was deeply impressed by Bernini. He started out in extreme poverty. He had many commissions in Rome and Florence. In Rome, his reputation was established by the frescoes of Santa Bibiana (1624-1626) and those of the Villa Sacchetti at Castel Fusano (1626-1629). From 1633 to 1629, he worked on the ceiling of the Palazzo Barberini, his most famous undertaking. He created a sumptuous style of decoration in which garlands of flowers, stucco and golden frames and allegorical figures abound. This art of contrast is distin-

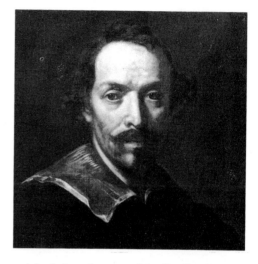

guished by the careful distribution of characters, perspective effects seen from below and skilful use of lighting effects. In the service of the Medici family in Florence, he decorated the rooms of the Pitti Palace (1640); in Rome, he painted the frescoes of the Galleria of the Palazzo Pamphilj (1651-1664) and for Innocent X he decorated the apse and dome of the Chiesa Nuova (1648-1660). Pietro da Cortona was at the same time an architect of stature. He built the marvellous church of Santi Martina e Luca (1635-1650), set in the Forum, a building which offered the first example of a curved front. In 1656 he built the façade of Santa Maria della Pace and in 1658 that of Santa Maria in Via Lata. Together with Bernini in sculpture and Borromini in architecture, Cortona was one of the three great masters of Roman Baroque.

Cossiers, Jan (1600-1671)

Born and died in Antwerp. Painted historical scenes, was a pupil of Cornelis de Vos and worked with Rubens.

Coypel, Antoine (1661-1722)

French painter, born in Paris, son of the painter Noel Coypel. He went to Italy very early, his father being the Director of the Roman Academy. Bernini had too much influence on him, and his faces never lost a "grimacing" sort of expression. Very much an infant prodigy, he returned to Paris at the age of fifteen and became a member of the Academy in 1681. At the same time he was appointed official painter to Monsieur the king's brother. He painted a most skilful composition for the roof of the chapel at Versailles, *The Eternal Father in Glory*. From then onwards, he chose his themes from stories and incidents in the Bible. In a superbly theatrical décor, he presented *Esther before Ahasuerus* (Louvre); it was essentially the same as an 18th-century history painting. In 1714 he was appointed Director of the Academy. In 1715, the Regent commissioned him to decorate the Palais-Royal. The *Assembly of the Gods* was his largest composition and his goddesses were modelled on the most beautiful ladies at court. He had a very great influence on the art of his period. The Académie des Inscriptions asked him to design portrait medals of Louis XIV. He was working on a series of paintings from the *Iliad* when he died at the age of sixty-one.

Craesbeeck, Joos van (1606-1654)

Flemish painter, born in Neerlinter. He was originally a baker, but turned to painting under the influence of Brouwer. He specialised in genre paintings and religious scenes. He died in Brussels.

Crayer, Gaspard de (1584-1669)

Flemish painter, born in Antwerp. Friend of Rubens and Van Dyck. He worked in Ghent at the court of the Cardinal-Infante before he was appointed court painter in Madrid. He returned to Ghent in 1664 and died five years later, leaving an important body of work mainly devoted to historical scenes and altar-pieces.

Crespi, Daniele (1590-1630)

Italian painter, much influenced by the Carracci. The Brera Museum in Milan has a fairly well-known *Last Supper* by him. He did some work for the Pavia Charterhouse and the Palazzo Ducale in Mantua before dying of the plague at the age of forty.

Croce, Benedetto (1866-1952)

Italian politician and critic, born in Pescasseroli, died in Naples. A Hegelian philosopher, he had a great influence on the thought of his time. As Senator and later, in 1920, as Minister, he refused to give his support to Fascism and drew up his *Manifesto for anti-fascist intellectuals*. In Naples, he founded the Italian Institute for Historical Research. He published over eighty works; some deal with literary and political history, others expound his philosophy. His aesthetic theories appear in his *Breviary of Aesthetics*. He maintained that intuition played a basic role in every creation and he advocated the independence of the artist. He had great confidence in reason and attacked the doctrines of art for art's sake and Futurism.

163

Cross, St John of the (1542-1591)

Spanish theologian. He was a member of the Carmelite order and was soon notable for his austerities. He worked with St Teresa to found the reformed Carmelites—the Discalced Carmelites (1580). He wrote a number of mystical works and was canonised by Benedict XIII in 1726.

Cucci, Domenico

Italian cabinet-maker and worker in marquetry and metal. From 1664 onwards he worked in the Gobelins factory and produced cabinets decorated with mosaics made from jasper and multi-coloured stones, finishing them off with sumptuous bronze appliqué-work. He was also in charge of all metalwork at Versailles.

Curia, Francesco (1538-1610)

Italian painter, born in Naples. He spent some time in Rome, where he grew familiar with the works of Raphael and other masters. He worked mainly on paintings for churches in Naples; one of the finest, *The Circumcision of Christ*, is in the Pietà. He started a school of painting in Naples. The museum there has a *Madonna* and a *Holy Family with Saints*.

Desportes, Alexandre-François (1661-1743)

French painter, son of a wealthy farmer from Champagne. He studied with a

Flemish painter, Nicasius, then travelled in Poland where he stayed for two years. Back in Paris, he was specially appointed to paint Louis XIV's hunting scenes. He was a man of great sincerity and simplicity. A series of studies and sketches he made for more detailed paintings are preserved at the Sèvres factory and show him to be a simple, direct observer of nature. He stayed in England for a long period. He decorated all the royal residences and prepared eight large compositions for the Gobelins as well as five for Compiègne, including the *Stag at Bay*. The Louvre has two portraits and nineteen hunting scenes or still-lifes. Other pictures are in Stockholm, Leningrad and Prague.

Domenichino (Domenico Zampieri) (1582-1641)

Born in Bologna, pupil of the Carracci Academy; worked with Annibale on the Palazzo Farnese. His youthful works reflect the serious teachings and thoughtful eclecticism of Lodovico, his first master. The influence of the Carracci teaching is equally evident in his frescoes for San Gregorio al Celio in Rome (*Flagellation of St Andrew*) and his work in the Abbey of Grottaferrata (*The Life of St Nilus and St Bartholomew*). His works were mostly

of a religious nature: *The Communion of St John* (Vatican), *Guardian Angel* (Naples Museum), *Pietà* and *St Cecilia* (both in the Louvre). Between 1616 and 1618, he completed the frescoes in the Villa Aldobrandini (*The Legend of Apollo*, now in the National Gallery) and in 1617 painted the famous *Diana* for the Galleria Borghese: this is a painting which achieves an admirable balance between Baroque and Classicism.

Dosio, Giovanni Antonio (1553-1609)

Italian architect, born in Florence, died in Rome. In Florence, he designed the Gaddi Chapel in Santa Maria Novella and the Palazzo Giacomini. In 1589, he left his birthplace to go to Naples, where he redesigned the Charterhouse of San Martino and started the church of San Philip Neri.

Du Cerceau, Baptiste (1560-1602)

French architect, from a famous architect family. In 1578 he succeeded Pierre Lescot as architect for the Louvre and in the same year started the Pont-Neuf. He built the Valois Chapel in Saint Denis.

Elsheimer, Adam (1578-1610)

A German landscape painter who did most of his work in Italy. He settled in Rome in about 1600. His landscapes are idealised and his figures have little importance. His use of light and atmospheric night effects suggest that he was influenced by both Tintoretto and Caravaggio. His pictures are on a small scale and are always on copper. Rubens, Rembrandt and Claude all admired his work. Amongst his best works is a superbly lighted *Flight into Egypt* (now in Munich).

Errard, Charles (1601-1689)

French painter and architect, born in Nantes. He studied in Rome and on his return to Paris worked on the Louvre and the Tuileries. He drew up the plans for the church of the Assumption. He was one of the founders of the Royal Academy of Painting and in 1666 became director of the French Academy in Rome. He died there in 1689.

Fanzago, Cosimo (1593-1678)

Architect, sculptor and designer. Born in Clusone, died in Naples. His first works of sculpture were abandoned in favour of architecture. He worked mainly in Naples, adapting Bernini's style to his use, and had considerable influence. He built the cloister of the Charterhouse of San Martino (1623-1631), one of Naples' most elegant 17th-century buildings. He worked in the Abbey of Monte Cassino (about 1630) where he is thought to have re-

designed the church with three naves. In Naples, he built San Giorgio Maggiore and Santa Maria the Egyptian (Pizzo Falcone). Still in Naples, he drew up the plans for various other buildings: San Francesco Severino, San Fernando (1628), della Sapienza (1638-1641), the great chapel in the royal palace, and in Chiaia the churches of Santa Teresa (1650-1662) and the Ascension.

Feti, Domenico (1589-1624)

Born in Rome, died in Venice. At first, he worked in Mantua under the patronage of Cardinal Federigo Gonzaga and painted the cathedral frescoes on the *Feeding of the Forty Thousand*, a work filled with charming rustic details; in the Palazzo Ducale, he painted a series of portraits of the Apostles. He went to live in Venice in 1621 and decided to stay there permanently. He painted a series of parables, now scattered between Vienna, Dresden, Leningrad and Milan, the expression of a strong artistic feeling. His art is a happy marriage of pure Italian and more generalised European styles. He painted a considerable number of pictures on religious subjects, though his somewhat sturdy, earthy talent seemed to fit him for more realistic paintings. His best works include: *Melancholy, Nero, The Guardian Angel* (all three in the Louvre); *The Workers in the Vineyard* (Pitti, Florence); and *Meditation, The Good Samaritan, The Sower* (Accademia, Venice). The naturalist school, Courbet in particular, much admired Feti and he was a notable precursor of modern art.

Finson (or Fynson, or Finsonius), Louis (about 1580-1617)

A Provençal painter belonging to the Flemish school. He travelled in Italy and worked in Naples under the direction of Caravaggio and in Aix in the Peiresc Gallery. He painted altar-pictures and portraits. He painted a fine *Resurrection* (1610) for the church Saint Jean d'Aix. He was tragically drowned in the Rhône when only twenty-seven.

Fontana, Cesare

Italian architect active at the end of the 16th and beginning of the 17th century. He was the son of Domenico Fontana and inherited considerable wealth from his father as well as the title of chief architect to the King of Naples. His most famous building is that of Naples University, now converted into a museum.

Fontana, Domenico (1543-1603)

Italian architect and town-planner. He arrived in Rome in about 1563 and worked at the Quirinal Palace and Santa Maria Maggiore. Pope Sixtus V appointed him chief planner from 1585 to 1590. It was Fontana who planned the star-shaped lay-out of the roads leading from Santa Maria Maggiore, set up the obelisk of Caligula in the Piazzi di San Pietro and built the Aqua Felice aqueduct (1587). Also for Sixtus V, he built the Sistine Chapel in Santa Maria Maggiore and the Villa Montalta. When the Pope died, he left Rome and was appointed architect to the Kingdom of Naples in 1592. Whilst holding this post, he built the Carno aqueduct, the Palazzo Carafa, the church of Jesus and Mary and the new royal palace.

Fontana, Lavinia (1552-1602)

Italian woman painter, daughter of Prospero Fontana. She painted historical and religious pictures, but was particularly gifted in portrait painting. She married a wealthy amateur painter (Paul Zappi) who helped fill in some of the background detail of her pictures. She became official painter to Gregory XIII and was tremendously successful in Rome, where she painted portraits of members of the papal court and the aristocracy. Amongst her main works are *The Nativity of the Virgin, St Francis of Paola* (Bologna Museum); *Self-portrait, Portrait of Panigarola* (Florence); seven portraits in the Milan Museum; *Venus and Love* (Berlin Museum) and *The Holy Family* (Pinakothek, Dresden).

Fontana, Prospero (1512-1597)

Bolognese painter, pupil of Francussi da Imola. He went to France to work with Primaticcio at Fontainebleau. He worked mainly in Genoa and Rome. He was an imitator of Raphael with tremendous facility and talent. His virtuosity was astounding: in eighteen days he could finish the entire decorative scheme for a palace or a church. He was an excellent portrait painter and was summoned to Rome by Pope Julius III who appointed him one of his official painters. His masterpiece is the altar-picture *The Baptism of Christ* (1566), painted for the Poggi Chapel in San Giacomo Maggiore. Amongst his other works, one should mention *The Adoration of the Magi* (San Salvatore) and *St Alexis begging for Alms* (San Giacomo Maggiore). Milan Museum has an *Annunciation* by him and the Dresden Museum a *Virgin feeding the Baby Jesus*. His greatest claim to fame is that he was the master of the Carracci.

Fouquet, Nicolas (1615-1680)

French Surintendant des Finances, born in Paris. He amassed a considerable

167

Nanteuil
Portrait of Fouquet
Paris, Bibliothèque Nationale

Nicolas Francken
Pietà
Tours Museum

fortune in the course of his duties and used it to patronise men of letters, such as Molière and La Fontaine, and to build himself the magnificent Château de Vaux. The splendour of the opening party sent Louis XIV into a fit of jealousy and Fouquet was arrested on a charge of having subverted state funds to his own use (1664). His condemnation was followed by sixteen years' imprisonment at Pignerol, where he died in 1680.

Fracanzano, Francesco (?-1657)

Neapolitan painter. Both he and his brother Cesare were pupils of Jusepe Ribera, and Francesco in turn taught his brother-in-law Salvatore Rosa. He led a life of dissipation and was eventually condemned to death for a series of crimes. Some of his works can be seen in the Béziers Museum (*Spanish Weaver*), at Compiègne (a *Child*), and in the Prado (*Two Fighters*).

Franchoys (The)

Family name of three Flemish painters: Lucas the Elder (1574-1643); Lucas the

Younger (1616-1681), his son, pupil of Rubens and friend of Jordaens and Van Dyck, both painters of religious scenes; Lucas Elias, son of the former, died in 1670 (?).

Francken (The)

Name of a family of Flemish artists comprising five generations of painters. Nicolas (1520-1596) had four sons: Hieronymus I, known as the Elder (1540-1610); Frans I (1542-1616); Ambrosius I and Cornelis. The second generation bred the painters who flourished in the 17th century: Frans III (1607-1667), nicknamed Rubens Francken; Hieronymus III (born in 1611); and Ambrosius III (born in 1622) who worked in Antwerp.

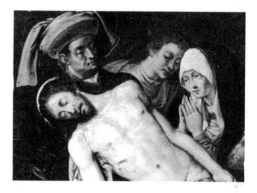

Fréart de Chantelou, Paul (1605-1694)

Art connoisseur and keen collector, born in Le Mans. He was the king's steward-in-ordinary and as such was sent to Italy in 1640 to bring Nicolas Poussin back to Paris. The two men became great friends. When Bernini came to Paris Chantelou was delegated to take care of him.

Furini, Francesco (1600-1646)

He owed his early artistic training to his father and he soon became the painter most sought after by the Florentine aristocracy. His *Creation of Eve* is in the Pitti Palace, *David and Abigail* is in the Palazzo Capponi and *Ila and the Nymphs* in the Palatine Gallery; he also painted frescoes in the Palazzo Corsini. A long stay in Venice brought a new attitude to the use of colour. He took holy orders in 1633 and became priest at Sant' Ansamo in Mugello, where he stayed almost until the end of his life. His religious and allegorical subjects sometimes have a rather indifferent look. The most famous works are: *Madonna of the Rosary* (1634), *St Mary of the Well* (Empoli), *St Francis praying*, *The Daughters of Lot* (Prado) and *St Lucy* (Galleria Spada, Rome).

Fyt, Jan (1609-1661)

Painter of animal pictures, born in Antwerp. He worked with Jordaens and possibly with Rubens. After a stay in Italy, he began to specialise in hunting scenes and left a remarkable body of work.

Galle, Jerome (the Elder) (1625-?)

A Flemish artist, specialising in flower paintings.

Gassendi (Abbé Pierre Gassend) (1592-1655)

French mathematician, philosopher and astronomer. He was a canon at Digne. His attacks on Aristotelian philosophy made him famous in Europe. He was specially interested in a moral system based on Epicureanism and a search for pleasure and tranquillity; he tried to reconcile these doctrines with Christianity.

Gentileschi, Artemesia (Signora Antonio Schiatessi) (1597-1651)

Painter of the Florentine school, born in Rome, died in Naples. She was the daughter and pupil of Orazio Gentileschi; she accompanied her father to England, where she painted some portraits of the nobility and produced a number of historical pictures for the king, the best being *David holding the Head of Goliath*. Her *Self-portrait* is at Hampton Court. There is a *Magdalene* in the Pitti Palace (Florence) and a *Birth of St John the Baptist* in the Prado.

Gentileschi, Lomi Orazio (1565-1647)

He worked in Florence with his brother Aurelio Lomi. His Florentine origins were always visible in his work. At the age of seventeen he went to live with his maternal uncle and took his name. He was influenced by Guido Reni and Caravaggio; he interpreted Caravaggio's style in a very personal fashion—bright colours, translucent shadows. In Rome, he painted frescoes in Santa Maria Maggiore and Saint John Lateran as well as pictures in

Santa Maria della Pace. There are several paintings by him in Ancona and Fabriano (Casa Agabiti). His *Ecstasy of St Cecilia* (Brera, Milan) also dates from this period (1605). In 1621 he went to Genoa where he met Van Dyck and painted his portrait. Called to France in 1624 by Marie de' Medici, he painted a *Rest during the Flight into Egypt* (Louvre), and in 1626 he went to England to work for Charles I. He stayed there till his death. He painted a number of works in Greenwich Palace and in the Duke of Buckingham's mansion, amongst which was *The Chastity of St Joseph* (Hampton Court). His influence in the north of Europe—especially in Holland—was considerable. Art critics have been able to attribute very few works to him with any certainty.

Giordano, Luca (known as Luca, fa presto) (1632-1705)

Neapolitan painter and interior designer. A great improviser, he was a pupil of Pietro da Cortona and Ribera and was influenced by Caravaggio. His virtuosity was prodigious—in a mere forty-eight hours he painted the roof of San Martino in Naples with pictures of *Judith* and *The Bronze Serpent*. *St Xavier baptising the Heathen* (Naples Museum) took three days. Until 1654, Giordano was influenced by Ribera's style, but his art gradually became brighter and more ethereal. The body of his *œuvre* is enormous, but religious and mythological scenes form a very large section of it. In 1682, he decorated the dome of Santa Brigitta in Naples. He worked in Florence between 1684 and 1686, decorating with frescoes the main

hall of the Palazzo Riccardi: he found extremely modern solutions for the problems posed here and his Neapolitan love of drama led him to paint splendid scenes of gods and goddesses riding on luxurious-looking clouds. In 1690, his work in Santa Maria della Salute in Venice was so much admired that he was summoned to Spain by Charles II and from 1693 to 1702 he painted enormous frescoes in the Escorial, in Toledo and Madrid. He produced a number of fine pictures showing biblical and allegorical scenes. Back in Naples, he gave a last demonstration of his strength and vitality by painting the frescoes for the sacristy in the Charterhouse of San Martino. He revealed the true elements of Baroque art to Naples and her artists. His most typical works are to be seen in Florence, Naples and Madrid.

Gissey, Henri de (1612-1673)

Designer of the king's ballets, born in Paris. His finest one was the famous *Carrousel* (1662), a work of superb taste and tremendous imaginative power.

Gonzalès Coques (about 1618-1684)

Flemish painter from Antwerp, pupil and brother-in-law of David III Ryckaert.

Gouwi or **Gowi,** Jacques-Pierre

Flemish painter who worked with Rubens on the decorations for the castle at Torre della Parada.

Grimaldi, Francesco (1543-about 1633)

Italian architect, one of the Theatines. Worked in Rome on the church of Sant' Andrea della Valle. He designed a number of large religious buildings in Naples, all characterised by their special " Neapolitan Baroque" décor: Sant' Andrea della Dame (1585-1590), San Paolo Maggiore (1590-1603), Santa Maria degli Angeli (after 1600), Santa Maria della Sapienza (after 1614), Santi Apostoli (1626-1633) and the Cathedral treasure chapel (1608-1630).

Guarini, Guarino (1624-1683)

An architect from Modena. He worked mainly in Piedmont where he popularised a rather grandiose Baroque style of somewhat severe disposition. He became a lay Theatine regular. As a theologian and mathematician trained in Rome, he taught in Sicily and Paris. In 1639, he started his novitiate in Rome, then became reader in philosophy in Modena. In about 1655 he went to Rome, then in 1660 went to Messina, where he built the Annunziata, in a style very typical of his previous work. He was invited to Paris by his fellow Theatines to design the church of Sainte-Anne la Royale (since destroyed). In 1666 he went to Savoy to enter the service of Charles-Emmanuel II and while there built the Palais Carignano (1679). In Turin, he designed San Lorenzo, the Palazzo of the Academy of Science, the sumptuous chapel of the Holy Shroud in the Cathedral (1680), a building with an extraordinary dome, and San Lorenzo, a most unusual and interesting church in which arches and balconies swing forward beneath a central dome. His style is packed with marvellous virtuosity and is very typically Baroque. His influence was considerable.

Guercino (Giovanni Francesco Barbieri, known as) (1591-1666)

He was called "Guercino" because he had only one eye. An Emilian painter born in Ferrara, he trained at the Carracci's Bologna Academy. His stay in Venice in 1618 was of great importance: from this period come *St William of Aquitaine* (1620, Bologna Pinacoteca) and *St Benedict and St Francis* (1620, Louvre). He was summoned to Rome by Pope Gregory XV in 1621 and decorated the Casino with two famous ceiling-paintings: *Aurora* and *Fame*. In 1623 he finished *The Burial of St Petronilla* (originally for Saint Peter's, but now in the Capitoline Museum). He was attracted by the work of Caravaggio, especially by his oppositions of light and shadow—which he imitated for all he was worth. Domenichino also influenced him. In 1625 he returned to Cento and in 1626 started the decoration of the dome of Piacenza Cathedral; this was a composition showing prophets and sybils. Towards the end of his life, his love for classical poetry led him towards a subtlety of style which was to appear more generally in the 18th century. His sentimental scenes are touchingly pathetic. He stressed the naturalism of his pictures (the bleeding wounds of Christ). His plastic strength is at its best in pagan subjects (*Venus* and *Mars and Cupid*, Modena Museum).

171

Guido Reni (1575-1642)

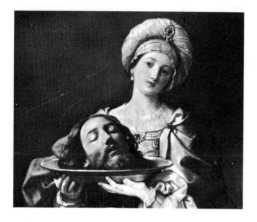

A Bolognese painter, he was one of the Carracci's most gifted pupils. He followed the general trend of contemporary artists and went to Rome, drawn by the splendour of its palaces and the wealth of its princes. The impact of his meeting with Caravaggio influenced his first masterpieces: *The Crucifixion of St Peter* (Vatican) and *St Paul and St Anthony in the Desert* (Berlin), where he makes use of very strong *chiaroscuro* effects. The same style is seen in the frescoes in San Gregorio al Celio, the martyrdom scene in the San Andrea chapel and in the picture of angels and musicians in that of Santa Silvia (all in Rome). He decorated the Pauline chapel of Santa Maria Maggiore and the dome of the Quirinal Palace (1610); all these works show strong dramatic concentration and a clear sense of arrangement. Amongst his finest mythological compositions two stand out particularly: the superb *Aurora* ceiling in the Casino Rospigliosi (about 1613) and the four *Hercules* pictures commissioned in 1620 for the Duke of Mantua (two of which are now in the Louvre). The most elegant

of his pictures is *Atalanta and Hippomenes* (Naples, 1625). Finally, he painted any number of Lucretias, Cleopatras and Magdalenes, all much admired then as now. He painted works of larger compass such as *The Plague Standard* (Bologna Pinacoteca); during the last years of his life, his rate of production increased enormously.

Imparato, Girolamo (born before 1565)

Neapolitan painter. He started by studying with his father Francesco Imparato, then went to work in Rome and Venice with Tintoretto and Palma Giovane. In Parma, he was influenced by the works of Correggio. He painted some very fine works in San Tommaso and San Severino in Naples. There is also an *Annunciation* in the town museum.

Janssens, Jean (1592-after 1650)

Flemish painter born in Ghent. The town museum has an *Annunciation* he painted.

Jordaens, Jacob (1593-1678)

Flemish painter. Son of a merchant, he went to work in Van Noort's studio in

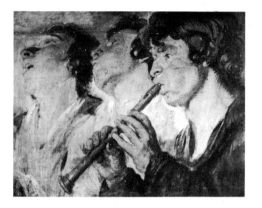

Jacob Jordaens
Three Strolling Musicians
Madrid, Prado

1607 and in 1616 married his daughter. He had a happy family life, full of hard work but enlivened by feasts and drinking bouts. He travelled in Italy and copied many paintings of the old masters. He joined the Guild of St Luke as a "water-colour painter" and in 1621 was appointed Dean of the Guild. In 1646 he was condemned for a text he had written which was judged heretical; he eventually abjured his religion and became a Protestant. Rubens admired his facility in painting and his splendid displays of colour—luminous blond shades and rich reds; Jordaens was one of the finest representatives of the naturalist tendency in Flemish painting. His production was abundant and varied. He specialised in scenes of ordinary life, packed with spirit and movement: *The Concert*, *The King Drinking*, *Pan and Syrinx* and *Portrait of an Armed Man with his Parents* (all in the Louvre). He painted scenes of revelry and mythological subjects with great facility. The tale of the peasant and the satyr appears over and over again. His temperament was less well suited to religious themes, but even so he painted a good number of them. Churches in Antwerp have a fair share of them: *Christ crucified* (Saint Paul); *The Martyrdom of St Apollonia* (Augustinians); *St Charles Borromeo* (Saint Jacques) He found equal inspiration in mythology: *The Triumph of Bacchus* (Brussels Museum); *Diana Resting* (Hermitage); *Jupiter and Amalthea* (Louvre). ... He was also a fine interior decorator. In 1641 he painted twenty-two pictures for Henrietta Maria's apartments in Greenwich Palace. For the Huis ten Bosch near The Hague he painted *The Triumph of Henry of Nassau*, possibly one of his best pictures; in addition, he decorated his own home and died at the age of eighty-five. His works have been engraved by the most outstanding artists in this field.

Jouvenet, Jean-Baptiste (1644-1717)

Born in Rouen, the son of a painter. He won second prize for drawing at the Royal Academy in Paris. In 1673 he painted *Jesus and the Paralytic* for Notre-Dame. Le Brun got him to work at Versailles and he was asked to join the Academy in 1675. He was very famous and extremely successful. As an interior decorator, he had great talent. Amongst his works one should mention: *The Apotheosis of the Apostles* (Invalides); four huge pictures for Saint-Martin-des-Champs, now in the Louvre; and a *Magnificat* for Notre-Dame. His larger works were sometimes painted a little too quickly. Most European museums have pictures by him.

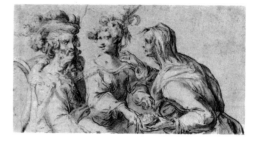

Lafosse, Charles de (1636-1716)

French painter, born in Paris. He worked as an interior decorator with Le Brun, Mignard and Jouvenet. He was a pupil of Le Brun and spent five years in Italy. In Paris, he painted frescoes for the wedding chapel of Saint Eustache and decorated the church of the Assumption in the Rue St Honoré. In London, he worked for Lord Montague. He was one of the artists called to decorate the Invalides; the frescoes on the dome and pendentives are from his brush.

La Hyre, Laurent de (1606-1656)

French painter, born in Paris. He was a pupil of Lallemand. He was much impressed by Primaticcio's work at Fontainebleau. He mainly painted religious pictures with backgrounds based on architectural motifs or classical ruins. He worked for the Carmelites in the Rue St Jacques and decorated the Hôtel Tillemont and the Hôtel Montoron in the Marais. He did some work for Richelieu in the Palais-Royal and rapidly became very much sought after; in 1635 he did a painting for Notre-Dame, *St Peter curing the Sick with his Shadow* (now in the Louvre). He followed this in 1637 with *The Conversion of St Paul*.

Lallemand, Georges (1575-1635)

French painter, born in Nancy, a pupil of Vouet. He was not especially talented, but very quickly became one of the most famous painters of the reign of Louis XIII. In 1630, he was commissioned to paint a picture for Notre-Dame in Paris and produced *St Paul and St Peter going to the Temple* and *St Peter curing a Sick Woman*. In 1633, the commission was renewed and this time he painted *St Stephen in Prayer before being Stoned*. He had many pupils, including Nicolas Poussin and Philippe de Champaigne.

Lanfranco, Giovanni (1580-1647)

A follower of Agostino and Annibale Carracci, he went to Rome in 1603. He worked in the Palazzo Farnese and collaborated with Guido Reni on the Pauline chapel in the Quirinal. In 1609, he went to Parma and painted a number of altarpieces for Piacenza and Parma. In 1612, he returned to Rome and painted the Palazzo Mattei frescoes (*The Annunciation*, now at San Carlo ai Catinari, 1615), decorated the Bongiovanni chapel in 1616, and between 1621 and 1625 decorated San Paolo furi le Mure, San Giovanni dei Fiorentini and the Villa Borghese; between 1625 and 1627 he painted the dome of San Andrea della Valle, the mainspring of illusionist Baroque in the 17th century. In 1634, he went to Naples and painted the dome of the Gesù (1634-1635), the

churches of San Martino, Santi Apostoli and the San Januarius chapel in the cathedral left unfinished by Domenichino. In 1646 he was in Rome painting the frescoes in the apse of San Carlo ai Catinari. Very Baroque in spirit, he specialised in foreshortenings and perspective treatments.

Largillière, Nicolas de (1656-1746)

Son of a French merchant living in Antwerp, he worked in England for four years and got to know Sir Peter Lely, who gave him the job of restoring the old pictures at Windsor Castle. Back in Paris in 1678, he soon became well known. He began working with Van der Meulen and Le Brun. Historiated pictures were very popular at this time and this was the genre which particularly suited his talent: *Louis XIV*, *The Cardinal de Noailles*, *Colbert*, *Mlle Duclos* and *Charles Le Brun*). He was swamped with commissions from the wealthy bourgeoisie and the nobility. In 1684, he returned to England at the request of James II and painted portraits of the King, the Queen, the Prince of Wales and many artists and notabilities. In 1686, he was received as a member of the Royal Academy of Paris for his fine portrait of *Le Brun* (Louvre). He worked for the municipality of Paris: two large pictures for the Hôtel de Ville (*The Convalescence of Louis XIV* and *The Marriage of the Duke of Bourgogne*, in 1697) and *The Banquet given by the Town to Louis XIV in 1687*. He painted an *Ex-Voto* for Saint-Etienne-du-Mont. Many of his pictures can be seen in the Louvre and at the Musée Carnavalet: *The Magistrates* and *Portrait of Voltaire* (Carnavalet); and *Self-portrait* (Louvre).

La Tour, Georges de (1593-1652)

Son of a baker from Vic-sur-Seille, Georges de La Tour settled in Lunéville in about 1620. He married in 1621 into a family of the local nobility. He was soon considered a master of painting and from 1644 onwards was the official painter of the town of Lunéville. In 1646 he became painter-in-ordinary to the king. He gave both Louis XIII and the Duke of Lorraine a painting of *St Sebastian* who was invoked as protector against the plague. (This probably took place between 1631 and 1633, a period when the plague was at its very worst in Lorraine.) It seems possible that he spent some time in Italy. His reputation was very great and he was commissioned to paint some pictures for the Governor of Nancy. In his lifetime he was particularly famous for his "nocturnal" scenes (*Nativity*, Rennes Museum, and *Nativity*, Louvre) and his "daylight" effects (*The Hurdy-Gurdy Player*, Nantes Museum; *The Trickster*, private collection; *Jerome Penitent*, Stockholm Museum; *St Sebastian mourned by St Irene*, Berlin

175

Georges de La Tour
Young Man lighting a Pipe
Besançon, Musée des beaux-arts

Le Brun
Head of a Man
Montpellier, Musée Fabre

Museum). Like the Le Nain brothers, La Tour was "a painter of reality", as much in his religious pictures as in his imaginary scenes and everyday subjects. There is no doubt that he was much affected by Caravaggio. He soon went far beyond a picture telling a banal story to paint scenes of deep spiritual significance: almost all his pictures have a religious character. He was one of the most original painters of the 17th century, but was very quickly forgotten—completely forgotten—not to be rediscovered till 1915. His works were variously attributed to Le Nain, Vermeer or to a number of Spanish artists.

Le Brun, Charles (1619-1690)

Son of a Parisian painter, he was sent to Rome by Chancellor Séguier who had noticed his precocious talent. In 1647, he painted a *Martyrdom of St Andrew* for Notre-Dame; in 1649, he worked with Le Sueur on the decoration of the Hôtel Lambert and painted a picture for the Queen Mother (*Crucifix with Angels*,

Louvre). In 1657, Fouquet commissioned him to do the decoration of his château at Vaux (two ceilings). His varied talent could tackle any kind of painting. After the fall of Fouquet, Le Brun was sponsored by Colbert. Appointed Director of the Gobelins factory in 1663 and Chancellor of the Academy of Painting which he had helped to found, he painted between 1660 and 1668 the very famous and extremely large works on *The Life of Alexander* (Louvre), packed with battle scenes that manage to be vigorous yet unconfused. He decorated the Apollo Gallery in the Louvre and in 1667 undertook the decorative works for the great staircase, the Galerie des Glaces, the Salon de la Guerre and the Salon de la Paix. At the same time, he planned the ornamentation of the entire park. All the decorative arts of the period drew on his inspiration; he drew cartoons for the Gobelins tapestries and was in charge of the decoration of the king's ships. When Colbert died in 1683, Le Brun fell out of favour and he died in 1690. The Apollo Gallery is his master-

piece as a decorator; it is a superb conception which includes paintings, sculpture, gold and bronze. It is impossible to conceive of the art of this period without him, for he was virtually in charge of its every aspect. The splendour of his artistic vision and the sumptuousness of his style make him the artist who best represents the royal grandeur.

Leclerc, Jean (1587-1633)

French painter and engraver, born in Nancy. He went to Italy at an early age and was a pupil of Saraceni. He was made a Knight of St Mark in Venice; in 1623, he was ennobled by Henry II of Lorraine whose portrait he had painted. In 1632, he painted eight pictures for the Jesuit church in Nancy. In the Palazzo Ducale in Venice there is an enormous painting by him: *The Alliance of the Doge Enrico Dandolo with the Crusaders at the Church of San Marco in 1201*. He was a friend of Jacques Callot and engraved some of his religious pictures.

Le Nain (The Brothers)

Antoine (1588-1648); Louis (1593-1648); Mathieu (1607-1677). They were born in Laon. Antoine was received as a master-painter at St Germain-des-Prés in 1629. Like his brother Louis, he was admitted to the Academy on 1 March 1648, and died two days after him, on 25 March in the same year. Mathieu, who was also an academician, lived until 1677. The three brothers lived together. They owned three houses in Paris and had property in Laon.

Later, Mathieu lived in great luxury. They were painters of everyday scenes of reality, typical good-living bourgeois used to a pleasant life, painting with equal skill and style the elegant figure of *Henri de Montmorency* and the poor guests at *The Village Feast* (both in the Louvre). Their religious paintings (at Saint-Germain-des-Prés, Notre-Dame and Saint-Etienne-du-Mont) are of secondary importance compared with such scenes of peasant life as *The Blacksmith, The Watering-place* and *The Crib* (all three in the Louvre). They show a realism keenly aware of simple daily work and play. The realist painters who came later brought the Le Nain brothers back into fashion.

Le Nôtre, André (1613-1700)

French architect, born in Paris, garden designer. Of very humble birth (both father and grandfather were themselves gardeners). His father was appointed to the post of superintendent of the Tuileries gardens. He studied painting and the elements of Classical architecture in Simon Vouet's studio and became a gardener in the Tuileries under the direction of Claude Mollet. In 1637, he became chief gardener and, six years later, garden designer for all the royal parks. In 1661 he was given the official post of Director of the King's Gardens and Louis XIV took him away from Vaux (where he was working for Fouquet). The gardens at Vaux were superb and Le Nôtre had created grottoes, rock-gardens, lattice-work, skilfully trimmed trees, long lines of hedges, all elements which contributed to the overall effect of Classical perfection. For the

king, he created the gardens at Versailles, a true architectural concept; this is his masterpiece. He worked in almost all the great parks of the period: Trianon, Saint-Cloud, Chantilly, Meudon, Sceaux, Chagny, Chaville, Saint-Germain. . . . At the age of sixty-five he travelled in Italy on the king's business. In 1681 he was admitted to the Academy of Architecture and in 1693 was made a Knight of Saint-Michel. He was an artist of original and outstanding talent and is the true founder of French garden design.

Le Sueur, Eustache (1616-1655)

Born in Paris, son of a poor sculptor from Montdidier, he was a pupil of Simon Vouet. In fact, his genius was drawn from his own inspiration rather than from anyone else. The Louvre has his *St Paul in Ephesus*, considered his masterpiece. In about 1642, he was commissioned

to paint eight pictures based on episodes from the *Hypnerotomachia Poliphili*. In 1644 he married the daughter of a master painter. To earn a living, he was reduced to painting vignettes and frontispieces in books. In 1645 he was commissioned to decorate the Hôtel Lambert (the Cabinet de l'Amour, the Chambre des Muses and the bathrooms); his decorative panels, most delicately coloured, are now in the Louvre. There were various mythological subjects amongst them—*Melpomene, Urania, Terpsichore.* . . . Above all, though, he was a deeply sincere religious painter, but with a gentle piety and restrained emotion. Between 1645 and 1648 he painted *The Life of St Bruno* for the Carthusians of the Rue d'Enfer (twenty-two pictures, all in the Louvre). *The Death of St Bruno* is a work of genius which best displays the artist's talent. He did works for the Hôtel Fieubert, Saint-Etienne-du-Mont, Saint-Germain-l'Auxerrois and Saint-Gervais, all works of great size and all now in the Louvre: *The Martyrdom of St Lawrence, The Hail Mary!, Jesus Carrying His Cross.* . . . His brothers helped him in his enterprises. He died young in his house on the Ile Saint-Louis, having been greatly disparaged by Le Brun and Vouet.

Le Vau, Louis (!612-1670)

French architect, born in Paris. He had a great sense of arrangement. A favourite of Mazarin and Fouquet, he built the Château of Vaux-le-Vicomte. There is a very noticeable Italian influence in this splendid residence (colonnades, porticoes, domes). In 1653, he was appointed Director of the King's Buildings. He built the

Château de Livry, the Hôtel Lambert, the Hôtel Colbert and the Hôtel Lyonne in Paris. In 1655 he drew the plans for Saint-Sulpice (they were not used, apart from the plan for the Lady Chapel). Between 1660 and 1664, he worked on the extensions for the Tuileries and built the Pavilion de Marsan. He built the wings for the Château de Vincennes. His work in the Louvre was masked by the Colonnade de Perrault. His pupil and son-in-law, François Dorbay, used his designs for the Collège des Quatre-Nations, now the Palais de l'Institut.

Lippi, Lorenzo (1606-1664)

This Florentine artist was equally skilled in painting and in poetry. As a court painter in Innsbruck, he produced a number of religious pictures (*The Woman of Samaria*, Vienna Museum; *The Martyrdom of St James* and *Christ Crucified* are the best known). In 1660 he wrote *Il Malmantile riacquistato*, a short poem of immense stylistic elegance.

Lorraine (Claude Gellée, known as Claude Lorraine) (1600-1682)

Born at Chamagne in Lorraine, of a poor family. He was orphaned at twelve and decided to go to Rome where he stayed for the next few years. In 1625 he went back to Lorraine via Venice and Munich where he produced two superb studies. He was very quickly back in Italy again (1627). His amazing memory enabled him to become a famous landscape artist. In *The Embarkation of Cleopatra* and *Ulysses*

returning Chryseis to Her Father he paints with admirable skill all the beauties of sky, light and banks of flowers. All his life, he never lost his passion for light, sun and the infinity of the horizon. As soon as he became famous, he had commissions from the Pope and the King of Spain and found his paintings being eagerly copied by forgers; this is why he drew up his *Liber Veritatis*, in which he left studies for almost all his paintings, the better to identify them. He did a number of etchings, including the *Campo Vaccino* (Louvre) and a scene from the *Aeneid*, which belongs to the Queen.

Loyola, St Ignatius (1491-1556)

Spanish saint, founder of the Company of Jesus. With six followers he decided to dedicate himself to the conversion of heretics and to put himself at the Pope's disposal. Author of *Spiritual Exercises*.

Lubin, Jacques (1637-1695)

French engraver, born in Paris. He was a pupil of G. Edelinck. He engraved *Turenne*, after Philippe de Champaigne; *The Comte de Brienne*, after Largillière; and *The Entombment*, after Le Sueur. He also engraved a number of portraits, including those of Callot and Séguier.

Ludovico Il Moro (1451-1508)

Duke of Milan, he opposed Charles VIII's projects in Italy and joined the League formed by Pope Alexander VI, the Emperor Maximilian I and the King of Spain.

Betrayed by Swiss troops at the siege of Milan, he was captured and imprisoned at Loches where he died. In the Pinacoteca Ambrosiana in Milan, there is a portrait of him by Leonardo.

Lully, Jean-Baptiste (1633-1687)

French composer and violoncellist, born in Florence, died in Paris. He entered the service of Mlle de Montpensier and formed a small consort of violins. As Surintendant de la Musique, he gradually won a monopoly of all musical productions. He wrote the music for the ballets Louis XIV danced; he set all Molière's comedy-ballets to music (e.g. *Le Bourgeois Gentilhomme*). Later, as Director of the Opera, he wrote for this theatre a score of operas, one of which is *Alcestis*, and many ballets (*The Triumph of Love*, for instance). He also wrote some church music. Although of Italian origin, he followed the French style with complete conformity.

Maderno, Carlo (1556-1629)

Roman architect, born at Bissone—a true Ticinese, he has an important place in Baroque architecture, though he had no great sense of originality. With Vignole and Borromini, he gave Rome a new look by building sumptuous palaces and complicated churches. He started by building the Palazzo Salviati and by finishing off San Giacomo al Corso. In 1605, he began the task of supervising the works at Saint Peter's at the request of Pope Paul V. He lengthened the nave by three bays and designed the portico and the present façade. Still in Rome, he built the façade of Santa Susanna (1605), all Sant' Andrea della Valle (1608) apart from the façade, Santa Maria della Vittoria and the façade of the Palazzo Mattei; he worked at the Palazzo Chigi and started the famous Palazzo Barberini, where he built the façade looking on to the garden. He raised the Column of Constantine in front of Santa Maria Maggiore. He was equally talented as a military engineer.

Mansart, François (1598-1666)

Son of a master carpenter of Italian origin, he had his first lessons from an architect brother-in-law. Most of his buildings no longer exist. He had a very fertile imagination, a real feeling for what was beautiful and a tendency to aim at a majestic style, which often gave his designs a ponderous look. He built the churches of Sainte-Marie de Chaillot, the Visitation, Rue Saint-Antoine (1632), and the church of

the Minims in the Place Royale. In 1635, he built the Hôtel de La Vrillière, the Hôtel d'Aumont, the Hôtel Fieubert, the Châteaux of Gesvres, Berny, Choisy-le-Roi and Maisons (1642-1650), the last-named usually being considered his masterpiece. It was to him that the invention of the so-called "mansard" roof is attributed.

Mansart, Jules Hardouin (1646-1708)

Nephew of François Mansart. Son of a painter, Jules Hardouin, he took the name of his uncle, his first teacher. In 1674, he was commissioned by Louis XIV to build the Château de Clagny. Mansart was as much a courtier as he was an architect and knew how to capture his master's imagination, leading him into an absolute passion for building. He undertook the greatest building projects of Louis's reign —he built the Châteaux of Marly, Dampierre and Lunéville, and in 1670 took control of the building works at Versailles, a task which was his until 1685. He then started work at Saint-Cyr. Amongst his other works, one should mention the Grand Trianon, the Château de Vanves, the dome of the Invalides (1677), perhaps his finest achievement, the superb Place Vendôme (1687-1699), the Place des Victoires (1699) and the church of Notre-Dame at Versailles. He became extremely wealthy and was covered with honours of all kinds. He became successively first architect to the king, Superintendent of Building Works, Art and Manufactories (1699), and member of the Academy of Painting and Sculpture (1699). His vanity and egoism made him a large number of enemies. He died very suddenly and was buried in Saint Paul in Paris; Coysevox designed his tomb. He was an artist of great genius and his best works show remarkable intelligence and superb technical skill.

Marsy (The Brothers)
Balthasar (1628-1674); Gaspard (1624-1681)

French sculptors working in Paris. They were excitable, witty artists and commissions poured into their studio. They undertook the decoration of the Hôtel Sallé and the Hôtel de la Vrillière; in the Louvre they did some of the stucco decorations in the Apollo Gallery. They made nine statues for the central façade of the Château de Versailles and for the park they sculpted a number of stone groups: *The Lycian Peasants turned into Frogs, Bacchus and the Four little Satyrs* and *Two Sun Horses and Two Tritons Bandaging Them.* They were excellent aides for Le Brun.

Massari, Giorgio (1686-1766)

Venetian architect working mainly in Venice, where he built Santa Maria delle Rosario (1725-1736), Santi Ermagora e Fortunato (1728-1736) and Santa Maria degli Penitente (finished in 1763); the façade of the Scuola della Carita (1750), now the Accademia; he designed the church of Santa Maria del Misericorde. He also built the Palazzo Grassi, now the Palazzo Stucky (1705-1745) and the top floor of the Palazzo Pesaro, Longhena's masterpiece. Outside Venice, he built the Pace church in Brescia (1720-1746), the façade of San Antonio (1733) and San Spirito (1738) at Udine. He was classically inclined as an architect, and blended Palladian trends with elements taken from Longhena.

Meert or **Meerte,** Pierre (1619-1669)

A Flemish portrait-painter, born in Brussels. Some of his works have been mistaken for van Dyck's.

Mellan, Claude (1598-1688)

French engraver, born in Abbeville. Son of an artisan, he came to Paris very early, but soon went to Rome, where he studied with Simon Vouet. He invented a new method of engraving and produced the famous *Editions du Louvre*. As a reward, Louis XIV appointed him engraver-in-ordinary to the king. He engraved a *Holy Face on St Veronica's Cloth* which is technically outstanding. We have some four hundred plates which he engraved; half of them are portraits. His drawings are equally fine.

Metezeau, Louis (1559-1615)

Born in Dreux, died in Paris. Son of an architect, he was himself the official architect to Henri IV and Louis XIII. It is not clear which buildings he actually designed: he seems to have built the first half of the Grande Galerie of the Louvre and may have designed the houses in the Place Royale in Paris. He drew the plans for the Rungis aqueduct (1613).

Mignard, Nicolas (1606-1668)

Brother of Pierre Mignard, born in Troyes, died in· Paris. He stayed for a while in Rome, then settled in Avignon. Summoned to court in 1660, he painted the young king and queen. His reputation was established by two large works he painted for the Charterhouse at Grenoble. The museum in Avignon has a fine self-portrait. He was also a very skilful engraver.

Mignard, Pierre (1610-1695)

Born in Troyes, died in Paris. He worked at Fontainebleau and studied with Vouet. In 1635, he went to Rome where he stayed for twenty-two years—hence his nickname " le Romain ". Two paintings established his reputation: *The Family of M. Hugues de Lione* and *M. Arnaud*; he was invited to paint Pope Alexander VII and Pope Urbain VIII. For Richelieu, he copied the Galleria Borghese. He was commissioned to paint the frescoes in San Carlo alle Quattro Fontane and Santa Maria in Campitelli. He married the daughter of· an architect and went to

Venice, where he started painting a series of Virgins who were flatteringly described as "mignardes". In 1657, he was summoned to Paris by the king, but on the

way back, he stayed in Cavaillon where he painted *St Véran Slaying the Dragon of the Fontaine-de-Vaucluse* for the local church. In 1659, he painted a portrait of the king; in fact, he painted eighteen of them in time. He was commissioned to paint the dome of the Val-de-Grâce. His clients were all people of position and wealth. All the ladies of the court wanted to be painted as "mignardes" (Mme de Maintenon, Mme de La Fayette, Mme de Montespan, Mme de Sévigné). Received into the Royal Academy, he became the king's official painter and gradually took over from Le Brun. In 1686, he was commissioned to paint the Nouvelle Galerie at Versailles and decorated Saint-Cloud. Mignard was a painter of skill and delicacy, but could not equal Le Brun. He was at his best in portraits. His decorative works are basically somewhat banal.

Mignard, Pierre (1640-1725)

Nephew of Pierre and son of Nicolas, born in Avignon, died in Paris. He was in charge of the building of the Porte Saint-

Martin and of the façade of the Collège Saint-Nicolas. His greatest work is the Abbey of Montmajour, near Arles.

Momper, Joos de (the Younger) (1564-1635)

Flemish landscape painter, born in Antwerp, one of a family of artists. He travelled in Italy and Switzerland before joining the Antwerp Guild.

Monrealese (Novelli Pietro, known as) (1603-1647)

Painter and engraver, born in Monreale. He admired Ribera and continued painting in his tradition, though he mainly worked in Palermo. His works include a picture entitled *Lady with Page*, at the Palazzo Colonna in Rome; *Susanna Bathing*, in the Berne Museum; and *The Wedding at Cana* in the Benedictines' cloister at Monreale. His paintings show the influence of Caravaggio.

Morazzone (Pier Francesco Mazzuchelli, known as) (1571-1626)

Milanese painter, born in Morazzone, died in Piacenza. He was influenced by Camillo Procaccini. First, he worked in Rome and painted an *Assumption* for Santa Maria. A stay in Venice changed his colour sense and his style (*Adoration of the Magi*, San Antonio, Milan). He was invited to paint the great dome of Piacenza Cathedral, but he died before the work was completed. Other works include: *Lucrezia* (Prado) and *The Dream of St Joseph* (Berlin Museum).

Neri, St Philip (1515-1595)

His parents wanted him to be a merchant, but in 1538 he sold his goods to devote himself to the service of the poor and in 1548 founded the confraternity of the hospital of the Holy Trinity. He took holy orders in 1551 and started encouraging young priests to preach publicly in the streets of Rome (hence the name Oratorians). The men who followed him took vows of poverty and promised to do works of charity. Pope Gregory XIII approved the Oratorian foundation and gave them the church of Santa Maria della Vallicella in Rome. Philip Neri was canonised by Gregory XV in 1622.

Nuvolo (Giuseppe Donzelli, known as Fra) (first half of 17th century)

This Italian architect was a Dominican monk from Naples. He was the first to use majolica to decorate the domes of his churches (Santa Maria di Constantinople). Between 1602 and 1613, he built Santa Maria della Sanita and San Sebastian and, in 1613, San Carlo all'Areno.

Ors y Rovira, Eugenio d' (1882-1954)

Spanish philosopher, novelist and art critic, author of many essays. He started out by writing only in Catalan and, under pseudonym of Xenius, published a number of short tales. In about 1920, he started writing in Spanish. He wrote for the newspaper *ABC*, grew interested in fine arts and started a movement in favour of Baroque. His main works are: *The Art of Goya* (1928), *Ideas and Forms* (1928) and *The Philosophy of Intelligence* (1950). In his work *On Baroque*, he discussed the history of this art movement for the first time from both historical and stylistic points of view. His influence was widespread.

Palazzo Barberini

One of the most imposing palaces in Rome; it was started in 1625 by Maderno; Borromini and Bernini worked there, the latter designing the central part and the forepart of the sides. Inside there are frescoes by Pietro da Cortona and Andrea Sacchi. The palace belonged to the Barberini family, one of whom became Pope as Urban VIII.

Palazzo Farnese

Superb Renaissance building. Work started on the Palace in 1514, for Cardinal Alexander Farnese (Paul III), under the direction of Andrea da Sangallo. Della Porta came after him and added the rear façade. It was finished after 1546 according to plans drawn up by Michelangelo. It was he who designed a very fine loggia in the middle of the façade, the second floor and the famous cornice. Some of the stones used in the building works came from the Colosseum and some from the Theatre of Marcellus. The Farnese art collection, originally lodged in the palace, is now in Naples Museum. The palace is now the French Embassy in Rome and the French school in Rome has been established there since 1875.

Palazzo Fava

There are three Palazzo Fava in Bologna, the first from the 14th, the second from the 15th and the third from the 16th century. The latter was built by Terribilia and is decorated with frescoes by Francesco Albani and the Carracci.

Palazzo Magnani

Bolognese palace famous for its decorations by Annibale Carracci, who painted the story of Romulus and Remus, surrounding it with sturdy Atlantes and garlands.

Patin, Gui (1602-1672)

French doctor and man of letters, born in Hodenc-en-Bray, died in Paris. His fame was due to his wit and enthusiasm. During the Fronde he wrote his *Mazarinades* and some very witty *Letters* attacking Mazarin.

Paul V (Camillo Borghese, Pope) (1552-1621)

Became Pope in 1605, he had been Clement VIII's legate in Spain. He tried

to promote reform in the church on the lines suggested by the Council of Trent and excommunicated the Doge of Venice following a conflict on a matter of ecclesiastical discipline. He published the bull *In caena Domini* (1610). During his reign, Bernini finished building Saint Peter's and the town of Rome was much embellished.

Peeters (1589-after 1648)

Flemish still-life painter, born in Antwerp. The Prado has a fine collection of his works.

Perrault, Claude (1613-1688)

Member of a good bourgeois family—his father was a lawyer in the Paris Parlement—he studied medicine. In 1666, he joined the Académie des Sciences as an anatomist. The new translation of Vitruvius gave Perrault a keen interest in architecture. The Colonnade at the Louvre (1666-1670) is so splendid that it quite overshadows the fact that he built most of the rest of the modern Louvre (the Seine frontage, the north façade). His outlines are of a sturdy simplicity and have a majestic bareness. The entire 18th century found inspiration in the lines of the Colonnade. Between 1667 and 1671 he built the severe Observatory. He offers a more elegant concept in the *arc de triomphe* in the Faubourg St Antoine. He was interested in practical mechanics and invented a machine for raising heavy weights. He wrote a number of scientific works and was a curious mixture of out-

spoken free thought and the standard dogma of his time. He fell gravely ill after dissecting a putrefying camel and died at the age of seventy-five.

Peterzano, Simone

Italian painter born in Venice. He was particularly active in the period around 1590. He was a pupil of Titian and was so proud of this that he usually mentioned the fact in his signature. Most of his works are in Milan: frescoes on the life of St Paul in San Barbara, a *Pietà* in San Fidele and an *Assumption* in the Chiesa di Brera.

Picchiatti, Francesco Antonio (1619-1694)

Italian architect, son of the architect Bartolomeo Picchiatti. He built the main staircase in the royal palace (1651); he built San Domenico (1658), San Giovanni Battista and Santa Maria de' Miracoli (1661-1675) as well as the palace and the church of the Misericordia (1658-1670).

Piles, Roger de (1635-1709)

French painter and writer, born in Clamecy. A pupil of Claude François, he visited Italy and Holland; he engraved a number of portraits and wrote a well-known treatise on art.

Pomarancio (Niccolo Circignano, known as) (1520-1593)

Italian painter, pupil of Titian who was extremely fond of him; he had considerable

Pomarancio
The Magdalene
Rome, Galleria Barberini

talent. He had a gift for composition, an agreeable colour sense and extraordinary skill. His works in the Vatican, produced under Titian's direction, brought him a number of commissions: the dome of Santa Pudenziana where the Eternal Father is seen in a glory of angels, the *St John the Baptist* in the church of the Consolation. He also painted in San Stefano Rotondo a series of frescoes showing terrible scenes of martyrdom in which the ferocity of the tortures is uncomfortable to contemplate. Sometimes his realism seems close to that of the 15th-century Spanish school. One of his most famous pictures is *The Descent from the Cross* in San Giusto, Volterra.

Ponzio, Flaminio (about 1570-1615)

Roman architect, representative of the Baroque style. At the end of the 16th century, he built the Palazzo Sciarra, austere and imposing, one of the finest buildings of the period with its plain and well-proportioned façade. At the request of Cardinal Scipio Borghese, he built the Basilica of San Sebastiano (1614); he produced the plans for the Palazzo Rospi-

gliosi, finished the Palazzo di Ripetto and, at Santa Maria Maggiore, built a new sacristy and the famous Borghese chapel (1611). He was also responsible for the double staircase in the Quirinal Palace.

Porpora, Paolo (1617-1673)

Born in Naples, died in Rome. Paolo Porpora, together with Lucas Forte, is outstanding in the Neapolitan school of still-life painting. He was famous for his paintings of tables laden with fruit in the Dutch manner (*Still-life with Fruit, Flowers and Birds*, Naples, Capodimonte Museum). He probably studied art with Giacomo Recco or some as yet unknown master, a painter influenced by Caravaggio. Now that we know for certain that he was responsible for the enormous composition in the Palazzo Gervasio in Bari, it is possible to appreciate his personality somewhat better. The sumptuous compositions have more than a hint of the Baroque to come—they have subtle colouring and a firm strong sweep; they mark the encounter of a Northern taste for the picturesque and a naturalistic tendency. The artist worked in Naples but was in Rome from 1656 onwards. He joined the Academy of St Luke.

Port-Royal

Convent founded in 1204 near Chevreuse in the department of Seine-et-Oise. Reformed in 1608 by Angélique Arnauld, it became a centre of Jansenism. Pascal went there in 1654. In 1712, the abbey was destroyed on the orders of Louis XIV.

187

Pourbus, Frans II, or the Younger (1569-1622)

Flemish painter born in Antwerp, died in Paris. Between 1599 and 1610, he was in the service of Vicenzo Gonzaga, Duke of Mantua, and painted for him the famous *Room of Beauties*, a series of portraits of all the gay ladies of the time. Marie de' Medici appointed him her painter-in-ordinary. He was a court painter and did the portraits of *Henri IV* (Louvre), *Marie de' Medici* (1610, Louvre) and *Louis XIII as a Child* (Prado). His paintings have a certain nobility of style, but are somewhat cold.

Poussin, Nicolas (1594-1665)

Born at Andelys, died in Rome. Born into a noble family from Soissons, he set off on foot for Paris in 1616 and entered the studio first of Quentin Varin and then of Van Elle. He tried unsuccessfully to get to Rome. In 1623, he became acquainted with Marino, a popular poet of the period. Thanks to him, he managed to reach Rome in 1624. Neither the realism of Caravaggio nor the materialism of the followers of the Carracci had any influence on him. Only the lucid coolness of Domenichino impressed him at all. His style of painting was unfashionable; he was then as always faithful to antiquity. He worked tremendously hard. In 1629, after a serious illness, he married the daughter of Jacques Dughet who had looked after him. In the period 1630-1640, deeply impressed by Titian, he became the "real founder of the laws of landscape painting" (Burckhardt). His *Kingdom of Flora* (Dresden),

Parnassus (Prado) and *Inspiration of the Poet* (Louvre) attract realists and idealists alike. From this moment onwards, all his works go near to perfection: *Erasmus* for Saint Peter's in Rome, *Camillus Handing the Faliscan Schoolmaster over to the Students* (1637) and *Plague amongst the Philistines* (Louvre). In 1641 he arrived at the Tuileries at the request of Louis XIII and was commissioned to paint the Grande Galerie of the Louvre. He painted a few religious pictures: a *Last Supper* for Saint-Germain-en-Laye and *St Francis Xavier* (Louvre); but he was soon troubled by the intrigues of Vouet and Lemercier and went back to Rome permanently in 1642. He turned more and more towards antiquity: *The Arcadian Shepherds* (Louvre). The older he got, the less he used models; the setting interested him above all. His pictures offer the religious and moral lessons which spring from a great mind. His art drew its inspiration ever more from nature itself. All his life he loved proportion, logic and lucidity and in this is a true representative of his age and of the best qualities of the French mind.

Pozzo, Cassiano del (1584-1657)

Italian antiquary, born and died in Turin. He was keenly interested in art and

gathered together a collection famous throughout Europe, including medals, inscriptions, bas-reliefs and statues. He was the patron of such artists as Poussin and had him illustrate Leonardo's *Treatise on Painting*. He and Poussin became close friends and the artist painted for him his first version of *The Seven Sacraments*.

Preti, Mattia (known as Il Calabrese) (1613-1699)

Italian painter, born at Taverno (Calabria), died in Malta. He went to Rome when young and became a pupil of Lanfranco, then went to Cento to work with Guercino, who was his real master. During a trip to Venice and Bologna, he became famous by decorating public buildings as he travelled. In Rome he did three paintings for Sant' Andrea della Valle (scenes from the life of St Andrew). The Grand Master of the Order of the Knights of Malta invited him to work on the island; he decorated the cathedral with frescoes of St John the Baptist. In Naples, he did some frescoes in the Charterhouse chapel and in Saint Peter's painted *The Legend of St Catherine*. He died from complications following a barber's cut.

Procaccini, Giulo Cesare (1548-1626)

Milanese painter, born in Bologna. He was the second son and pupil of Ercole Procaccini the Elder. He originally planned to study sculpture, but changed to painting; he studied the works of Raphael in Rome but was most influenced

by Correggio. In 1617, he worked on the decoration of Milan Cathedral; there is an *Annunciation* by him in Sant' Antonio, Milan. Many museums in Europe have paintings by him.

Puget, Pierre (1620-1694)

Son of a Marseilles mason, he was originally apprenticed to a shipbuilder. He was not quite sixteen when they launched a ship whose woodwork was entirely carved by him. At the age of seventeen, he set off on foot for Italy and was taken in by Pietro da Cortona who gave him work on the decorative schemes in the Palazzo Barberini and the Palazzo Pitti. In 1644 he went back to Marseilles and worked in the Royal Arsenal, Toulon, decorating the royal galleys. In 1655, he decorated the façade of Toulon Town Hall and carved the superb caryatids which support the balcony. His success brought him some notoriety. Fouquet sent him to Carrara to choose the marble for Vaux-le-Vicomte. He stayed in Genoa from 1661 to 1667 and received many commissions, including one for three colossal statues for Santa Maria di Carignano and one for a *Madonna* for the Hospital of the

Poor. In 1667, he went back to Marseilles and in 1672 Colbert commissioned from him the *Milo of Croton, Alexander and Diogenes* and *Perseus and Andromeda*, which are now in the Louvre. Other magnificent works from this period include his *Hercules* (Louvre) and a statue of *Louis XIV*. He was a man of blunt and arrogant temperament, his technique was strong and vigorous. However, he was extremely untypical of his time and unfortunately for him lacked the necessary courtier spirit.

Quellin, Erasmus (1607-1678)

Landscape and history painter belonging to a family of artists in Antwerp. A close friend of Rubens, he worked with him till his death. As a specialist in figure painting, he collaborated with other Antwerp painters. He was also noted for his activities as architect, poet and philosopher.

Ribera, Jusepe or José (1588-1656)

Son of a Valencia cobbler, he started by studying art with Ribalta. He seems to have been thoroughly imbued with his master's technique before he left Spain, because he was an accomplished artist by the time he reached Italy. He never returned to Spain. He left for Rome in 1610 and lived in poverty. Originally influenced by Raphael and Michelangelo, he worked for a time with Caravaggio. He was a completely naturalist painter. He went to Naples in 1616, at the height of Spanish domination, and soon became well known for his *Martyrdom of St Bartholomew* (Prado). Success came to him all at once. His fame spread as far as Spain. Velasquez came to visit him twice. The Viceroy of Naples was his protector and commissions poured in. He was appointed court painter for life. In 1630 he was received into the Academy of St Luke in Rome and made a Knight of Christ. His wealthy marriage aroused much jealousy. He had many pupils working for him in his studio. In 1648, the Pope gave him the habit of the Military Order of Christ. This was the great period of his best religious paintings, with scenes of martyrdom, beggars and philosophers. His sixteen-year-old daughter Maria Rosa whom he adored allowed herself to be seduced by Don John of Austria, whose portrait he had painted. The effect on Ribera was catastrophic. After 1650, he appears to have done no more painting. He left his superb home in Naples and went to live in Pausilippa, where he died in 1656. He was a remark-

Ribera
Woman in Despair
Bayonne, Musée Bonnat

Rigaud
Portrait of Saint-Simon
Chartres Museum

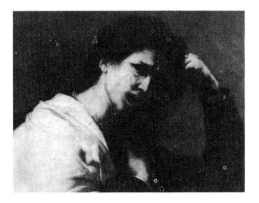

able portrait-painter, much influenced by Caravaggio, but he moved instinctively towards the Baroque: *Comte de Monterey and his Sister Doña Margarita Fonseca* (Augustinians, Salamanca) and *Portrait of the Artist by Himself* (Uffizi, Florence). He vulgarised some of Caravaggio's violence by conventional additions of small angels, *The Deposition* (Charterhouse of San Martino, Naples), by the crudity of his anatomy, *St Sebastian* (Naples Museum) or his predilection for scenes of martyrdom: *The Martyrdom of St Lawrence* (Vatican) and *St Januarius coming out of the Furnace* (Naples Cathedral). However, he did not ignore more cheerful things: *Drunken Silenus* (Naples Museum). He painted many apostles (Prado, Louvre), patriarchs, prophets, saints, innumerable bearded philosophers, odd deformities, *The Club Foot* (Louvre). Ribera was amazingly successful in the way he rendered the absolute stillness of death, as in his *St Sebastian* (Valencia Museum), his *Dead Christ* (National Gallery) and other similar works in Naples and Bilbao. As the years passed, his backgrounds grew brighter and his colours became softer. He had a very vigorous line in his drawings.

Rigaud y Ros, Hyacinthe-François-Honorat-Matthias-Pierre-André-Jean (1659-1743)

Son and grandson of obscure artists, he was born in Perpignan and died in Paris. In 1681, he came to Paris and had the good fortune to please Le Brun. He painted portraits of all the great men of his time and may be considered the best portrait-painter of his period. He painted Girardon, Desjardins, Coysevox, Nicolas Coustou, La Fosse, Louis de Bologne, Claude Hallé and Mansart; the writers Boileau, Racine and Santeul; his *Mignard* in Versailles Museum and *Portrait of His Mother* (Louvre) reveal deep emotion. The heads are full of life and character; the relief beautifully rendered, the colour clear and fresh. He is never better than when he is painting the great men of Louis' court: there they stand, tall, magnificently bewigged, hung with lace, erect before a magnificent background. One should mention the superb portraits of *Bossuet*, *The Duc d'Anjou* (the future

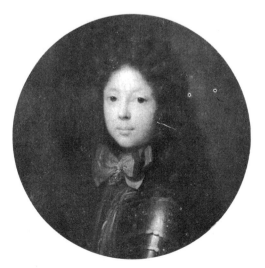

191

Philip V of Spain—1700, Louvre) and *Cardinal de Polignac* (1715, Louvre). At last, the king had a portrait-painter worthy of the name. In 1709, the town of Perpignan granted him letters of nobility. He died at the age of eighty-four, leaving no descendants.

Rombouts, Theodor (1597-1637)

Born in Antwerp, he visited Italy, then received a number of commissions in Antwerp where he painted a variety of pictures for the local churches. For a short time, he was a rival to Rubens. His engravings are very fine.

Rosa, Salvator (1615-1673)

Born in Arenello and died in Rome. He was the pupil of his brother-in-law Francesco Fracanzano. Trained in a Caravaggesque milieu in contact with the exaggerated realism of Ribera, but interested in Aniello Falcone's genre painting. In 1635, he went to Rome and spent his working life there, apart from a stay in Florence working for the Medici family (1640-1647); here, he got to know the versifier L. Lippi. He was a versatile artist, poet, musician, engraver and author of striking satires; his complex personality dominated the Roman scene. He had trouble with the Inquisition but when he died was even so allowed a formal funeral. His paintings were all well conceived and well painted; at first, he specialised in battle and sea scenes: *Beach with Two Towers*, *Cavalry Engagement* (Pitti, Florence), *The Philosophers' Forest* (Uffizi, Florence); *Battle* (Louvre); and *Battles*

(Galleria Corsini). He played an important part in the development of landscape painting and was one of the founders of the modern style of treatment; his landscapes were anticlassical and have been defined as "preromantic". They are packed with literary allusions and suggestions of necromancy, as in the famous "witchcraft scenes" now in the Capitoline Gallery in Rome and the Palazzo Bianco in Genoa. Others works include: *The Bridge* (1640, Pitti, Florence) and *Landscape* (1640, Gallery Estense, Modena). He also painted some portraits: *Lucrezia, The Artist's Wife* (1650, Palazzo Corsini, Rome) and two self-portraits (1660-1665, Uffizi).

Rubens, Peter-Paul (1577-1640)

Born in Siegen, died in Antwerp, member of a sound bourgeois family. He became famous very early and in 1600 went to Italy where he began working for the Duke of Mantua. In 1603, he was sent on a diplomatic mission to Spain and painted some apostles (Prado). From the three paintings for the tomb of the Duke of Mantua's mother, it was clear that he was to be outstanding in his talent. When his mother died, he settled in Antwerp and in 1609 married Isabella Brandt who was to be a perfect wife to him. The

Portrait of the Painter and his Wife (Munich) shows their happiness. His life was packed with happy and constant toil. One masterpiece after another flowed from his magically inspired brush. In 1610, the *Descent from the Cross* in Antwerp Cathedral aroused such admiration that pupils flooded in to his studio and Rubens had to move to a much larger house. It is impossible to even count his works (there are at least 1,300 items). He painted every kind of picture: religious subjects, country scenes, history pictures and portraits. His fertile imagination can be seen in every one. Nature is painted in all its variety and exuberance and form is subject to colour. The boldness and spirit of his touch are remarkable. Between 1610 and 1612 he painted a number of religious subjects: descents from the cross, *Return of the Prodigal Son* (Antwerp) and *The Conversion of St Paul* (Munich). From 1615 to 1618, he painted hunting scenes and satyrs in pictures which brimmed over with the wild joy of drunken fauns and voluptuous nymphs and the pearly flesh of plump, naked women: *Perseus and Andromeda* (Berlin Museum) and *The Battle of the Amazons* (Munich). Rubens' gods are sturdy Flemings, vigorously masculine; he loved to paint swooning goddesses, huntresses surprised at rest, lovesick nymphs. At the same time, he was busy with religious paintings: *The Miraculous Draught of Fishes* (Notre Dame de Malines), beautiful plump Virgins surrounded by saints (many of his Assumptions are pictures alive with joy). In 1622, at the request of Marie de' Medici, he went to Paris to work at the Palais du Luxembourg. In 1626, the sudden death of his wife affected him deeply. He travelled a great deal and went as Ambassador to Madrid, where he painted portraits of Philip IV and his family. In 1629, Charles I welcomed him enthusiastically to London. At the age of fifty-five, he gave up everything but art. In 1630, he married a young girl of sixteen, Hélène Fourment. No woman was ever made more superbly famous by her husband's art. Her portraits are in every museum in Europe. Her face appears in *Susanna at her Bath* (Munich), *Bathsheba* (Dresden) and *Andromeda* (Berlin). He painted a number of landscapes between 1635 and 1637. In 1638, he was immobilised by an attack of gout and died two years later. The whole town mourned its most famous citizen.

Ryckaert, David III (1612-1661)

Name of a family of artists, the most brilliant of whom, David III, was a genre painter. He executed a number of commissions for the Archduke Leopold William.

Ryn, Jean van (1610-1678)

Flemish portrait-painter, born in Dunkirk. A pupil of Van Dyck, he went to London with him before returning to his birthplace. Many works are in the Fitzwilliam Museum, Cambridge.

Ryngraaf (Abraham, known as Brueghel) (1631-1690)

Born in Antwerp, died in Naples. Specialist in flower painting. He worked with Luca Giordano. He got his nickname Ryngraaf in Rome.

Sacchi, Andrea (1599-1661)

Bolognese painter, born at Nettuno, died in Rome; pupil of Albani. His works are some of the most grandiose compositions of the Roman 17th century. One should mention: *The Miracle of St Gregory* (Petriano Museum, Rome), *The Miracle of St Anthony* (Capucins, Rome), *The Drunken Noah* (Kaiser-Friedrich-Museum, Berlin), the frescoes in the Palazzo Sacchetti at Castel Fusano, *Cain and Abel* (Barberini Gallery, Rome) and *The Purification of the Virgin* (Perugia); his masterpiece is *The Vision of St Romuald* (Vatican Gallery). He was, at the same time, a fine portrait-painter: *Merlini* (Borghese Gallery, Rome) and *Portrait of a Cardinal* (Ottawa). His art is clear and balanced. He seems to have been basically lazy and he left few paintings.

Saint Peter's, Rome

This great church stands in Rome on the right bank of the Tiber on the site of Nero's circus where many Christians were put to death in 64 and where St Peter himself was martyred. In 326, Constantine built a basilica which was the wonder of the Christian world for eleven centuries. Pope Nicholas V decided to replace it with a more spectacular building in 1450. Popes Julius II, Leo X, Pius V and Clement VIII all continued the work and Paul V finally completed it. It is the largest church in Christendom and was the work of a series of architects, the most famous being Bramante, Raphael, Michel-

angelo and Bernini. It was completed in 1614 by Carlo Maderno. The extraordinary interior, based on a plan by Bramante, is richly decorated (precious marble, gold, silver and bronze); among the many monuments are Michelangelo's beautiful *Pietà*, Bernini's four statues on the pillars of the dome, the baldaquin, water-stoups, Bernini's angels, the tombs of the Popes. . . . Outside, the setting is completed by Bernini's marvellous oval colonnade, superbly in keeping with the church.

Santafede, Fabrizio (about 1559-after 1628)

Neapolitan painter. He was a pupil of Francesco Curia and studied in Rome, Bologna and Modena. He painted about forty pictures under the influence of Caravaggio. In Naples Museum can be seen a *Madonna with St Jerome and St Peter Cambacurta* and the Harrach Collection in Vienna has a *Madonna with St Anne and St Gaetano.*

Saraceni, Carlo (1585-1625)

Venetian painter; he came to Rome and was a rallying influence on the Caravaggists. His contact with Elsheimer gave him a taste for landscapes which can be discerned in his small mythological pictures (Naples). He was interested in painting light and there is a hint of Giorgione in his *Rest in Egypt* (1606, Frascati Collection, Rome). He painted a number of altar-pictures in Rome, some of them masterpieces: *The Miracle of St Benon*

and *The Martyrdom of St Lambert* (1617-1618) in Santa Maria dell'Anima. In about 1616, he worked with Tassi and Lanfranco on the decoration of the Sala Regia in the Quirinal and went back to Venice, where he and Jean Leclerc painted one of the historical pictures in the Grand Council room of the Doge's Palace. Amongst his best works are *St Cecilia* (Rome, Galleria Nazionale) and *The Preaching of St Romuald* (Sant' Adriano, Rome).

Savery, Roelandt (1576-1639)

Member of a family of artists, born in Courtrai, died in Utrecht. Henri IV summoned him to Paris; later he went to Prague at the request of Rudolf II. He specialised in animal painting and still-life.

Schedoni, Bartolomeo (1570-1615)

Painter from the Bolognese school, born in Formigine, died in Parma. We know little of his life. Influenced by Correggio, he imitated him with great skill. He entered the service of Duke Renuccio in Parma and was appointed chief painter. According to tradition, he was a very keen gambler and is supposed to have died young, overcome with rage and grief at having lost a large sum of money in one night. He painted a great deal and most European museums have pictures by him. Naples Museum has, among others, *The Portrait of a Cobbler, St Eustace and the Stag* and *Amourette*. There is a *Holy Family* by him in the Louvre.

Schonfeldt, Johann Heinrich (1609-about 1682)

This German painter, born in Biberach, died in Augsburg, was very much influenced by a journey he made in Italy. Back again in Germany, he worked in Vienna, Munich, Salzburg and Augsburg, where he did some fine work in the Senate Palace and the church of the Holy Cross (*Christ on the Way to Calvary*). He also produced a few pleasant engravings of landscapes.

Schut, Cornelius (1597-1655)

Flemish painter, pupil of Rubens. He became very famous after his master's death.

Seghers, Daniel (1590-1661)

Nicknamed the Jesuit of Antwerp. A flower-painter, he collaborated with Rubens and other artists, his skill and detailed botanical knowledge being of the greatest assistance to them in their work.

Seghers, Gerard (1591-1651)

Younger brother of the former. After travelling in Italy and Spain, where he worked for Philip III, he became one of the richest painters of his time after the death of Rubens.

Siberechts, Jan (1627-1700)

Flemish landscape artist, born in Antwerp. The Duke of Buckingham invited him to London, where he worked right until his death.

Siciliano (Rodriguez Luigi, known as)

Italian 17th-century painter, originally from Messina. He was mainly active in Naples at the beginning of the century. The town museum has a *Trinity* and a *Rosary* by him. For the refectory of the St Lawrence monastery in Naples, he painted frescoes showing the twelve provinces of the kingdom of Naples.

Snyders, Frans (1579-1657)

Flemish painter, specialising in animal and still-life painting. A pupil of Peter Brueghel, he went to Italy in 1608 and married (in 1611) the sister of Cornelis de Vos. With Fyt, he represents the best tradition of animal painting in Flanders. His light touch and luminous colours made him one of Rubens' most useful collaborators. It was he who painted the animals in Rubens' great hunting scenes, as well as all the fruit and flowers (*Diana Returning from the Hunt* and *The Pro-*

cession of Silenus). His paintings give evidence of great power and much sincerity. His enthusiasm is seen at its height in his hunting scenes: *The Stag Hunt* (The Hague), *The Bear Hunt* (Berlin), *The Fox Hunt* (Vienna), *Fight between Swans and Dogs* (Antwerp). ... More peaceful scenes show monkeys playing, animal concerts, gatherings of barnyard animals and great displays of game (the museums of Brussels, Valenciennes, Munich). Snyders had many admirers and pupils, including Fyt and Paul de Vos.

Solimena, Francesco (1657-1747)

Neapolitan decorator, working in Francesco de Maria's academy of painting in 1674. He was influenced by Mattia Preti and Giordano. His talent was precocious and he used it to paint vast panoramas and enormous architectural scenes. His compositions are packed with people swirling here and there through light and shade. There are great melodramatic scenes in San Paolo Maggiore in Naples: *The Fall of Simon Magus* and *The Conversion of St Paul* (1689-1690), and in

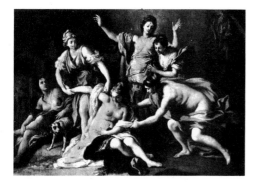

leading painters. It is even claimed that Ribera was jealous of him. In Naples, he painted the ceilings of San Paolo and the Gesù Nuovo; he painted a *Sant' Emidio* for San Martino. Other paintings include: at the Uffizi, *The Artist*; in the Prado, *The Vision of Zacharias*; and at the Galleria Corsini, *Madonna and Child*. All his pictures are notable for their purity of line.

them he moves through an ever-increasing range of colours while the characters twist and turn in all directions. He had great skill in painting spiralling groups of figures (the sacristy of San Domenico Maggiore, 1709, and especially the tumultuous fresco *Heliodorus Driven from the Temple*, Gesù Nuovo, 1725). His magnificent use of detail can be seen in the sketch for *The Massacre of the Giustiniani at Chios* (Naples Museum). His stay in Spain (1692-1702) doubtless strengthened the strong position he held in Neapolitan art.

Soreau, Isaac or Jan

Specialist in flower painting and still-life. He lived in Hanau from 1620 to 1638. He also etched some landscapes.

Stanzioni, Massimo (known as the Cavaliere Massimo) (1585-1656)

Italian painter born in Naples. He learnt fresco painting with Giovanni Caracciolo and Corenzio. In Rome, he was influenced by Annibale Carracci and became the friend of Guido Reni. Back in Naples, he was soon recognised as one of the

Stella, Jacques (1596-1657)

French painter and engraver, born in Lyons, died in Paris. As a young man, he went to Italy where he became a close friend of Poussin. On his return to France in 1634, he was named painter to the king. He worked for various churches, but was not outstanding in large compositions. His smaller pictures are better: *Holy Family* (at the Hermitage), *Repentant Magdalene* (in Munich) and *St Cecilia Playing the Organ* (in the Louvre). He engraved religious subjects and genre scenes.

Stomer, Mathaus (1649-1702)

Flemish school. Painted landscapes and battle scenes. He may have been a pupil of Orlandini in Parma. Dresden Museum has some paintings by him: *Attack by Brigands* and *Troops Disembarking*.

Susterman, Joos (1597-1681)

Flemish portrait-painter, born in Antwerp. He went to live in Italy at the invitation of Cosimo de' Medici and he died in Florence. Many paintings by him are in the Uffizi.

Jean Tassel
Portrait of Catherine de Montholon
Dijon, Musée des beaux-arts

David Teniers II
The Artist's Wife and Son
Turin, Pinacoteca

Tanzio (Antonio d'Enrico Tanzio di Varallo) (1575-1635)

Italian painter born in Alagna, died in Varallo(?). He was influenced by Caravaggio and Gentileschi. He painted pictures for churches in Milan, Bergamo and Novara. The Brera in Milan has a *Portrait of a Lady* and the Turin Gallery a *Conception of St Anne.*

Tassel (The)

Family of French artists, 17th century, born in Langres.

Tassel, Richard (1583-1668)

Sculptor and painter, son of Pierre Tassel (history painter, born in 1521). He went to Italy, where he worked under the direction of Guido Reni. He painted a considerable number of pictures, some of which can be seen in Dijon, Langres and Troyes.

Tassel, Jean (1608-1667)

Son and pupil of Richard Tassel, less gifted as a painter than his father. The Museum in Langres has his *Return from Market.*

Tassi, Buonamico Agostino (1565-1644)

Born in Perugia, died in Rome. Italian landscape and seascape painter, engraver. In Rome, he was a pupil of Paul Bril. According to some biographers, Tassi is supposed to have been sent to the galleys at Leghorn for some crime he committed and it would have been here that he studied maritime scenery. His decorations in the Quirinal and the Palazzo Lancellotti show great originality. He worked in Genoa and may have taught Claude Lorraine.

Temporiti, Francesco (1634-1674)

Born in Milan, died in Paris. Ornamental sculptor of the Paris school. Between 1667 and 1673 he worked for the Louvre, the Paris Observatory and the royal châteaux of Versailles and Trianon.

Teniers (David II, the Younger) (1610-1690)

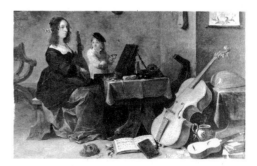

Born in Antwerp, died in Brussels. Flemish painter, once greatly admired. He produced a considerable volume of work (over a thousand catalogued items), painted with great talent and covering a wide area of subjects. His most famous works are in Brussels.

Tournier, Nicolas

French painter, end of the 16th and beginning of the 17th century. A pupil of Valentin and Caravaggio, he seems to have worked almost exclusively in Toulouse. Most of his works are to be seen in the Capitole: *Virgin and Child, The Dinner at Emmaus* There is a *Concert* in the Louvre.

Troy, François de (1645-1730)

French painter, born in Toulouse, died in Paris, He went to Paris when he was young and was a pupil of Claude Loir whose daughter he married. He soon established a fine reputation as a portrait-painter. In 1693, he was appointed a teacher at the Académie and in 1708 he became Director. Louis XIV sent him to the royal court in Munich to paint the portrait of Princess Maria Cristina of Bavaria. He painted many famous people of the time. In the Wallace Collection in London we can see his *Louis XIV and his Family*; in the Louvre, *Charles Mouton, the Lute Player*; and in Vienna, *Portrait of a Man.*

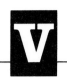

Valentin (Jean de Boullongne, known as Moïse le) (1594-1632)

French painter, born at Coulommiers, died in Rome. He was very young when he went to Italy and was a pupil of Simon Vouet; he became a close friend of Nicolas Poussin. For Saint Peter's in Rome, he painted a picture entitled *The Martyrdom of St Processus and St Martinian*, which is his masterpiece. He was an imitator of Michelangelo and Caravaggio and painted principally historical and genre scenes. His knowledge of drawing and his lively colour sense are outstanding. He was typically French in his presentation. He was especially good in scenes with gipsies, strolling musicians and gamblers. The Louvre has his *Judgement of Solomon* and the Borghese Gallery a *St John in the Desert*; at Versailles he painted a ceiling showing the *Four Evangelists* for Louis XIV's bedroom.

Valeriani, Giuseppe (end of the 16th century)

Italian architect, member of the Company of Jesus, working mainly in Naples, his birthplace (church of the Gesù Nuovo, 1585), and in Genoa (Sant' Ambrogio, 1587).

Van den Hecke, Jean (1620-1684)

Flemish painter and engraver. He did all types of painting. He travelled to Italy and was much admired in Rome. Many engravings of animals and battle scenes.

199

Van Dyck, Anthony (1599-1641)

Son of a rich bourgeois from Antwerp, he had an excellent education. He was a pupil of and collaborator with Rubens. He had a lively temperament and was a man of great elegance. He worked hard and left a great number of paintings. In 1620, he spent three months in England, painting a variety of portraits. Then he went to Italy, where he soon became very popular with the aristocracy. His portraits are full of imaginative detail: *Cardinal Bentivoglio* (Pitti, Florence) and *The Blue Child* (Palazzo Durazzo). 1624 marks a new trend in religious painting, inspired by the Venetian artists: *Virgin Looking Heavenwards* (Pitti) and *Virgin with the Child Jesus and Two Angel Musicians* (Academy of St Luke, Rome).

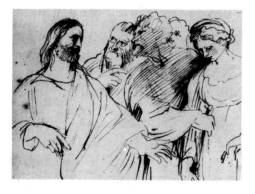

He returned to Antwerp, where he stayed for the next six years (1626-1632). His large religious compositions are admirable in their calm and tender treatment of religious feeling: *The Crucifying of Jesus* (Notre-Dame de Courtrai), *Flight into Egypt* (Munich) and *Virgin with Donors* (Louvre). He was a most remarkable portrait-painter and his skilful brush has left us pictures of princes and great men

from all the courts of Europe. In 1632 he went back to England, where he stayed until his death. It was here that his genius reached its full flowering. Charles I named him official painter to the king. In ten years, he painted about 350 portraits: thirty-eight of the king, thirty-five of the queen. The most famous of all, *Charles I Hunting* (1635), is in the Louvre. Van Dyck enjoyed luxurious living and wore himself out in a life of hard work and hard play. He married in 1640 and died a year later. He was imitated by a variety of obscure artists until his true continuators, Reynolds and Gainsborough, appeared.

Van Eyck, Jan Karel (1649-?)

Flemish painter, born in Antwerp, pupil of Quenillus. We lose trace of him after 1669.

Van Hulsdonck, Jacob (1582-1647)

Flemish painter specialising in flowers and fruits, born in Antwerp.

Van Nuyssen (Janssens Abraham, known as) (1575 ?-1632)

Painter of historical and religious scenes, born in Antwerp. He decorated a number of churches in Flanders (Ghent Cathedral —a famous *Descent from the Cross*).

Van Thielen, Jean-Philippe (1618-1667)

Flemish flower painter, born in Malines.

Van Thulden, Theodore (1606-1676)

Dutch painter born at Bois-le-Duc. He worked on the Marie de' Medici frescoes in the Palais du Luxembourg.

Van Tilborch, Giles (the Elder) (1578-1632)

Antwerp genre painter.

Van Tilborch, Giles (the Younger) (1625-1678)

Portrait and genre painter.

Van Utrecht, Adriaan (1599-1653)

Flemish still-life painter. Born and died in Antwerp.

Vanvitelli, Luigi (1700-1773)

Neapolitan architect, born in Naples, died in Caserta. He was the son of Van Witel, a Dutch painter. He did a small amount of painting himself. When he was comparatively young, he worked in Ancona, where he built the hospital (1733), the Arch of Clementinus (1735), the chapel of St Cyriac's relics (1738-1739) and the Gesù (1746). He designed many buildings in Rome, including the church of San Agostino (1735), and the interior of Santa Maria degli Angeli. In 1751 he was invited to Naples by Charles VII of Bourbon, who wanted to build a new capital. The new Versailles was the Palace of Caserta (1752-1770), a work of classical nobility disturbed only by the inordinate size of the enterprise. The huge park which surrounds the palace is usually considered the ultimate masterpiece of Italian scenic design. In Naples itself, Vanvitelli built the Caroline aqueduct, the façade of the Palazzo Calabritto, the Eboli bridge and the Annunziata (1760), finished at a later date by his son. He had four sons and three were architects.

Varin, Quentin (about 1575-1627)

Painter from northern France, born in Beauvais. He was the master of Nicolas Poussin (from 1610 to 1612). In Paris, there is a *Presentation in the Temple* in Saint-Germain-des-Prés (1624) and *St Charles Borromeo Distributing Alms* at Saint-Etienne-du-Mont (1627).

Verbruggen, Gaspard (1635-1687)

Flower painter from Antwerp.

Vigarini, Gaspard, and his sons Ludovico and Carlo

Italian decorators who came to France in 1659 at the invitation of Mazarin, who wanted them to plan the marriage festivities for Louis XIV and to try to build the famous Salle des Machines in the Théâtre des Tuileries, which laid them open to the hostility of Le Vau. They were without equal in the organisation of entertainments: *The Pleasures of the Enchanted Island* (1664) and all the festivities from 1668 to 1674 were, in the main, of their devising.

Claude Vignon
Allegory
Tours, Musée des beaux-arts

Paul de Vos
Hunting Scene
Madrid, Prado

Vignon, Claude (the Elder) (1593-1670)

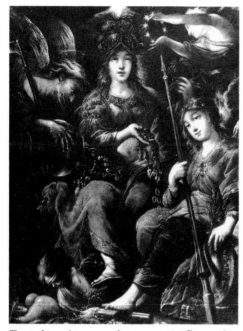

French painter and engraver. Son of a footman in the service of Henri III and Henri IV, he had thirty-four children from two marriages. Official painter to Louis XIII, he also worked for Cardinal Richelieu and his expertise in matters of art made him the perfect person for Marie de' Medici to send to Italy and Spain to buy pictures and pieces of sculpture. He had lessons from Caravaggio. He painted *The Wedding at Cana* for the Prince of Ludovicio. In Spain, he may have seen works by Zurbarán. In 1651 he became a founder member of the Academy of Painting. He painted a number of religious pictures for the churches of Paris. He painted swiftly, but his attractive colours have been much faded by time. His works include: *The Adoration of the Magi* (Lille Museum) and *Adam and Eve after the Fall* (Dresden Museum).

202

Vollant, Simon

Architect from Lille who built the Porte de Paris for the town in 1682, a splendid triumphal arch celebrating the conquest of Flanders by Louis XIV; between 1685 and 1695 he built Vauban's citadel.

Vos, Cornelis de (1585-1651)

Flemish painter, born in Hulst. He worked for Rubens, then began to specialise in portraits; he soon grew to rival Van Dyck and Frans Hals. His technique and colour sense are much admired. He died in Antwerp.

Vos, Paul de (1596?-1678)

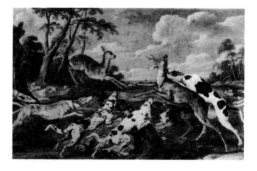

Born in Hulst, died in Antwerp. Brother of Cornelis. He specialised in painting animals, still-lifes and compositions with musical instruments and weapons.

Vouet, Aubin (1595-1641)

Painter, born in Paris, brother and pupil of Simon Vouet, with whom he collaborated. In 1639, he painted *May* for

Notre-Dame. In the Feuillants' cloister in Paris, he painted a variety of episodes from the life of St Bernard. In Nantes Museum there is a picture entitled *Monk reviving a Dead Man*. He died comparatively young and left one work unfinished.

Vouet, Simon (1590-1649)

He had his first lessons in painting from his brother Laurent. After a visit to England and Constantinople, he went to Venice in 1612 and was much influenced by Veronese. In 1613 he went to Rome and studied the works of Caravaggio. He married the pastel-artist Virginia da Vezzo. In 1627 he returned to France, where he was appointed official painter to Louis XIII. He designed cartoons for the royal tapestries. He was helped by Le Brun and Le Sueur, who gradually took the work over from him. He was out of favour at the time of his death. Today, his reputation is not very great. His sketches are somewhat mannered, his religious paintings lack sincerity. His decorative work in the Hôtel Séguier, the Palais-Royal and the Châteaux of Rueil and Chilly has disappeared. The Gobelins have two of his tapestries. His best work is to be found in his church paintings: *Christ Crucified*, *The Presentation in the Temple* and *Faith* (Louvre).

Vrancx or **Franks,** Sebastian (1573-1647)

Flemish painter from Antwerp, commandant of the Civic Guard. He painted a wide variety of subjects, but with a preference for lively scenes.

Wölfflin, Heinrich (1864-1945)

Swiss historian, German-speaking. He spent two years in Italy and wrote his great work *Renaissance and Baroque in Italy* (1888). He was Professor in Basle, Berlin, Munich and Zurich; in 1899 he published *Classical Art* and in 1915 he brought out his most important work, *Fundamental Concepts in Art History*.

Ykens or **Ijkens,** Frans (1601-1693?)

Flemish painter, born in Antwerp. Specialised in painting flowers and fruit.

Printed in Italy

Bibliography

I. Introduction. General works.

Bellori: *Le Vite*, Rome 1672 (last edition 1942).
Jan Bialostocki: "Le baroque; style; attitude; époque", *Revue d'Information d'Histoire d'Art*, Paris, January and February 1962.
Jacob Burckhardt: *Der Cicerone*, Leipzig 1907.
Sir Kenneth Clark: *Landscape into Art*, 1949; *The Nude* 1956.
André Félibien: *Lettres de Nicolas Poussin*, R. and J. Wittmann, Paris 1945.
Roger Fry: *Vision and Design*, Chatto & Windus, London 1957; *Transformations, Critical and Speculative Essays on Art*, ibid., 1926; *Architectural Heresies of a Painter*, ibid., 1921.
Henri Focillon: *La Vie des Formes*, Presses Universitaires de France, Paris 1955.
Cornelius Gurlitt: *Geschichte des Barockstils und des Rokoko*, Dresden 1889.
Emile Mâle: *L'art religieux après le Concile de Trente*, Armand Colin, Paris 1932.
Eugenio d'Ors: *Du Baroque*, Gallimard, Paris 1936-1937.
Roger de Piles: *Abrégé de la Vie des Peintres avec des Réflexions sur leurs ouvrages*, J. Etienne, Paris 1715; *Cours de Peinture par Principes*, Jombert, Paris 1766.
Aloïs Riegl: *Die Entstehung der Barockkunst in Rom*, Vienna 1894.
Victor-Lucien Tapié: *Le Baroque*, Presses Universitaires de France, Paris 1961; *Baroque et Classicisme*, Plon, Paris 1957.
Werner Weisbach: *Die Barockkunst der Gegenreformation*, Vienna 1921.
Heinrich Wölfflin: *Renaissance und Barock*, T. Ackermann, Munich 1888; *Kunstgeschichtliche Grundbegriffe* 1915.

II. Italy

Bernard Berenson: *Del Caravaggio, delle sue incongruenze e della sua fama*, Electa, Florence 1950.
André Berne-Joffroy: *Le Dossier Caravage*, Editions de Minuit, Paris 1959.
Charles de Brosses (Président): *Lettres familières sur l'Italie*, choix et préface de Roger Etiemble, Paris 1961.
André Chastel: *L'Art italien*, vol. II, Larousse, Paris 1956.
Benedetto Croce: *Storia dell'Eta Barocca in Italia*, G. Laterza, Bari 1929.
Marcel Reymond: *De Michel-Ange à Tiepolo*, Hachette, Paris 1912.
Stendhal: *Les Ecoles italiennes de Peinture*, Le Divan, Paris 1932 (3 vols.).
Rudolf Wittkower: *Art and Architecture in Italy, from 1600 to 1750*, Penguin Books, 1958.

III. France

Anthony Blunt: *Art and Architecture in France from 1500 to 1700*, Penguin Books, 1953.
Burlington Magazine: "The Age of Louis XIV at the Royal Academy", London, March 1958 (No. 660).
Colloque du Centre national de la Recherche scientifique sur Nicolas Poussin (2 vols.), Paris 1960.
Bernard Dorival: *La Peinture française des Origines au XVIII^e Siècle*, Paris 1941-1942.
Georges Isarlo: *La Peinture en France au XVII^e Siècle*, La Bibliothèque des Arts, Paris 1960.
Charles Sterling: Introduction au catalogue de l'exposition "Les Peintres de la réalité en France au XVII^e siècle"; préface de Paul Jamot, Musée de l'Orangerie, Paris 1934.
Jacques Thuillier et A. Châtelet: *La Peinture française de Fouquet à Fragonard*, Skira, Paris 1964 (2 vols.). J. Thuillier gives a list of essential works on the 17th century in his Bibliography.
R. Wittkower, A. Blunt and Friedländer: Catalogue for the exhibition "The Drawings of Nicolas Poussin", London 1949.

Interesting articles on research into 17th-century art may be found in the *Bulletin de la Société d'Etudes du XVII^e siècle*, especially Nos. 36 and 37, Paris 1957.

IV. Flanders

Marie-Louise Airs: *Les Peintres flamands de Fleurs au XVII^e Siècle*, Paris, Brussels 1955.
André Chastel: "Bibliographie de la Peinture" in *Information d'Histoire d'Art*, Paris, January-February 1959.
Hans-Gerhard Evers: *Rubens und sein Werk*, Brussels 1943.
Eugène Fromentin: *Les Maîtres d'autrefois*, "La peinture en Belgique et en Hollande du XV^e au XVII^e siècle", Brussels 1948.
Marcel Fryns: *Rubens, Van Dyck et Jordaens*, Elsevier, Paris, Brussels 1962.
Robert Genaille: *La Peinture en Belgique de Rubens aux Surréalistes*, P. Tisné, Paris n.d.
Léo Van Puyvelde: *La Peinture flamande à Rome*, Librairie Encyclopédique, Brussels 1950.
Léo Van Puyvelde: *Rubens*, Elsevier, Brussels 1952.
Léo Van Puyvelde: *Van Dyck*, Elsevier, Brussels 1950.
Léo Van Puyvelde: *Jordaens*, Elsevier, Brussels 1953.

List of Illustrations

Dictionary

This volume in the series
History of Art was printed in offset
by Grafiche Editoriali Ambrosiane, Milano.

The text was composed in Times 10-point type;
the first and third parts were printed
on machine-coated paper and the second part on
blue cartridge paper.

The cover and lay-out of the inside pages
were designed by Jean-Marie Clerc.

Printed in Italy 13 045 06